ARTIST OUTDOORS

ARTIST OUTDOORS

Field Sketching in the American West

R. RICHARD GAYTON

Prentice Hall Press • New York

Published by Prentice Hall Press
A Division of Simon & Schuster, Inc.
Gulf + Western Plaza
One Gulf + Western Plaza
New York, New York 10023

PRENTICE HALL PRESS is a trademark of Simon & Schuster, Inc.

Library of Congress Cataloging-in-Publication Data

Gayton, R. Richard.
 Artist outdoors.

 Bibliography: p.
 Includes index.
 1. West (U.S.) in art. 2. Drawing—Technique.
I. Title.
NC825.W47G3 1987 743′.83 86–43111
ISBN 0–13–048166–1

Designed by C. Linda Dingler
Manufactured in the United States of America
10 9 8 7 6 5 4 3 2 1

First Edition

To Carol

ACKNOWLEDGMENTS

Clare Walker Leslie's interest and support led to the writing of this book, and I am indebted to her. Mary Kennan was encouraging at a time when I was reluctant to try my hand at authorship. Sarah Montague, Tami Cabot, and Gilda Abramowitz were especially sensitive in their treatment of the manuscript. I also owe a special debt to Carol Gayton, my wife, who has accompanied me on all of the field trips recounted here, adding significantly to my understanding of nature and guiding my eyes to birds I might not have seen. Thanks also go to Ann Zwinger for graciously allowing me to reproduce pages from her sketchbooks. Finally, I must acknowledge those who have taught me, teachers and students alike, especially those who have shared their love of nature.

Contents

Preface

If you are fascinated by the silhouette of a red-tailed hawk soaring in the afternoon sky, and reach for a piece of scratch paper on which to trace it, you already know the pleasure of a sketch. If you have paused over a wildflower, puzzling out its structure, or if you have traveled to the mountains or to the desert and felt the desire to make small drawings to record the landscape that passed before your eyes, these are clear indications that sketching would enrich your experience of the outdoors. Sketching is a way of seeing, an activity that can bring deep personal satisfaction, whether you are a scientist or a writer, artist or artist-to-be, traveler, or poet.

In illustrations and text I guide you through a complete introduction to nature sketching, and through selected field trips into the American West.

The variety of ways you can start and keep a sketchbook—possibly making it part of a journal—are reviewed. This is illustrated with examples of sketches (and a few journal excerpts) of both European and American artists who have looked to nature, and in so doing provide special inspiration.

All the materials that can be used to sketch in the outdoors, and the basics of drawing that apply to sketching, are explained simply, clearly, and completely. There is special coverage of the techniques of pen and ink, dry-brush watercolor, and colored pencil, all of which add variety to sketching.

Chapter 5 sets the stage for your first field trips of exploring the countryside and sketching. There are tips to give you a basic understanding of the forms in a landscape and in a single flower. You are introduced to ways to sketch animals, including birds, which are often neglected in books on drawing. The chapters that follow take you to the Pacific coast, the redwood forests, over chaparral, and into the mountains and deserts of the West. There is valuable practical advice on preparing for the conditions you might find and the experience of encountering these places for the first time. All of this is illustrated with many of the pages from my sketchbooks, sketches that demonstrate a variety of approaches with different drawing tools.

The exploration of landscapes is followed by a look at the supplementary resources to be found in zoos, natural history museums, aquariums, and botanical gardens, considering both what they provide and the difficulty of sketching in them. Sketching the figure in landscape is covered briefly.

Sketching is one way to gather reference for illustration and painting. For some, sketching will lead to an interest in these possibilities. The conclusion of this book offers practical guidance on sketching as a way of gathering reference material, with examples of this in practice. Altogether, I have endeavored to make this a complete reference guide to outdoor sketching.

ARTIST OUTDOORS

1
BEGINNING
A SKETCHBOOK

WHAT IS A SKETCH?

Before you can embark on a sketchbook, it's necessary to have some understanding of what *sketch* means, though this may seem akin to defining how many angels can stand on the head of a pin. I have known an artist to object to the term *sketch,* believing that it connoted a "lesser" drawing or—worse yet—an uncaring, sloppy approach to drawing. This artist maintained that even a brief and simple drawing was done with intention and represented a purposeful act. In other words, a drawing is a drawing, whether it has five lines and took a moment to do or contains shading and took weeks to do. However, as you inaugurate your sketchbook, how you yourself define the term has important consequences. If you regard each sketch as a formal drawing, you may easily inhibit the discoveries and the pleasures that are to be found in sketching. A sketch is many things.

The word *sketch* is used to describe a drawing that is done to visualize an idea or record the essential form of something seen. It can be simple or complex, as serves your interest. For Thoreau the simple sketch served well. At one point he says, "No pages in my Journal are so suggestive as those which contain a rude sketch."[1] Zbigniew Jastrzębski in *Scientific Illustration* sees sketching as the first stage of an exact analysis of visual appearance. Rather than as a quick notation, he sees it as a "slow but correct way to build the visualization of an object."[2] This corresponds with Leonardo's view that drawing or sketching should be approached slowly in order to learn confidence and careful observation.

Both meanings of the word *sketch* are seen in figure 1.1. In Pisanello's studies of the monkey, there is thoughtful observation *and* quick notation. The pages from Delacroix's Moroccan journal, figures 1.7 and 1.8, illustrate the spontaneity that is often characteristic of travel sketching. But here too, there is both immediate response and thoughtful observation.

What Jastrzębski defines as a sketch may be called a *study* by others, especially when it shows careful visual analysis. Ann Zwinger's sketches, figures 1.12 and 1.13, could be called studies. How we

define the word *sketch* has little real importance. What *is* important is that you sketch as quickly or as slowly, as completely or as suggestively, as you are moved to do. Sketching is a response.

BEGINNING TO SKETCH

If you have done little or no drawing before, it is natural to want each sketch to show improvement. Avoid overworking them. It is often hard—at first—to accept sketches that are composed of a few lines as having value. In your first sketches, draw without haste. Allow time to really look at the subject. If the subject moves or you don't finish, don't fret. This is not a matter of speed. When you have difficulty getting the outline right, don't draw repeatedly over the same contour. If a line is not where you want it, erase it. However, don't be too insistent on the accuracy of your first sketches. That will grow with practice.

It is in sketching often, and in doing many sketches, that your skill will grow and your interest blossom. If you do but few sketches, they become too important. You lose objectivity. You will not relax and respond to your subject. Sketch often and any fear of doing poorly lessens considerably. We have all experienced the first trying and difficult moments involved in learning a new skill. Self-doubt can be conquered by a willingness to practice. And don't set your standards too high when you are just beginning.

Drawing is a way of seeing. There is nothing mysterious about it. Learning to guide the hand, to coordinate it with what the eye sees, and at the same time to analyze what you see, will feel awkward. With practice it becomes less so. True, there are ever new levels of attainment that seem to lie just ahead. Nevertheless, you will quickly find yourself taking pleasure in the act of sketching and how it enhances the exploration of nature.

CHOOSING A SKETCHBOOK

Call it a sketchbook or a journal; carry a notebook or a pad of paper. All will serve to contain your sketches and observations of nature. Although you may feel a little self-conscious at first, carry it everywhere you go. Then you will always have it when you chance upon something you want to sketch. Jot down thoughts, sketch the hummingbird at the feeder, trace the shape of a cloud, or just doodle. The new sketchbook with its pristine pages can be intimidating, and including all manner of sketches and jottings helps overcome any hesitancy you might feel.

When I travel I sketch the landscapes I visit, rather than take snapshots. The snapshot is taken in a moment, but even with a brief sketch you pause awhile. In making observations for the sketch you more truly see the place you visit. A few selected contours and a hint of tone may not vividly reproduce the scene, but a sketch can rekindle memories of the experience in a way that the snapshot cannot. The sketch of the coast in figure 6.4 rekindles the memory of a place and a moment that was special for me.

In his *Journal* Thoreau says, "The question is not what you look

at, but what you see."[3] As you sketch, your eyes open wide to the world around you. The hawk as it soars, or leaves fluttering in the wind, studied with the intentness of the sketch, become part of your experience of nature. It is a moment of intense seeing. There is the thrill of discovery as you begin to discern the patterns of life in animals and plants.

Learning to sketch does not require the formal study of art. It does require practice and some patience. Read over the basic methods of drawing reviewed in chapter 3, and try the exercises. I cannot promise that the effort will always be easy, but I can promise that the rewards are worth the effort.

The ability to sketch grows with practice, and to draw in the sketchbook itself constitutes a good way to practice. It is natural to feel self-conscious and displeased with your first efforts, but keep sketching. Don't subject them to the opinions of others. Like a diary, a sketchbook is personal and private.

An informal sketchbook may be easier to use than a bound volume. You may find, as I did, that such a volume is too intimidating, and that you hesitate to "just" doodle in it. (If you already love to doodle, don't underestimate its value as an aspect of visual thought.) I use a clipboard contained in a folder, and unsatisfying pages are easily discarded. I do use a bound volume at times, although I tend to regard it more as a journal—a progression of slightly more formal ideas and observations. When I begin a new one I leave the first pages blank—a ploy that seems to lessen my fear of "spoiling" the book with a failed sketch. Don't hesitate to begin and then abandon sketchbooks until you find a format that suits you. It requires a little experimentation.

THE SKETCHBOOK AS A JOURNAL

Keeping a sketchbook for a time puts you in touch with the cycles of nature. If you sketch a particular scene in all seasons, wet and dry, as I have the oak-studded chaparral near my home, you soon develop a sense of the living rhythms of a place—rhythms that give life to any artwork the sketches might inspire. You become aware of the phases of the moon, the time of bird migrations, and (if you happen to sketch along a coast) the rhythm of the tides. As you begin to observe the cycles that govern all life, you become caught up in the living pulse of the landscape.

The sketchbook may take on the quality of a journal as it accompanies you in your travels. It did this for me as I went by rail to Denver, across Utah and Colorado in winter. As I gazed through the window, time seemed to stand still across the snow-covered scrub of a primeval landscape. Monumental cliffs reflected a cold hazy light. As the train slowly climbed long grades, I sketched as quickly as I could. My scrawls were the barest indications of what I saw. Larger formations of stone and sand remained in view long enough for me to sketch them, but the point of view changed constantly.

The sketches from that trip are—at best—tantalizing reminders of a magnificent landscape (see fig. 9.26). Only in my memories are the missing lines and tones to be found. Afterward, it is possible to sit

down and fill in some of the missing lines. Do this in a fresh sketch, in order to preserve the provocative quality of the original response.

You may choose to sketch only for the pleasure of doing so, with no end in mind. It can, and does, take you out of yourself. Or it may inspire a painting, or a poem. Sketches can renew the stimulation of a place and the pleasure of a moment. They recapture the warmth of summer light as you sit thumbing through them in the midst of winter. Whatever the season, the medium, or the style, a number of artists have gone into nature before us, both to explore it and to give substance to their art, and we can use their work as examples and inspiration.

ARTISTS WHO HAVE SKETCHED NATURE

The practice of keeping sketchbooks probably evolved from the pattern books used by medieval manuscript illuminators. At the beginning of the Italian Renaissance, artists began to study nature directly. Returning to their studios with sketches gathered from life, they used them as source material in the same way as the illuminators had used the pattern books, and it became common to carry a small hand-bound book of blank pages.

Antonio Pisanello (Italian, c. 1397–c. 1450) is the earliest European artist known to have sketched directly from nature. His careful studies of birds and mammals are gathered together in a collection called the Vallardi Codex, now owned by the Louvre. Whether these sketches were originally part of a sketchbook is unknown, but they are the first evidence of an artist sketching from nature. In figure 1.1, from the Codex, Pisanello observed a captive monkey. The slightly varied postures convey the experience of direct observation, the pen-and-ink line a decisive response to form. There is nothing primitive or groping. Pisanello's sketch is the work of someone who has frequently drawn from life, who is at ease with sketching the gesture of living subjects.

Sketchbook and Journal

Leonardo da Vinci (Italian, 1452–1519) has come to have the stature of a mythological being, remote, eccentric, and a seeker of arcane knowledge. His writings belie these perceptions. In his sketches and notes you discover someone with a consuming interest in natural history. Written as journal entries, his observations are short and to the point. Most of them are thought-provoking; some of them are inspiring.

In 1970 the Dover Company republished a nineteenth-century compilation of Leonardo's writings, translated by Jean Paul Richter and entitled *The Notebooks of Leonardo da Vinci*.[4] Thus, only recently has there been wide access to his thought. The journal writings were gathered from different collections and grouped by the main subject of each entry. Only a persistent reader discovers the beauty of his combination of sketchbook and journal.

Like Pisanello, Leonardo had a sensitive eye for the phenomena of nature. Pisanello has left an inheritance of animal sketches, Leonardo a treasure trove of landscape lore.

Leonardo perceived in towering mountain forms the titanic

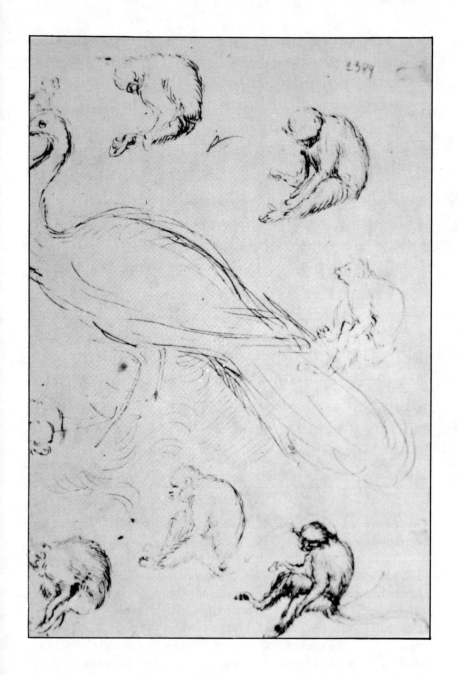

Figure 1.1
Antonio Pisanello (c. 1397–c. 1450).
Studies of a Peacock and a Monkey.
Pen and ink, 10¼" x 7".
(*From the Vallardi Codex, 2389 verso.
Courtesy of Cabinet des Dessins, Mu-
sée du Louvre, Paris.*)

forces that shaped the earth. His observation of fossil shells embed-
ded in rock high in the mountains caused him to question the origin
of mountains; they suggested to him that mountains arose from below
the surface of the sea. He probably would have found interest in the
mountains of the American West. His sketch of mountain peaks
could as easily have been the eastern face of the Sierra as the Italian
mountains it actually represents (see fig. 1.2).

Snow-covered Mountain Peaks is a delicate sketch. Leonardo
drew with a natural reddish chalk on a paper of similar color. White
highlights suggest the snowcapped peaks. Black-and-white reproduc-
tions make it look gray and dull. The white touches are almost
invisible. But look at it closely—the sketch is a treasure. Leonardo
has used natural chalk—which was cut from soft rock (hematite)—to
portray rocky summits; the medium suits the subject. His touch is
deft. He sees the mountain, not as a silhouette, but as a solid form.

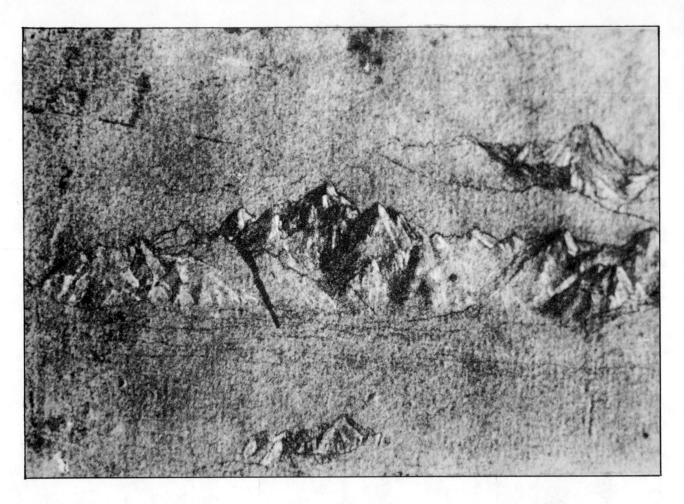

Figure 1.2
Leonardo da Vinci (1452–1519).
Snow-covered Mountain Peaks, 1511.
Red chalk with touches of white on
red prepared paper, 4¼" x 6¼".
(*Windsor Castle, Royal Library RL
12410. Reproduced by gracious per-
mission of Her Majesty Queen Eliz-
abeth II.*)

The peaks are sketched as a series of independent forms, one
overlapped by another.

Again and again throughout his writings and sketches Leonardo
shows his goal of understanding the qualities of a subject thoroughly,
rather than just representing surface appearance.

Figures 1.3 and 1.4 represent a single page from one of
Leonardo's journals. Figure 1.3 is the front of the page, figure 1.4 the
reverse. As in the previous sketch, he draws with natural chalk. Some
scholars have theorized that the blank space beneath the first
drawing, *Copse of Birches,* was probably left intentionally. Imagine
the space removed. A sense of space, of environment, is lost. The
blank areas of a sketch are as much a part of the entirety of a drawing
as the shapes described by lines or tones.

An excellent way to study *Copse of Birches*—or indeed any great
sketch—is to draw a copy of it. Natural chalk of the kind used to do
this sketch became scarce centuries ago. The most similar tool
available to us is a crayon, Conté crayon. Because it is softer than
natural chalk, your copy will have to be a little larger than the
original. To copy other artists' visions of the world is to see how they
translated what they saw into marks on a page. You are not learning
to draw like Leonardo; you are learning how Leonardo drew, how he
saw.

Note how he summarizes the texture of the leaves, how he
suggests the rippling effect of wind and light. He uses hatching
(closely spaced parallel lines or strokes) to produce luminosity

Figure 1.3
Leonardo da Vinci (1452–1519).
Copse of Birches, 1503–1504. Red
chalk, 7½" x 6".
*(Windsor Castle, Royal Library RL
12431 recto. Reproduced by gracious
permission of Her Majesty Queen Eliz-
abeth II.)*

Figure 1.4
Leonardo da Vinci (1452–1519). *A
Single Tree,* 1503–1504. Red chalk,
7½" x 6".
*(Windsor Castle, Royal Library RL
12431 verso. Reproduced by gracious
permission of Her Majesty Queen Eliz-
abeth II.)*
Leonardo's note on the sketch reads,
"That part of a tree which has
shadow for background is all of one
tone, and wherever the trees or
branches are thickest they will be
darkest, because there are no little
intervals of air. But where the boughs
lie against a background of other
boughs, the brightest parts are seen
lightest and the leaves lustrous from
the sunlight falling on them." *The
Notebooks of Leonardo da Vinci* (New
York: Dover, 1970), 1:229.

even in the depths of shadow. He achieves an astonishing sense of atmosphere by avoiding the use of a solid tone to show shadow.

It appears that Leonardo then turned the page of his original notebook and drew *A Single Tree* (fig. 1.4). The observation written below it shows this to be a page from a journal, and comments on the density of tree limbs and effects of light.

Both sketches appear to have been intended as studies. Carlo Pedretti, the well-known Leonardo scholar, theorizes that these were done in preparation for illustrations to accompany a treatise on a painting Leonardo was compiling.[5] The sketches in his journals are frequently extensions of written passages. Many of these passages are the product of so passionate an interest that particular observations occur repeatedly in his writings.

The page illustrated in figures 1.3 and 1.4 suggest that Leonardo favored a journal 7½-by-6 inches (approximately), at least during the period of his life represented by these drawings. (Always note the size of the originals when studying reproductions, as they tell what the artist's original choices and sense of scale were.)

John Constable (English, 1776–1837) frequently carried a sketchbook no larger than 3½-by-5 inches, easy to slip into a pocket before setting out for a walk. Although he did not keep a journal, he maintained an active correspondence with close friends. One of these, C. R. Leslie, published *Memoirs of the Life of John Constable,* which contains many of the letters.[6] Although it is essentially excerpts from the letters, it reads like a journal. Here you can follow the thoughts of one of the first artists to actively pursue landscape as a subject of special interest, studying and furthering the traditions of the Dutch landscape artists of earlier times.

Constable's sketches are impressive far beyond their small scale. They illustrate how evocative, how "complete" a small sketch can be. There is simplicity in the tool he selected to sketch with—a common pencil. He did occasionally augment the pencil sketch with water-color.

Figure 1.5
John Constable (1776–1837). *Dedham from Langham,* 1813. Pencil, 3½" x 4¾".
(*From the V. & A. sketchbook, no. 121, p. 39. Courtesy of the Victoria and Albert Museum.*)

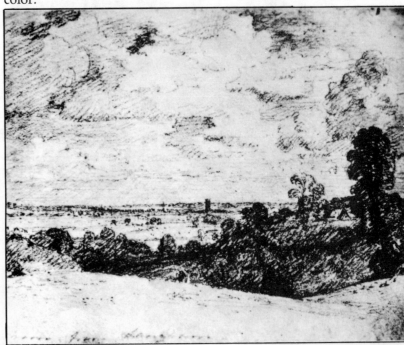

Note in *Dedham from Langham,* 1813 (fig. 1.5), how Constable gives the sense of a specific moment (rather than the eternal moment) by indicating the clouds and light he experienced on a particular day. The horizon communicates a sense of space and depth. This is accomplished with a few closely placed horizontal bands of tone. The clouds billow with movement reflecting the soft curves of the hillocks in the foreground. Compare how Constable has used pencil strokes in the crown of the tree at the right with Leonardo's treatment of the birch at the right in figure 1.3.

In *Mistley, near Harwich,* 1813 (fig. 1.6), Constable uses only a portion of the page for the sketch. (He has placed an inscription in the blank area, forestalling the kind of speculation about use of space that *Copse of Birches* has generated.) The small bound book containing the sketch is visible in the reproduction. This same book contains the sketch in figure 1.5. It is interesting to contrast the qualities of the two sketches, as it is likely that one was sketched only a very short time before the other. Note how in the *Mistley* sketch the strokes of the pencil repeat the line of the horizon and the ripples of the sea, emphasizing them.

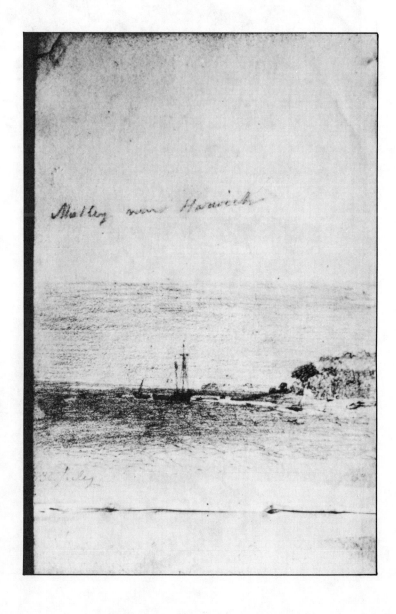

Figure 1.6
John Constable (1776–1837). *Mistley, near Harwich,* 1813. Pencil, 4¾" x 3½".
(From the V. & A. sketchbook, no. 121, p. 42. Courtesy of the Victoria and Albert Museum.)
This reproduction shows the character of Constable's small sketchbooks. The book fits easily into a pocket.

Like Thoreau, Constable developed an intimacy with the region in and around Suffolk where he spent his entire life. His sketches come to life, inspired by the close and thorough knowledge he possessed of a landscape he loved deeply.

Eugène Delacroix (French, 1798–1863) maintained throughout much of his life journals in which he both wrote and sketched. On occasion they contain the first draft of articles he wrote for publication. The literary effort seemed to be as important to him as sketching. In a journal he kept in 1832 during a journey to Morocco, both activities merged. Two facing pages from this journal are reproduced here (see figs. 1.7 and 1.8).

The stimulation and inspiration born of this journey served as an active catalyst in Delacroix's art for the remainder of his life. This travel journal was as important to him as a similar journal was to be to Paul Kane, traveling in the West of North America, only a few

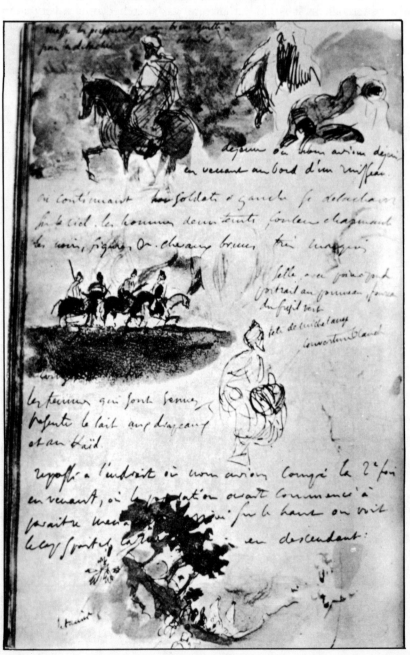

Figure 1.7
Eugène Delacroix (1798–1863). *Page 31v from an album of Moroccan sketches,* 1832. Pen and ink with water color, 7½" x 5".
(Courtesy Cabinet des Dessins, Musée du Louvre, Paris.)

years later. Kane's sketches were studies, while Delacroix's sketches were more notations, quickly done, to become evocations to memory at a later time.

It is suggested that Delacroix sketched astride a horse.[7] The image of him in the saddle, holding a bottle of ink in one hand and a pen in the other, with the journal in his lap, is hard to envision—but it may have been exactly what he did! Delacroix favored the pen, along with watercolor and pastel, for his sketches. No matter what technical reasons I might theorize for such preferences, they were intuitive or subjective preferences. Delacroix *liked* the pen; it suited his temperament, just as the pencil suited Constable.

Constable could evoke a coastline with a few tones of pencil, as he does in figure 1.6. Delacroix could evoke a mountain range in a desert with a few touches of watercolor and ink, as in the lower portion of figure 1.7. The ability of a shorthand sketch to communi-

Figure 1.8
Eugène Delacroix (1798–1863). *Page 32r from an album of Moroccan sketches,* 1832. Pen and ink with water color, 7½" x 5".
(*Courtesy Cabinet des Dessins, Musée du Louvre, Paris.*)
An excellent example of the notational nature of a sketchbook and journal. This particular journal records impressions that Delacroix looked back to and was inspired by for the rest of his life.

cate much with little lends it importance in the eye of an artist. In the eye of Delacroix it possessed an importance beyond that of a finished painting.[8]

Delacroix did not give landscape the special importance that is reflected in the work of Constable. Constable saw land, sea, and sky as a drama unto itself. The human figure, when it appears, is small. Delacroix was less inclined to minimize the human presence, and in his Moroccan sketches he gloried in its color.

Delacroix truly loved to sketch, and recorded in his journal for August 21, 1857:

> Rose early and did a sketch in perfect conditions, from the Promenade des Dames beside a delicious little stream; the slopes were covered with dew, and the sun was shining through the trees. Afterwards I climbed a long way up the hill to the left. Views admirable in the morning. Made two sketches.
>
> Rather tired when I got back, but very well on the whole.[9]

Sketchbook and Journal in the American West

Many years ago I was given an old book with yellowed pages, titled *Wanderings of an Artist,* by Paul Kane (Canachan, 1810–71).[10] It recounts a four-year journey, virtually under the auspices of the Hudson's Bay Company, among the lands and peoples of the North American West. He narrates how he sketched all that he saw, taking on a mission of recording a culture and a landscape that were disappearing.

Kane was clearly influenced by George Catlin, the best-known of the artists who portrayed the American West, and his work has been overshadowed by Catlin's. Only in recent years has a degree of critical appreciation come to Kane's work. His narrative, based almost word for word on a journal he maintained while sketching in the West,[11] captured my imagination. He vividly describes hardships, exploring and observing a new world with pencil and watercolor. He traveled by horseback and canoe, equipped with a small kit of sketchbooks, watercolors, materials for oil sketches, and a gun. His journey took him farther west than Catlin, and in addition to the record of the native peoples, he took delight in sketching the landscape and animal life of the rugged frontier.

Kane's sketches underline the fact that the rugged West was not an unpeopled land when Europeans first arrived. The farthest reaches of his journey took him to the Pacific Northwest, with its diversity of aboriginal peoples. In what is now the state of Washington, he was inspired by such dramatic landforms as *Chimney Rocks, Columbia River* (fig. 1.9). In his journal entry for July 11, 1847, he mentions this sketch:

> . . . As we approached the place where the Walla-Walla debauches [*sic*] into the Columbia River, we came in sight of two extraordinary rocks projecting from a high steep cone or mound about 700 feet above the level of the river. These are called by the voyageurs the Chimney Rocks, and from their being visible from a great distance they are very serviceable as landmarks. Sketch No. 13 represents one of them and the cone, but, owing to the position in which I stood while taking the

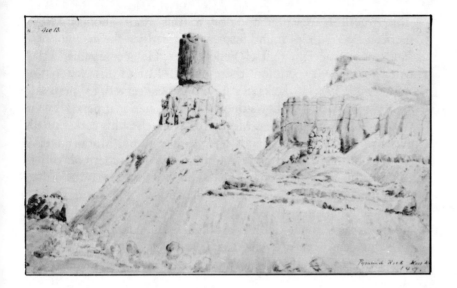

Figure 1.9
Paul Kane (1810–71). *Chimney Rocks, Columbia River,* July 11, 1847. Pencil and watercolor, 5⅜" x 9½". (*Courtesy of Stark Museum of Art, Orange, Texas.*)
Like Delacroix, Paul Kane found inspiration in a once-in-a-lifetime journey into the lands and peoples of another culture.

sketch, the other rock or chimney is not visible, being immediately in the rear of the one represented.

The Walla-Walla Indians call these rocks the "Rocks of the Ki-use girls." . . .

In 1842, five years before Kane's arrival, Mount St. Helens had erupted, much as it did in May 1980. He witnessed smoke emitted from the cone when he visited it in 1847, and sketched it. Reportedly, he wanted to climb Mount St. Helens—then unclimbed—but could find no guide to accompany him.[12]

The sketch of the Chimney Rocks is a contour drawing in pencil, with tonal indications added with touches of watercolor. The direct and matter-of-fact quality of its execution served Kane's purpose. He was documenting a landscape unknown to eastern audiences, which might be inclined to be skeptical of the artist's accuracy. (Kane went so far as to secure signed documents attesting to the truth of his observations.) This emphasis on reportage in the sketches tends to preclude the kind of poetry present in the sketches of Constable and Delacroix. Kane's constraint to be factual exemplifies the challenge of sketching in the American West. The overwhelming monumentality of towering mountains or vastness of desert seems beyond portrayal— certainly beyond a simple sketch. It dwarfs human scale to an extent that many find disconcerting, though part of the purpose of this book is to make this momentous landscape accessible.

Kane's narrative of his journey and his sketching offer a unique inspiration. We can follow him, step by step, in his journal, and refer to many of the sketches he mentions there. Although they are certainly all that his narrative suggests, it is the spirit of his undertaking that fires the imagination. He explored a world with his sketches. This mission, which occupied him for four years, was to sustain him for the rest of his life.

In the Mountains and on the Rivers of the West

Paul Kane, like George Catlin, was motivated by a desire to record a vanishing native culture, and recorded the grandeur of the landscape

of the American West in addition to this goal. Thomas Moran (American, 1837–1926) found inspiration chiefly in the magnificence of landscape, especially that of Yellowstone. He accompanied F. V. Hayden's survey expedition there in 1871, and his watercolor sketches and W. H. Jackson's photographs served to persuade Congress to establish Yellowstone as the first national park.[13]

Like Paul Kane, Thomas Moran based much of his career on his experience of the frontier landscape. Unlike Kane, Moran made a brief first journey (a matter of months), and he undertook others throughout his life. The sketches he did on location were transformed into finished watercolors and large oils. Indeed, the inspiration he found in the immense geology of such places as the Grand Canyon led to his success as one of the most highly skilled landscape painters in late-nineteenth-century America. It is in the watercolor sketches done in preparation for these paintings that his reputation now continues.

But Moran was not inspired by every towering mountainous expanse. Carol Clark, in her *catalogue raisonné* of Moran's work, observes that his response to Yosemite did not yield the quantity or have the vigor of his Yellowstone work.[14] It is not uncommon to believe that an artist might transform any landscape into art, but what inspires one person leaves another unmoved. Yosemite did not seem to provide the level of inspiration Moran found in other landscapes of western America. It is instructive to compare figure 1.10, *South Dome, Yosemite,* 1873, with figure 1.11, *Looking up the Trail at Bright Angel, Grand Canyon of Arizona,* 1901. Both of these watercolor sketches contain mountains in the background, suggestions of trees in the middle ground, and rock in the foreground. Skill is evident in both. But the latter example has a greater degree of energy

Figure 1.10
Thomas Moran (1837–1926). *South Dome, Yosemite,* 1873. Pencil and watercolor, 16½″ x 12¼″. (*Courtesy Cooper-Hewitt Museum/ The Smithsonian Institution's National Museum of Design.*)

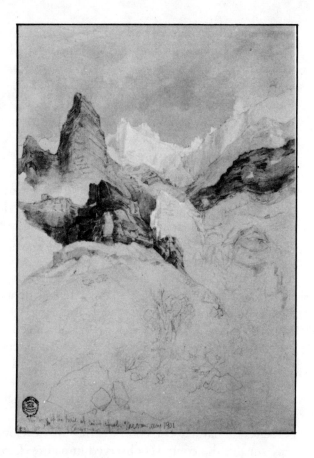

and vigor than the former. The contrast is even more suggestive if it is understood that Moran was sixty-four when he did the Grand Canyon sketch. Most assuredly, there was no dulling of the strength of the impression this landscape made on him even after thirty years of sketching it.

Moran did not find in Yosemite the qualities that moved him. This does not reflect a lack of skill in Moran, or a lack of beauty in Yosemite (and Moran's sketch is certainly admirable). As we explore nature we will each find that we respond to different places. We will each have our own preferences.

Study the method Moran employed in his sketches. In both examples (and, in fact, in many of his sketches) Moran preferred a paper of a blue-gray or buff tone. (This gives reproductions in black-and-white a murky appearance.) The contour was sketched with pencil (occasionally with pen and ink)—a studied, carefully considered line, but not a dull or lifeless one. The monumental scale and rugged surface of the rock form are delineated with a fine touch, sensitive to striation, fracture, and erosion. It is incisive. The contour lines were sketched on location. Watercolor was added "on site" if time and circumstance permitted, but many sketches were finished or developed later at camp. Moran's choice of toned paper allowed him to apply transparent watercolor mixed with Chinese white, introducing opaque qualities into the transparent color. This, in turn, allowed him to use highlighting to develop the sketch, and permitted him to mix a range of tones not possible with the exclusive use of transparent color. (This is a controversial assertion on my part. From Moran's time down to the present day, this practice has been

condemned by some. Charles Le Clair in his *Art of Watercolor* reviews this.[15]) The technique is peculiarly suited to the rendition of rock form.

Moran often favored a 10-by-14-inch format for his sketches, and various smaller proportions derived from that sheet size. There is little doubt in my mind that Moran altered the shape of his page to suit the subject at hand. If you sit as Moran did, facing South Dome in Yosemite, you may wonder how a form of such size can be made to seem monumental on the small page. How can large scale be suggested? This is the particular success, the enviable mastery Moran achieved, and it is well worth studying. Moran did not use a large sheet, and often sketched outward on the page from the focus of his interest. Although this is sometimes considered an amateurish approach, in the face of monumental subject matter and the limits of time, it has its place as an effective method. It allowed Moran to sketch incisively, selecting the small telling details that suggest by contrast the enormous scale of the landscape.

Moran's approach to color was influenced by the writings of John Ruskin, the English art critic and aesthetician (1819–1900). Ruskin devoted loving attention to nature, and studied its optical phenomena intensively. He cautioned the artist to keep in mind the very limited scale of light and dark that can be achieved on paper in comparison to the vast scale, the intense lights and darks, actually perceived in nature. The contrasts that are developed in a sketch can only suggest the contrasts observed in nature. Leonardo, Constable, and Delacroix, all sensitive observers of nature, had understood how successfully the illusion of atmosphere could be rendered by *reducing by degrees* the broader scale of lights and darks in landscape to the much narrower scale of lights and darks on paper. This observation has a profound effect on judging color. (See chapter 4.)

Ruskin's observations often concerned the perceptions to be seen in the work of noted artists when they sketched from nature, but, in principle, he addressed all who would use sketching to see into nature with greater perception.

In our own time the American artist and writer Ann H. Zwinger has given a new dimension to journeying into the outdoors of the American West with journal and sketchbook. In *Run, River, Run*[16] she narrates a descent she made of the Green River from its source to its confluence with the Colorado, running rapids by canoe and raft. The descent was undertaken in segments, allowing the author-artist to describe the full turn of the seasons on portions of the river. Her narrative is a sensitive and evocative observation of nature, blended with the history of the region before her eyes at any given point along the way. All of this is accompanied by sketches, which serve as her illustrations and evoke in microcosm the macrocosm of which they are part.

Where Moran sketched the impressive monuments of geology, and Kane the changing face of a native people, Zwinger records the small plant or flower, a rock form that can be held in the hand, or the small artifacts of a vanished culture.

The Desert Lily (*Hesperocallis undulata*) in figure 1.12 and Lupine (*Lupinus shockleyi*) in figure 1.13 are from the pages of

Figure 1.12
Ann H. Zwinger. *Desert Lily,* 1985.
Pencil, 12″ x 9″.
(*Courtesy of the artist.*)

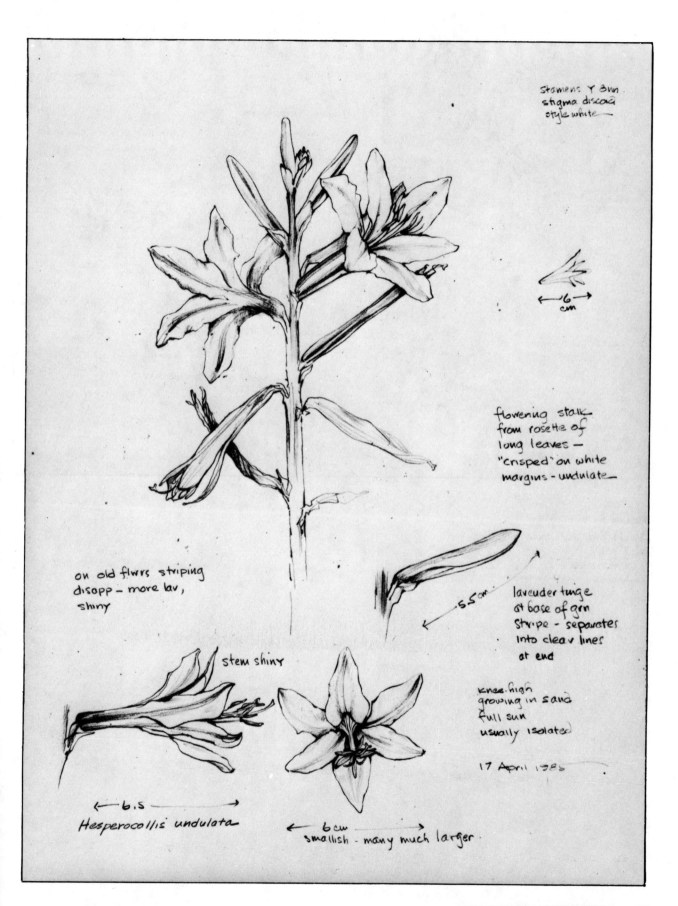

stamens Y 3nn
stigma discoid
style white —

6 cm

flowering stalk
from rosette of
long leaves —
"crisped" on white
margins — undulate —

on old flwrs striping
disopp — more lav,
shiny

5.5cm

lavender tinge
at base of grn
stripe — separates
into clear lines
at end

knee high
growing in sand
full sun
usually isolated

17 April 1985

stem shiny

6.5

Hesperocallis undulata

6 cm
smallish - many much larger.

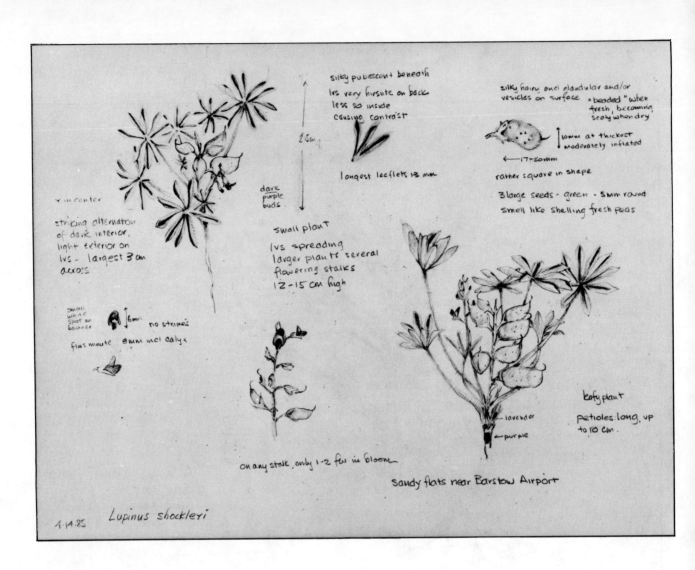

Figure 1.13
Ann H. Zwinger. *Lupine,* 1985. Pencil, 9″ x 12″.
(*Courtesy of the artist.*)

Zwinger's sketchbooks, studies in preparation for a book on North American deserts. Her approach and materials are as direct and uncomplicated as those of Constable. Her kit consists of several .5 mm micro-point pencils (in case one fails) with HB graphite lead and a pad of Strathmore drawing paper, 9-by-12 inches, as that size is easy to carry in a backpack without warping. The spiral binding lessens the chance of losing or damaging pages (as compared to pads with glue binding). The kit has also included a separate box of about fifteen colored pencils. She comments that the colors are inevitably the wrong colors for the subjects she finds on location. (It is impossible to anticipate one's needs where color is concerned.) This kit is the practical selection of tools of an artist who undertakes sustained treks into rugged country.

Zwinger says that the drawings in figures 1.12 and 1.13

. . . are studies from which I can go on to do finished drawings as book illustration, hence the measurements and proportions. They are like eating salted peanuts. Once I get started I can't stop. I like them much better than the finished drawings. They are immediate, real, not one step removed. In the past I have done most drawings on the spot, but with so much territory to cover it has been wiser to collect and stick in the ice-chest and draw in the evening. It can also be difficult at times—

Figure 1.14
Ernest Thompson Seton (1860–1946).
Sketchbooks.
(Neg. 2A 12949, courtesy Department Library Services, American Museum of Natural History.)
Note Seton's practice of mounting his sketches in the manner of a scrapbook. This allows a planned assembling of sketches.

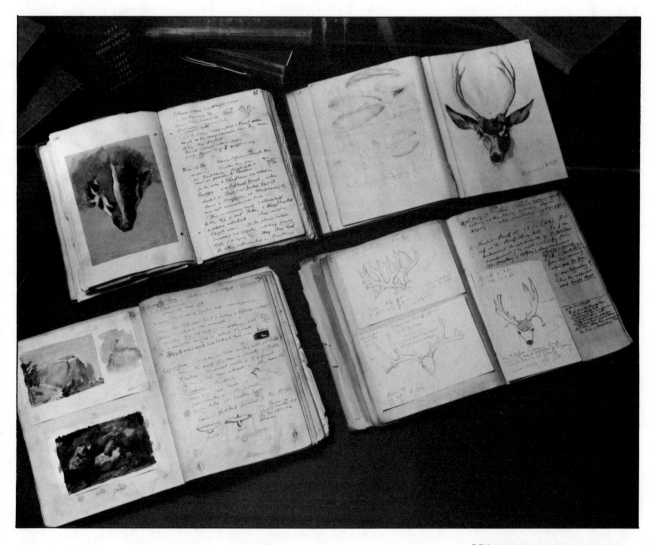

a rain storm, air so hot that you perspire on the page, etc. One of the unexpected advantages is that over a period of days you can catch different plants opening in individual ways, which gives a good sense of progression, and after all, that's what you're drawing—green and growing.[17]

As Moran's sketches are instructive for an approach to a geologic landscape, Zwinger's sketches are instructive for an approach to flowering plants. The penciled contours successfully convey the delicate texture of the petals of the lily in figure 1.12. There is a soft caressing quality to the paler lines, and a discerning incisiveness to the darker contour lines. When I first saw the drawing it touched an association in my mind. Leonardo also drew a lily, one quite similar to the specimen that Zwinger sketched. (Leonardo's study is in pen and ink with touches of watercolor wash.) I have compared good reproductions of both studies. (I have seen neither in the original.) Although it may seem heretical to say so, I found the qualities of both sketches comparable, like inspiration and like sketches across a span of more than five hundred years. In further parallel, both studies were intended as source material for work to be done in the studio. (Leonardo's study contains puncture marks that indicate it was used for transfer to canvas.)

In Leonardo, with whom I began, and in Zwinger, with whom I conclude, I find cyclic elements—rugged individuals with intense curiosity, sketching the lily in rapt appreciation.

We can learn—I have continued to learn—from those I have introduced here. If one or another of them has inspired your interest, look up their work or their writings. (See the bibliography.) Other artists who chose the American West as their subject, such as Karl Bodmer, Marianne North, Ernest Thompson Seton (see fig. 1.14), who wrote copiously of his experiences, and Carl Rungius, may also provide inspiration and give the impetus for your own ventures into nature, as might the works of the many landscape artists from all periods and regions, whose works are readily accessible in museums and books.

2
SUPPLIES: Sketchbooks, Drawing Materials, and Accessories

The materials for sketching do not have to be any more complicated than a pencil and small sketchbook, very like those Constable favored. Or, like Delacroix, you might prefer a combination of pen and ink and watercolor. The materials for drawing all have exciting possibilities. A tool can be used alone or in combination with others. The potentials contained in them are realized in a different way by each of us. The common pencil can be sharpened to a fine point to sketch the most delicate lines, or left blunt to yield a sketch of determined boldness. There is no one approach to any one medium.

All of the implements of drawing and watercolor are portable, but some of them can be inconvenient in the out-of-doors. It makes good sense to give careful consideration to your kit. A pencil of B softness, an eraser, a pen, a small set of watercolors, a No. 6 brush, and a small container of water are all easily carried in a backpack with the sketchbook. (You might substitute a set of colored pencils for the watercolors.) With such a kit you can sketch almost any aspect of nature—a line study of a fragile wildflower or a wash study of passing clouds.

As I list the following materials, keep in mind that they are options. I will take many of them along, depending on where I plan to go. You may find some of them unpromising or awkward to use. Experiment with them; test them. Discard those that are inappropriate and save them for another day.

SKETCHBOOKS

Sketchbooks are bound in a variety of ways, each with advantages and disadvantages. Some are bound like hardcover books, and pages cannot be removed without weakening the binding. If you already keep a diary, you will enjoy the growing accumulation of your sketches in such volumes. If you have not kept a diary, the permanence and formality of such a book can inhibit you. If you find that you are constantly tearing out what you consider to be unworthy sketches, it would be better to use a sketchbook that is loosely bound with a spiral.

The spiral-bound book can have a diarylike quality also, but it allows you to remove pages easily. (I have had sketchbooks become very slim with editing of this sort.) The only drawback is the spiral itself. As you carry the book in a backpack, the spiral may get bent, making it hard to turn the pages.

A pad of paper may be pressed into service as a sketchbook, but be aware that glued bindings don't hold the pages firmly.

You can also use loose sheets held in a clipboard, and a clipboard in a folio is convenient. It doesn't have the unity of a book, but it has the advantage of informality, helpful to a beginner. You can store your sketches in folders (see fig. 2.1). I have used this arrangement to form a reference file, and the clipboard has served me for most of my sketching. You may use whatever types of paper you favor at the moment. The disadvantage here is like that of the glue-bound pad. I have had a sheaf of blank pages scatter along a shore when a sudden wind caught them as I released the clip. Using a second clip can avert the problem, and it can be necessary to clip the pages of any sketchbook when sketching in a windy place.

Sketchbook Formats

The ease of working in a sketchbook depends much on its format and the quality of its paper. These considerations are important and should not be overlooked.

Format refers both to the shape and to the size of the page. When you shop for them, you will notice that sketchbooks are available in a range of dimensions, and in a rectangular shape that has similar proportions regardless of size. The smallest will fit in your pocket, like the 3-by-5-inch sketchbook Constable carried. Select a size and shape that is convenient for you to carry; it should be neither cumbersome nor awkward. If it is awkward, you will be tempted to leave it behind, and then you will not have it with you on the very occasion you chance on a subject you wish to draw.

Although most sketchbooks have similar proportions in terms of the relationship of horizontal to vertical, some have recently become available that have the proportions of both shorter and longer

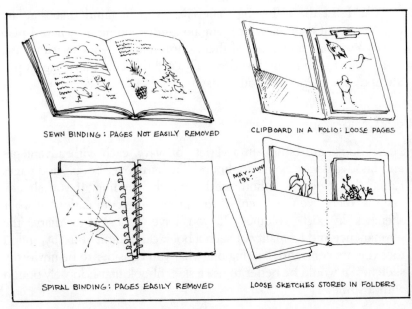

SEWN BINDING: PAGES NOT EASILY REMOVED

CLIPBOARD IN A FOLIO: LOOSE PAGES

SPIRAL BINDING: PAGES EASILY REMOVED

LOOSE SKETCHES STORED IN FOLDERS

Figure 2.1
Possible formats for a sketchbook. Sketches done on a clipboard in a folio can later be stored in folders as shown.

rectangles. I have used one of almost square shape made by Pentalic. Its shape lent it to diptych sketches—sketches across two facing pages—i.e., panoramas. (See figs. 6.1 and 8.1.) It has been a refreshing change from the more common rectangular books, and it has led me to an interest in a neglected form of representing landscape.

Sketchbook Papers

There is no such thing as an all-purpose paper. Each maker selects a different paper for its sketchbooks. Some have smooth thin sheets suitable for pen and ink or pencil. Others have a more textured, thicker paper that will take watercolor without much buckling. As you can see, your choice should be based on the tools you use. Keep in mind that no paper is universally suited to all materials. If you are planning to use dry tools (graphite pencils, colored pencils, and such), paper that is smooth and thin will suffice. It may not be ideal, but it will serve your purpose. If you intend to add touches of watercolor, it will be to your advantage to select a sketchbook with thicker paper, paper labeled "70 pound," or having the thickness of several sheets of typing paper. Some sketchbooks indicate that they contain paper for watercolor. With a concern for permanence, many sketchbooks are supplied with paper that has a neutral pH. This paper is chemically balanced. It should remain flexible and unyellowed as it ages.

Using a clipboard as a sketchbook, I prefer the thickness and durability of index paper. It has enough body for almost any medium I care to use, be it pencil, ink, or watercolor. I purchase it in quantity at a local stationery warehouse that sells to the general public. Purchasing it in bulk keeps the cost low. However, it has no tooth—no "bite"—and is not pH neutral.

DRAWING SUPPLIES

Give careful thought to drawing tools. How many different kinds do you think you might use? How do you plan to carry them, and have quick access to them? A household pencil and a ballpoint pen can be carried in your pocket. As you do more sketching, it will add variety to the experience to experiment with other tools.

In some instances of listing materials, I refer to brand names to call your attention to desirable qualities they possess. Remember, however, that brand names frequently change, and quality changes even if the brand name does not. If you shop for your supplies from a mail-order catalogue, the brand names will be helpful where I have included them.

Pencils

Graphite Pencil. The term *pencil* used by itself usually refers to graphite. The common No. 1 or No. 2 pencil is graphite. The scale in figure 2.2 illustrates how the hardness or softness of a graphite pencil is indicated. To confuse matters, there are so-called sketching pencils. These may have square leads, thicker round leads, or a shellac rather than wood covering. Some of them are constituted to yield a tone or

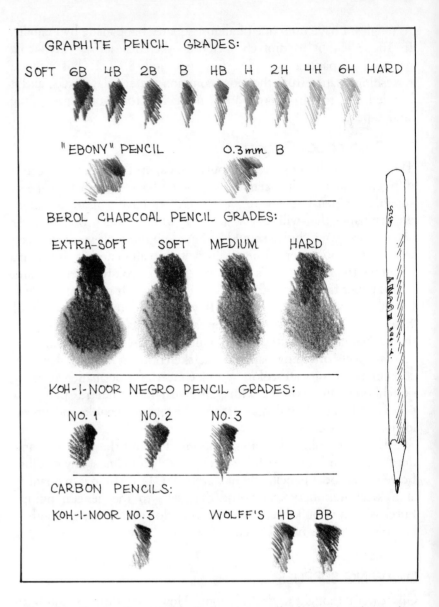

Figure 2.2
Pencil grades. Individual touch will vary, and this scale can only suggest relative softness.

a line that comes closer to black than is usually the case with graphite (for example, the Ebony pencil, or the Berol Draughting Pencil). Graphite is a slightly oily substance that looks gray and somewhat shiny on paper. We don't think of it as possessing these qualities because we are so accustomed to it that we have stopped paying attention to its true appearance. The moment we smudge it, or try to produce a dark tone, we are reminded of its limitations.

I recommend that you try 2B, B, and HB graphite pencils. The HB will smudge and transfer less when the pages of your sketchbook rub together, and the 2B yields darker lines and tones without imprinting them into the surface of the paper (enabling you to erase cleanly). In many of the pencil sketches in this book, I used a .5 or .3 mm mechanical pencil with 2B and B graphite leads respectively. This eliminated the dulling of the point that occurs with a wood-encased pencil. Ann Zwinger has also found it convenient to use this tool (see figs. 1.12 and 1.13).

Eraser.　Graphite erases with relative ease. I recommend a soft white vinyl eraser. It is especially useful to have one in the form of a pencil. Better yet, use one that comes in a holder that allows you to

advance a fresh portion. It will serve for many of the materials of drawing, although nothing else erases quite so easily as graphite. If you are going to erase at all, you want to erase cleanly, leaving no greasy residue. For this reason, I caution you that the art gum eraser and the kneaded rubber eraser traditionally associated with drawing tend to leave traces that show when you resketch over an erased area.

Beginners are often advised not to use an eraser because it adds to indecisiveness. Erasing is not wrong, but if you find that you are erasing frequently in a sketch, it is best to start afresh. This develops skill—and confidence.

An eraser can also serve as a drawing tool. For instance, it can be used to blend charcoal pencil or Conté crayon. (In this application, it is being substituted for the felt blending stomp.)

Charcoal Pencil. Each manufacturer constitutes and designates the relative hardness and softness of charcoal pencils differently. Berol (formerly Blaisdell) labels its pencils "Hard," "Medium," "Soft," and "Extra-soft." They are less grainy, less abrasive on paper than those of other makers. Conveniently, they have a peel-away feature that eliminates sharpening them with a knife. This isn't foolproof, but it does result in less breakage and waste than with wood-encased charcoal pencils.

Berol's charcoal pencil resembles compressed charcoal, a chalk-like charcoal, whereas other brands resemble vine charcoal with its gritty texture. I prefer the softer, more easily blended quality of the Berol pencil (see figs. 7.7, 7.8, and 7.9). It is a matter of personal taste, and you may prefer others.

Charcoal pencils can be used bluntly, with emphasis on the rich black they will yield. Although they can be erased, the result is likely to be messy. Tones achieved by rubbing the charcoal are more appealing than the greasy tones of rubbed graphite.

Negro Pencil and Conté Crayon. In the lexicon of drawing the term *crayon* has no exact meaning, although I would use it to describe both Koh-i-noor's Negro pencil and Conté crayon. The Negro pencil has a slightly greasy, crayonlike quality. It is harder and has more density than a charcoal pencil. It comes in three degress: No. 1 (soft), No. 2 (medium), and No. 3 (hard). (See fig. 2.2.) I prefer the No. 1. It produces a velvety black line without the mess of charcoal. It has less tendency to transfer inside the pages of a book, making it a desirable sketching tool. It will hold a point longer than charcoal pencil, but cannot be used in the sweeping, bold manner charcoal allows. Although this tool is a favorite of mine, I must admit that it has its temperamental side. Just a fraction too much pressure will break the point on it. The sketch in figure 7.1 was done with this tool. The crayon lead is brittle, and care must be exercised in sharpening it.

Good natural chalk of the kind used by Leonardo (see fig. 1.4) long ago disappeared from the market. Conté manufactures a crayon intended to imitate the properties of natural chalk, the Conté crayon, a familiar part of artists' equipment for generations. The crayons are also made in pencil form, and it is in this form that they are most likely to appeal as a tool for sketching. Conté crayon pencils are excessively fragile, a nuisance in the outdoors. If you drop one you

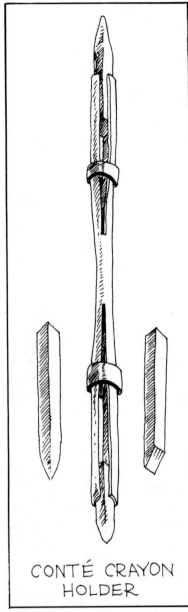

Figure 2.3
Crayon or chalk holder. Some are chrome and have a handle. Conté-type crayons are best for loose sketches. In a book such sketches quickly become blurred as the pages rub together.

will have a pencil casing containing short useless pieces. This can happen to them before you buy them; check the ends for signs of crumbling. They are also difficult to sharpen.

The crayons (sometimes referred to as chalks) are, on the other hand, not especially fragile. They are soft and messy to hold (fingerprints seem suddenly to appear on everything you touch), but a holder with a sliding ring is available that allows you to effect the same control you would have with a pencil (fig. 2.3). Black, white, and the reddish-browns referred to as earth reds were the preferred colors of natural chalk. Conté crayons are made in that range. Black and white are available in three degrees of softness: H, HB, and 2B. The degree H is quite hard, and it can be used in sketching. The reddish-browns, called "sanguines," are all medium-soft.

To draw with the crayon, you should sharpen it first with either sandpaper or a knife. Sketches made with this tool smear easily. A varnish spray called fixative, applied sparingly, does help.

Crayon is difficult to erase, and, coupled with the new sensation of manipulating its small square shape, it lacks immediate appeal. However, as you gain experience with it, you may come to enjoy its unique qualities.

Carbon Pencil. The carbon pencil is a variety of charcoal pencil. However, it is harder (and more abrasive) and yields a truer black. Its abrasiveness makes it difficult to use on smooth paper (see fig. 2.2). Like the Conté pencil, it is fragile and must be sharpened with care. Also like Conté, it is available in the form of a stick. It holds a point well and can serve for sketching, being somewhat harder and less messy than the compressed charcoal that it resembles. Koh-i-noor is the only company I know of that manufactures carbon sticks, and they are not always stocked by art materials stores. The charcoal pencils, the Negro pencil, the black Conté pencil, and the carbon pencil are all made from carbon pigments.

Colored Pencil. Colored pencils are excellent for sketching out-of-doors, and are especially effective when combined with pen-and-ink line. A set of eighteen pencils is large enough, but you will have to mix colors to achieve the color you observe in nature.

There are three broad categories of colored pencils—waxy, water-soluble, and chalky. Berol's Prismacolor is an example of the first. The pencils are lightfast. This means that you can remove a sketch from your book, frame it, and exhibit it without fear that it will fade. Once on the page, the colors of water-soluble pencils can be dissolved with a moistened brush. An English company, Derwent, has advertised that its water-soluble colored pencils are lightfast. As a general rule, most brands are not. This is not a problem if the sketch remains in the book. Finally, there is the chalky kind. Schwan's Carb-Othello pencil has a texture like pastel. Blending can be achieved by rubbing. Here again, not all the colors are lightfast.

Colored pencils are often sold in attractive sets. If the colors are not also sold individually, this will hamper your ability to replace pencils you have used up, or add colors to your selection. For more information and an introduction to techniques of using colored pencil, see chapter 4.

Chalk pastels, oil pastels, and color crayons can all be used in

sketching, although they are broader, less precise tools than colored pencils. One of them may provide the working qualities you would like. All are problematic when it comes to the question of whether they are lightfast. You can test this for yourself (see fig. 4.14).

Sharpeners. Portable hand sharpeners are intended primarily for graphite pencils, and the blades quickly become dull. Charcoal, carbon, and crayon leads are all more friable (easily crumbled), and must be sharpened by hand, using a knife. A small Swiss Army knife will stay sharp, and folds for safe carrying. Colored pencils in particular should be hand-sharpened. It is good practice to think of sharpening a pencil as planing away wood from the lead, a slow, deliberate shaving. Then a point can be pared on the exposed lead. This is illustrated, using a mat knife, in figure 2.4. It seems tedious at first, but fewer leads are broken than with mechanical sharpeners. When you purchase your pencils, especially the more friable kind, notice their ends. If any crumbling is evident around the lead, there is a good possibility that the lead within is already broken.

Pens

Pen and Ink. Many favor the ballpoint pen as a portable form of pen and ink. In sketching, its convenience is an advantage. The poor quality of the ink (in most of them) and the unvarying width of line are its disadvantages, as is the fact that the cheaper varieties tend to clot and bead. The one quality that gives it great appeal is that it draws smoothly over the surface of the sketchbook page.

Porous-point pen. This pen, also called the felt-tip pen, allows a more autographic and varied line. The inks can have distinctly different properties in the various brands. Some inks will penetrate the page quickly, while others appear not to (taking months to do so). Some dry waterproof, others do not. To my annoyance, I found that

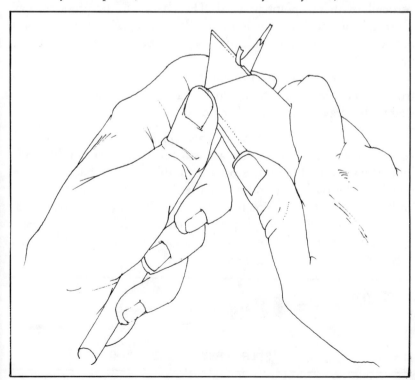

Figure 2.4
Sharpening a pencil. Some pare their pencils with the blade turned toward them—not the safest practice. Sharpening is accomplished with a slow planing action.

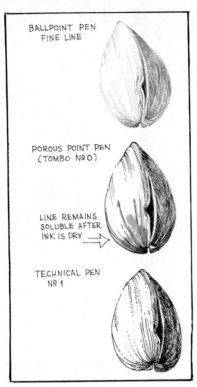

Figure 2.5

A clamshell sketched with a variety of pens. Practice with a ballpoint is a good introduction to sketching with a pen. The Tombo pen is refillable, and its point replaceable.

the ink in one brand would gradually transfer to the facing page, leaving a ghost image of the sketch. The design and properties of these pens are changed frequently by the manufacturers, making it impossible to catalogue their qualities. They are undeniably convenient, and the staining character of some of the inks gives variety to the quality of line. (See fig. 2.5.) The inks in these pens do fade.

Fountain pens. Those made specifically for sketching are almost as transient in the marketplace as the porous-point pens. Ideally, such a pen should have a flexible but sturdy nib. It should use drawing ink without clogging, and it shouldn't leak. All of these qualities never seem to come together in an inexpensive pen. Most of the pens introduced over the last thirty years performed well when new, but inevitably failed in one way or another. If you decide to purchase such a pen, test it before you leave the store, and be prepared to clean it regularly.

Technical pen. This is another matter. It is equipped with a stylus point that performs to its optimum so long as the pen is held at a true vertical. With the very fine points (for example, Nos. 0–0000), the needle in the center of the stylus point will snag on paper that has any texture at all. If you can manage all this, you must also accept the unvarying line width the stylus is designed to produce. (The pens are available in eleven point sizes.) Although not made for use with India ink (which contains shellac), technical pens accept drawing ink specially formulated for them.

The technical pen is not completely reliable, but for sketching it is more reliable than any other fountain pen. It requires some care. If it sits unused for more than a week, you should empty the ink and flush both the barrel and the point with clear water. Even if the pen is in continuous use, you will find cleaning necessary occasionally. If you transport the pen from sea level to high elevations, store it vertically with the point upward. The change in air pressure may cause the pen to leak if it is carried lying flat. (Accidents can still happen, and it is a good idea to keep the pen isolated from other materials.)

I recommend the No. 1 (.5 mm) point as a useful and reasonably trouble-free size. I have found that I can vary the width of the line slightly by drawing with quicker or slower strokes.

Penholder with Pen Point. This will seem archaic and inconvenient if you are not already accustomed to it. Carrying it while hiking, you should store the point carefully. (I have had the point penetrate the backpack and my clothes.) There is a crowquill point and a holder that allows you to store the point (fig. 2.6). Carrying ink in a bottle is risky; although plastic bottles are less likely to break, leakage at the cap is still possible. It should be contained and carried separately from everything else.

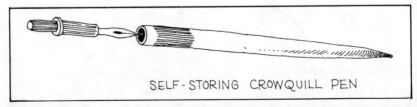

SELF-STORING CROWQUILL PEN

Figure 2.6

Portable crowquill pen. To use, insert the base of the point into the holder.

I recommend the Hunt No. 108 crowquill point or the Gillott No. 303 point for an introduction to the handling of the flexible steel pen point. (See chapter 4 for an introduction to the technique of the pen.) The crowquill point requires its own holder to accommodate its small size. It will produce an extraordinarily fine line, and has long been favored for sketching. The Gillott No. 303 point is a medium point that produces a fine to medium line. It takes an ordinary penholder, but take care to select one of light weight that fits comfortably in your hand. This is not as simple as it sounds, since most art materials stores do not stock a variety of penholders. The points are sometimes coated with a thin oil to prevent rust while they sit on store shelves. This should be wiped away with a little solvent. (The practice of burning it away with a match can harm the point.)

Drawing Ink. This is available in both waterproof and water-soluble forms. The waterproof variety is traditionally called India ink. It contains shellac, which renders the ink impervious to water after it has dried. The shellac in the ink will ruin fountain pens and good watercolor brushes, and techniques that involve ink washes are better done with water-soluble drawing ink, which does not contain shellac and does not dry completely waterproof. Both inks are made from carbon and are considered lightfast. This is not always true of inks formulated for use in fountain pens. Such inks are frequently no more than dyes.

An excellent waterproof ink can be made as needed, with the Oriental ink stick and grinding stone. This ink is lightfast and yields fine grays when diluted with water. It takes a five-minute effort to grind it, and some cleaning up afterward, but it is an option to be considered (see fig. 4.3).

Watercolors

Brushes. A round watercolor brush, No. 6 or No. 8, is useful. It can serve to add a dilute ink wash to the sketch; it can add a touch of watercolor.

The best brushes are composed of Kolinsky sable. The hair is taken from the tail of an Asian weasel. It is unusually resilient when wet, and as the hair is one of the few natural hairs that taper, it holds an excellent point. Gathered into a brush, it holds a good quantity of fluid—a trait desirable in a good brush. The expense of the larger sizes of this brush will take your breath away. It is the standard against which other watercolor brushes are measured.

For sketching, a synthetic hair serves very well. It is much less expensive than sable. It does not have as good a reservoir (water-holding capacity), but it will hold a good point. Its poor reservoir actually enhances its use in sketching, where a drier brush is often desirable. (see fig. 2.7.)

Watercolor. A small watercolor set is ideal for sketching. Unfortunately, most of the small sets available are intended for children. The pigments they contain are weak and unsatisfying. They may look intense in the box, but they paint out in pale tints. Even the student-quality box made by Winsor & Newton is a disappointment. The most satisfying set is the half-pan watercolor set. It is

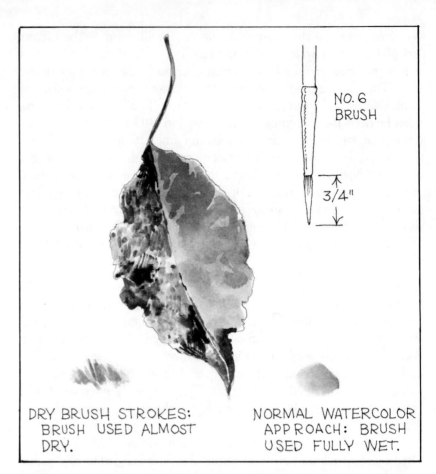

NO. 6
BRUSH

3/4"

DRY BRUSH STROKES:
BRUSH USED ALMOST
DRY.

NORMAL WATERCOLOR
APPROACH: BRUSH
USED FULLY WET.

Figure 2.7
A No. 6 round watercolor brush of synthetic hair is ideal for adding touches of watercolor to a sketch. It also works well for dry-brush.

manufactured by both English and European companies, and provided with quality watercolor pigments. I use the smaller size set (sixteen colors) made by Winsor & Newton. It is a metal box containing replaceable colors, and is provided with two short-handled sable brushes that fit in the box. Open, the cover of the set serves as a palette; closed, the set is smaller than a paperback book and is easily carried (fig. 2.8).

Although most sets come already filled with colors, Winsor & Newton sells some of the boxes empty, to allow you to make your own selection of the half-pan colors. (Although more art supply stores are carrying this imported item, you may have to order it and the colors through a mail-order firm like Daniel Smith Inc., Seattle.) The following colors are suggested as a basic palette:

Cadmium yellow	Cadmium red	Cobalt blue
Lemon yellow	Alizarin crimson	Ultramarine blue
Yellow ochre	Burnt sienna	Payne's gray
Burnt umber	Chinese white	Viridian green
Raw umber	Phthalocyanine blue	Hooker's green dark

The colors represent warm and cool primaries, hard-to-mix greens, and earth colors.

Water Container. A leakproof, shatterproof container is required when you must carry your water supply with you. In sketching with watercolor you will not require much, and a small container will suffice. I carry a plastic bottle with a capacity of eight fluid ounces and a neck-sealing screw-top cover (fig. 2.9). It is available at

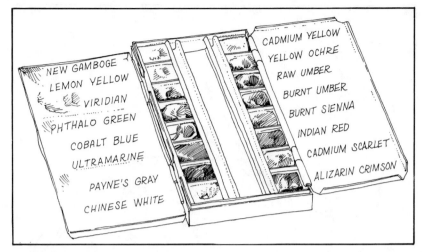

CADMIUM YELLOW
YELLOW OCHRE
RAW UMBER
BURNT UMBER
BURNT SIENNA
INDIAN RED
CADMIUM SCARLET
ALIZARIN CRIMSON

NEW GAMBOGE
LEMON YELLOW
VIRIDIAN
PHTHALO GREEN
COBALT BLUE
ULTRAMARINE
PAYNE'S GRAY
CHINESE WHITE

Figure 2.8
Portable watercolor set. This is an English set with half-pan color replacements. It is compact, its colors are intense, and it is convenient. It is also expensive. The colors listed are my personal choices.

scientific supply stores, and its reliability makes it well worth a special effort to acquire it.

Carriers

Once you have chosen your drawing tools, you'll need something to carry them in. Toolboxes, fishing tackle boxes, and wooden sketch boxes are popular containers for carrying pencils and watercolor supplies into the outdoors, especially when no hiking is involved and the intention is to stay put. However, if you combine hiking and sketching, you are likely to draw in a number of locations during a day, and will want to move easily from place to place. The total weight of the drawing materials and accessories you carry should be considered. I favor a backpack to carry supplies. It has almost no weight in itself, and it allows me to keep my hands free to manage such things as binoculars. Figure 2.10 illustrates the pack and what I typically carry in it.

The item referred to as a "pencil case" is a cloth container I carry pencils and brushes in. It keeps the more breakable pencils from hitting together; unroll it and you can readily get to the particular pencil you want. This container was homemade, but similar ones are available ready-made (fig. 2.11).

INNER RING
SEALS JAR

Figure 2.9
Portable water container, 8-ounce. This is available at stores that carry lab supplies. It is of durable plastic and it seals tightly—enough so that I have trusted it in my backpack. But never trust any container entirely.

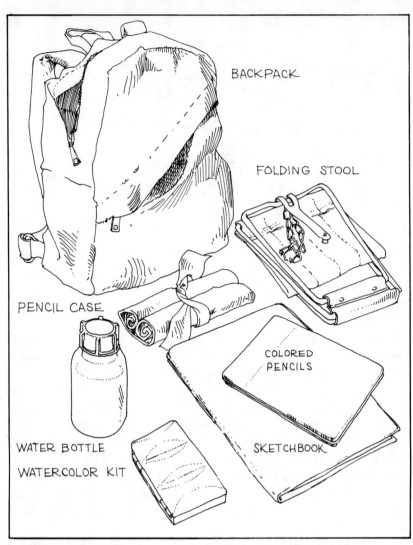

Figure 2.10
Kit for a day's sketching. In addition to the materials shown, I may carry binoculars and a thermos of hot tea (or cold water).

Most backpacks are water-repellent, not waterproof. In a real downpour, water will penetrate. Provide yourself with plastic bags to contain the sketchbook and anything else that would be damaged. In all but the driest times of year, it is difficult to avoid unexpected showers. And don't forget to carry a canteen of drinking water. An hour or more of sitting in the sun, even in a pleasant country meadow, can dehydrate you.

ACCESSORY EQUIPMENT

Stools and Chairs

Figure 2.12 illustrates a folding canvas-and-aluminum stool that will fit into the pocket of a backpack. This is the most convenient portable seat that I know of, if not necessarily the most comfortable. I use it sketching at museums, the aquarium, or the zoo, as it calls little attention to itself or to me. It will also accompany me on location if I plan any amount of hiking. But if I am going to spend the day on the coast, or at an outdoor location where I will not move often or hike far, I will use a small aluminum lawn chair with a backrest. It doesn't exactly fit the image of the outdoors person, but it provides needed back support if you plan to sketch for a period of

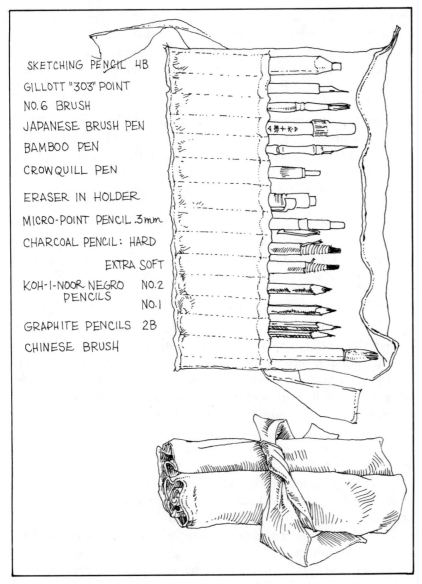

SKETCHING PENCIL 4B
GILLOTT "303" POINT
NO.6 BRUSH
JAPANESE BRUSH PEN
BAMBOO PEN
CROWQUILL PEN
ERASER IN HOLDER
MICRO-POINT PENCIL .3mm
CHARCOAL PENCIL: HARD
 EXTRA SOFT
KOH-I-NOOR NEGRO NO.2
 PENCILS NO.1
GRAPHITE PENCILS 2B
CHINESE BRUSH

Figure 2.11
Pencil case. This is useful if you like
to carry a variety of tools.

time. Aluminum tripod stools are also available. They are lightweight
and easily carried, but the canvas will wear through at the legs,
sometimes giving way without warning. If you can find one, the
portable English shooting stick, which sticks in the ground and
unfolds into a seat, is also convenient.

Optical Equipment

If your interest grows to include animals, and birds in particular, you
will be tempted to acquire a scope of some kind.

The monocular scope is the most portable and least expensive
optical tool. It is light enough to be held up to one eye while you
glance down with the other to draw. The Bushnell Pocket Scope
magnifies eight times (has a power of 8X), a magnification equal to
that used in binoculars best suited to watching birds.

The step up to binoculars does not involve increased powers of
magnification; it increases your field of view. You see over a wider
area. This adds to your ability to observe the bird in flight. (Bin-
oculars are available with higher powers of magnification, but this in
turn decreases your field of view.) Good binoculars are an expense.

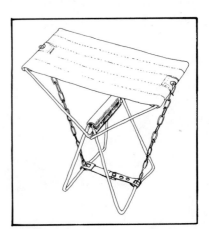

Figure 2.12
Portable stool. This one weighs little
and fits easily into a backpack. To
the degree that they are easily porta-
ble, they are structurally weak. Exer-
cise caution. Examine the stool
periodically for wear.

Part of the quality of the optics is the usefulness of the binoculars at twilight. Inexpensive binoculars quickly reveal their poor optics in such conditions. Compactness also adds to the expense. I sacrificed compactness to keep the expense down. My binoculars are as heavy as the rest of my kit put together.

If your sketches of birds or other animals lead you to an interest in doing detailed studies of the animal in the wild, you will require a stronger scope. A spotting scope with a power of 20X or 25X is considered ideal. Stronger scopes are more difficult to employ while drawing because they will magnify any vibration produced by the wind on the scope. It is easy to see that a spotting scope also requires a tripod.

Optical equipment adds weight to your sketching gear. I can testify that it becomes an encumbrance when any hiking at all is contemplated. Let the needs of your sketching dictate just how much gear you carry. Too formal an array of tools will definitely inhibit you.

Clothing and Such

Sketching outdoors in conditions of either heat or cold requires preparation. Sitting an hour in the sun without a hat can pose health hazards, possibly serious ones. It is inadvisable. Suntan lotion should be a part of your pack—and remember exposed shins and ankles when applying it. Bees and other insects love the bright colors of watercolors and colored pencils; insect repellent may become necessary. (Bright colors on your clothing will also attract pollinating insects.) As mentioned earlier, have a supply of drinking water to avoid dehydration.

In cold or cool weather you should consider gloves. Drawing with gloved hands is awkward, and you may wish to remove the fingers on the glove for the drawing hand. Don't underestimate how chilled you and your hands can become as you sit still in the cold air. Even in midsummer, in high mountain altitudes an overcast day can chill you to the bone. A warm hat, a scarf, and a sweater will all help. A thermos of hot tea can be most welcome at such a time.

Don't neglect your feet. Hiking for any length of time requires comfortable shoes with good support. If you are going to be in the habitat of snakes, or in muddy regions (natural springs will make an area muddy even in midsummer), hiking shoes or boots that cover your ankles are advisable.

Preparation

My sketching gear is usually assembled and ready to go at a moment's notice. I will vary what I take along, depending on what I can anticipate. Some will make do with a very abbreviated kit in the interests of portability and freedom of movement. I tend to carry slightly more than I think I will need. Experiment. My wife prefers "a warm rock" to carrying a stool. After several excursions you will know what your needs truly are.

3
SKETCHING
AND THE CONCEPT
OF DRAWING

Almost anyone can learn to sketch, and learn to sketch quite well. It is not mysterious. It is not a matter of special gifts, unless you count patience and a willingness to make no more than reasonable demands on yourself as special gifts. Although I might seem to address the aspiring artist as I review the basics of drawing, I include all who have an interest in sketching in the outdoors. The act of drawing is the act of seeing. When you sketch an oak upon a rolling meadow, you see the tree as you never have before. You come to know it.

BEGINNING TO SKETCH

Give some thought to the qualities of your pencil and your paper. A pencil with a sharp point that is not too hard or too soft, used on a paper that has a good feel when you make a line—these are important considerations. If the pencil is too hard and the paper too slick, the feeling of the paper as it resists taking the mark of the pencil can put you off. When the tools feel right, the experience is almost magical. I cannot predict what tools you will respond to. You will need to experiment. A starting point might be an HB graphite pencil, or a common No. 1 pencil. (The No. 2 will probably be too hard.) Keep a sharp point; this gives you more control of the line.

Holding the Pencil

Not only should you consider the relative softness of the pencil and the texture of the paper, you should also give some thought to how you hold the pencil. Figure 3.1 shows two ways. Each gives different results. There is no one correct way.

A lightness of touch gives you more control of the quality of line. Bear down as you draw with an HB pencil and the result is a broad black line. Allow just the weight of the pencil (with very little additional pressure) to touch the paper as you draw and the result will be a pale delicate line—with the very same HB pencil. Your touch is individual. Experiment with the manner in which you hold pen or pencil.

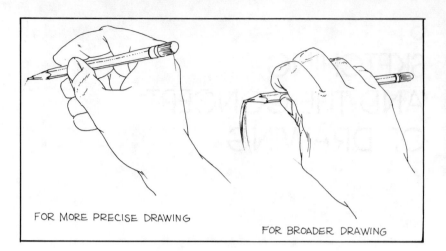

FOR MORE PRECISE DRAWING

FOR BROADER DRAWING

Figure 3.1
The first position shown is the one we all use to write, and will usually use to sketch. The second is useful for broader, less precise sketching, a manner of sketching frequently employed with chalks.

Direction

To sketch a natural form like a rock or tree, you will need to learn the skill of directing your pencil. Take care that in concentrating you don't hold your pencil too tightly. Practice making both curved and straight lines until you can do so with some ease. Everyone begins by saying, "I can't even draw a straight line!" Ironically, that is one of the easier skills to master. The method is simple. Take your pencil in hand and attempt a straight line. Start from any side of the page. As soon as the line begins to waver, stop. Reposition your hand so that you can comfortably continue the line. At first you will be repositioning your hand frequently. After some practice, however, you will direct the line with increased ease. *Practice* is the key word here (see fig. 3.2). For some the skill comes more easily than it does

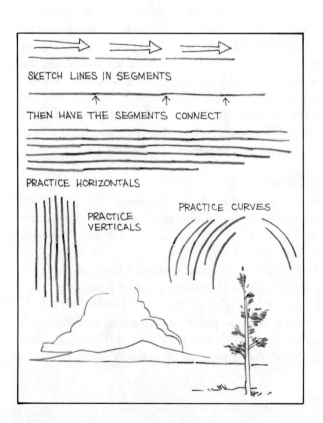

SKETCH LINES IN SEGMENTS

THEN HAVE THE SEGMENTS CONNECT

PRACTICE HORIZONTALS

PRACTICE VERTICALS

PRACTICE CURVES

Figure 3.2
Suggestions for practice in learning to control the sketching of a line. Use only moderate pressure on the point of the pencil. The weight of your line is a matter of control also.

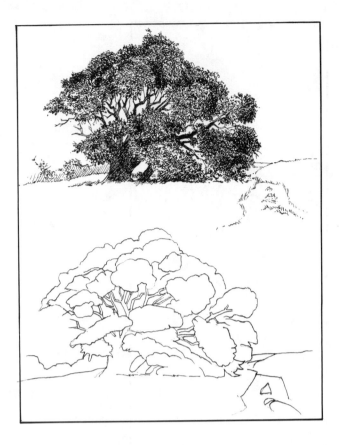

Figure 3.3
Sketching by beginning with simple shapes. The shapes used to summarize leafy areas of the tree are somewhat arbitrary. They generalize the larger branches with their leaves, and suggest how they overlap—creating a three-dimensional sense of the tree.

for others. Don't be discouraged. Consult the exercises at the end of the chapter.

As you develop confidence in your control, rest your hand on the page as lightly as possible. A sketched line has energy and life to the extent that it begins in the movement of your spine, and not just the movement of your wrist.

Concept

To sketch any subject, study it for a moment before sketching. Draw the simplest shape or shapes contained in it before attempting more detail. (See fig. 3.3.) Interpreting a complex three-dimensional form in simple flat shapes can seem arbitrary. Take the example of an oak tree. As we sit and study it, we see immediately the busy complexity of the foliage. Reducing the irregularity of the form of the tree to simple shape seems quite difficult. The art student is often taught to put the preconceived idea of "tree" and "leaf" out of mind because they hinder one's willingness to see shape. This mental step may prove troublesome. For a moment you must think, "I am looking at a series of smaller shapes that come together to form a larger shape." It is this larger shape that becomes the shape with which we begin our sketch. It is easier to see it if we can forget for a moment that the subject is a tree. We are reducing the complexity of the visual data we perceive to an abstract shape. By forgetting for a moment the name of a thing, we can concentrate on what we really see. This exercise helps you to see the inexhaustible richness of the natural world.

Figure 3.4
Gestural line. The lines here are sketched with the intention of broadly defining the form. They are not hesitantly drawn. You evolve the image, and refine it as it is evolved.

Figure 3.5
Contour line. It describes edge, silhouette, and sometimes elements of texture. Contour line is characterized by a degree of directness, and pen and ink is an apt choice of tools.

LINE

Most of us begin drawing with line. Some research on the functioning of the brain has suggested that our most immediate recognition of form is by perceiving edges, by seeing lines.

Line describes contour, the outline of a tree, rock, hill, or animal. It can begin as something loosely constructive, or gestural, as in figure 3.4. It allows you to start with vague shapes, refining and correcting as the drawing evolves. Or the line can be an immediately specific contour line, describing edges clearly, as in figure 3.5. It may be sketched slowly, thoughtfully, with close attention paid to the exact appearance of the contours of your subject.

Both ways of drawing a line are distinctive. Gestural line is frequently best in sketching the basic shapes of an unfamiliar subject. The exploratory character of the line lends itself to the trial and error involved. This character also suggests movement, aptly applied to sketching animals. Contour line is more direct. It well describes in detail the precise edges. Use it to sketch simpler forms where you do not feel the need to prepare the way with shapes roughed in with gestural line. Each line method may be described as an attitude, and they may be combined in a single sketch (see fig. 3.6).

Gestural Line and Basic Shapes

When you first sketch a shape (or shapes) as you look at the oak tree mentioned earlier, you may not be certain what shape best suggests

Figure 3.6
Gestural and contour line combined. Gestural line was used first, evolving the form of the heron. Contour line was then added to give definition. The combination of line qualities may imply volume.

the tree. It makes perfect sense to sketch the shape lightly with an explorative line, forming and then re-forming the shape until it matches what you see in the tree.

This style of line is often called gesture line because it is an animated line (see fig. 3.4). It also conveys inherent movement, the living force contained in a plant or the pulse of an animal. In other words, *gesture* refers both to the drawing action itself and to the potential for movement in the represented subject. Even a mountain is alive. The earth pulses with life. Leonardo likened the planet to a living organism: ". . . as man has in him a pool of blood in which the lungs rise and fall in breathing, so the body of the earth has its ocean tide which likewise rises and falls every six hours, as if the world breathed. . . ."[1]

Finally, the gestural line is a good way to analyze a form you have not sketched before. It will communicate some of the three-dimensional quality of your subject, convey the presence of the sides you do not see (see fig. 3.6). With an animal subject, the gestural line suggests any action we might observe, especially actions that happen so quickly as to leave only an impression (see fig. 3.7).

Contour Line

Sometimes there isn't the time to begin a sketch with basic shapes, or the subject is not so complex as to require them. We will then proceed directly to sketching the contours of the mountain, rock, tree, or flower. This line is at once the most rewarding and the most demanding of basic skills. Unlike gestural line, contour line is drawn with studied deliberateness. It delineates the silhouette; it also delineates the edges you see within the silhouette (see fig. 3.8). The line may take the form of a single continuous stroke, or it may be composed of a number of strokes—one superimposed on another—

Figure 3.7
Gestural line used to suggest movement. Animal movement is difficult to capture. Gestural line is the best approach.

feeling its way around the edge of the form. (This last has the disadvantage of being easily overworked.)

Blind Contour: A Practice Exercise. This is excellent for the development of hand and eye coordination. Select a subject. A plant with large leaves would do very well. Seat yourself comfortably, very near to it. Rest your sketchbook securely in your lap and take pencil in hand. Follow the movement of your eye with your hand, the hand holding pencil to paper, but do not look down to see what your hand is drawing. Follow the contour of one of the leaves with your eye. Move your eye slowly, as though you were following the progress of

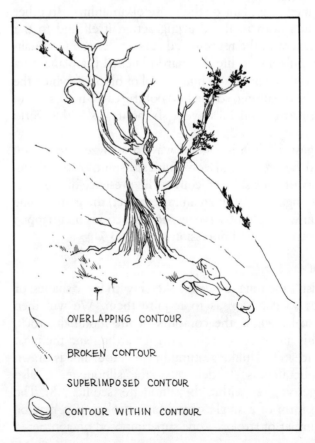

OVERLAPPING CONTOUR

BROKEN CONTOUR

SUPERIMPOSED CONTOUR

CONTOUR WITHIN CONTOUR

Figure 3.8
Aspects of contour line. In the direct approach of a contour sketch, forms that overlap other forms are drawn first.

an ant moving along the edge of the leaf. Allow time for your eye to recognize slight changes in the edge of the leaf, a fold, a notch, etc.; allow your hand time to respond to the slow movement of your eye along the contour.

Obviously, if you deliberately refrain from looking down to the drawing, the resulting image is likely to be distorted. The line, however, will have the quality of the contour of the subject. It can successfully convey the texture of that contour, yielding what is called a *tactile* line.

Possible results of this exercise are illustrated in figure 3.9. Do this exercise for ten minutes a day, over a week's time, and you will observe improvement in the coordination of your eye and hand. The hand will move on the paper in response to what the eye is seeing. Surprisingly, after a period of unhurried practice, some reasonably accurate sketches will be among the results. Even if you give in to the temptation to look down occasionally to guide your hand, discipline your eye to follow slowly along the contour of the form you are sketching. Normally we look at things by scanning, looking back and forth across the subject.[2] By developing the habit of having the eye follow edges, we become fully aware of the lines that delineate our subject.

A Lively Line. Much contemporary art education stresses rapidity of execution. A rapidly drawn line looks lively, unselfconscious. This encourages self-confidence and aids the beginner. But it can be misleading. Real skill and true liveliness in drawing a contour line grow only if you take all the time you need to see and to draw.

My eye followed the contour of a bug-bitten madrone leaf.

Figure 3.9
Blind contour exercise. You keep your gaze on your subject and don't look down to the page while you sketch. This exercise transcends exercise to become a useful approach in many situations.

The confidence you gain in this way is based on real understanding. The line is drawn with decreasing hesitation. It gains in liveliness, a liveliness born of sure perception rather than frenetic execution. Nearly five hundred years ago Leonardo noted, "If you, who draw, desire to study well and to good purpose, always go slowly to work in your drawing. . . ."[3] *Adagio*, the word Leonardo actually used for *slowly,* implies, as it does in music or ballet, the sense of full but gradual motion.

Drawing from Memory

Although drawing from memory seems difficult at first, it is how almost all drawing, especially of natural subjects, is done, and has two distinct advantages. First, it helps you to develop a sense of what you know about your subject. This is, in fact, the only way you can draw from living animals. You observe them, remember some part of them, draw it, and—memory failing—look back, if you can. Second, often when we are out in nature there are moments that touch an inner eye. It would be a loss if we were afraid to recover the image from our memory.

Don't be overly self-critical. The effort pays dividends, even if the results are unsatisfying. Many artists do not draw well from memory, but many develop good visual recall that aids sketching and enables them to refer to previous experience.

Forming a simple mental image and drawing it with a simple contour line can be a godsend when you wish to sketch moving animals or flying birds. (The blind contour exercise is useful here. Needing to glance only occasionally at the paper allows your eye to remain on the subject; see fig. 3.10.) For some, simple shapes

Figure 3.10
Aids to memory. Observe a key contour, or study the animals' shapes.

sketched with a gestural line may be more successful. This allows a searching for form that a directly drawn contour line does not.

Sketching usually involves a blending of contour and gestural line. In practice, each line quality has differing applications, applications determined by your own experience. Examine the variety of sketches illustrated in this book and notice how the two seemingly opposite line qualities blend one into the other.

LIGHT AND SHADOW
Value

In a first effort at sketching there is usually an irresistible impulse to add shading, and to show which forms are darker than others, by filling in darks. It adds information. It adds dramatic presence to our representation. The word *value* refers to the grays, to white, and to black—to the entire range of lights and darks we indicate in a sketch or drawing. The word *shading* has a specific meaning in the terminology of color study: it means to add black to a color. I use it here with the meaning it is often given in drawing: to add darker values to imply the presence of light.

Value in a drawing indicates light or coloration. The value white indicates a surface in light, or a surface of pale color, or both. In the same way, black may convey deep shadow, or a surface of dark color, or both. Thus, there are two ways we can read these values in a sketch. This creates confusion only if you emphasize one function and then the other, both in the same sketch. For example, in a sketch of a flower you are likely to emphasize the lightness and darkness of pigmentation of parts, and ignore the modeling effect of light and shadow. Try to do both equally and the sketch will look muddy. In a sketch of a rocky outcrop you might want to emphasize the modeling effects of light and ignore—to a degree—the inherent coloration. To know how to balance the interacting functions of value takes practice (see fig. 3.11).

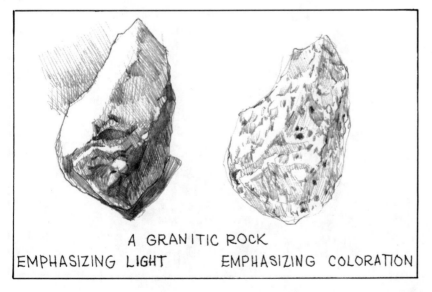

A GRANITIC ROCK

EMPHASIZING LIGHT EMPHASIZING COLORATION

Figure 3.11
When sketching in black-and-white, shading will show form *or* the coloration of surface. It can do both, but the results will be somewhat murky.

Black poses a special problem to the artist. If you look carefully at a form in nature that has black pigmentation, you will notice that it reflects a small amount of light and has a grayish cast. But, because we know it to be black, we are tempted to sketch a deep black value. If we do so, we succeed only in creating a "hole," because the only absolute black in nature is what we encounter in the complete absence of light. (A cave might provide this absolute black.) Here, once more, we are balancing properties of a value. We are balancing both the element of pigmentation and the absence of light represented by black with our preconceived idea of what black should look like.

Value can be thought of in terms of a progressive scale, something like a spectrum. A person of good visual acuity can perceive 150 steps in a value scale between white and black.[4] To adhere to so extensive a scale in a sketch or drawing would be cumbersome in the extreme. Obviously, we must simplify the scale to a number of steps that can be managed with ease. Including some shading in a brief sketch, we are unlikely to employ more than three grays, black, and white—a scale of five values. Even an elaborately shaded drawing is unlikely to exceed a scale of ten values. (See fig. 3.12.)

The basic value scale of five steps consists of white, light gray, middle gray, dark gray, and black. It is useful to be able to judge the visual appearance of middle gray. If you are sketching a tree with pencil, you have to equate the various greens of the leaves to light, middle, or dark gray. Knowing what a middle gray looks like makes it very much easier to judge how a color in nature will appear as a gray. This is important not only in black-and-white sketching, but in color sketching as well.

Figure 3.12
A sketch using five values. We certainly see more than five values, but the limitation to five values is useful in a sketch.

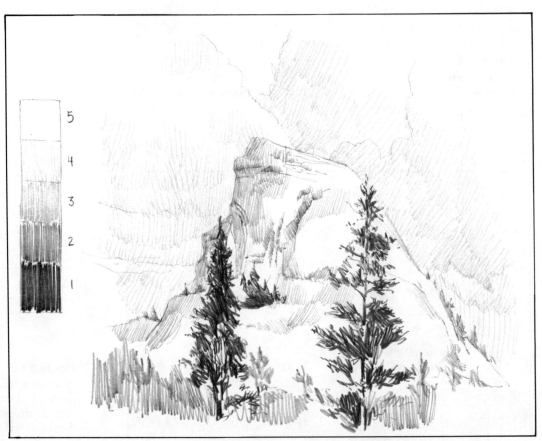

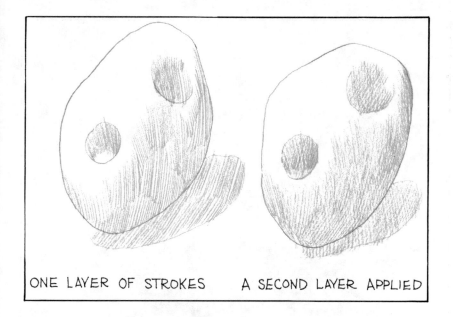

ONE LAYER OF STROKES A SECOND LAYER APPLIED

Figure 3.13
A method of producing a tone with strokes. Note how the illusion of volume can be suggested using only one value.

Sketching with Values: Basic Skills

As you begin to add shading or tonal areas to your sketches, you will develop three basic working skills:

1. The ability to sketch an even tone, called *continuous tone.*
2. The ability to blend darker into lighter values, producing a *gradated tone.*
3. The ability to represent a color, its intensity, or its tonality with an appropriate gray. (This skill is especially important in the use of color. See chapter 4.)

Even if your intention is to use but the barest minimum of shading in your sketches, review the technical advice I give here. It may sharpen your powers of discrimination and aid your decision. Remember also, as you review these skills, to try to approach sketching with a certain amount of freedom. If you think too much about producing a finished work of art, it may lessen the benefit that sketching has in taking you out of yourself.

Some artists have abandoned shading techniques as inappropriate to their intentions. For many centuries, artists in China and Japan rejected shading, as they rejected perspective, because it was based on a single vantage point, on an egocentric view of nature. If you find that, while you respond to sketching in line, the process of shading robs you of some of the pleasure of sketching, it indicates no lack in yourself to reject it.

Continuous Tone. A tone can be produced by layering strokes of the pencil as in figure 3.13. A finer, more delicate tone results if the pencil has a sharp point, a bold tone if the pencil is blunt. You begin by sketching a "patch" of a series of strokes. The strokes are not drawn one at a time, but in rapid succession. You can also scumble (soften the lines or colors by rubbing) them—especially appropriate to the demands of sketching (see fig. 3.14). If you hold the pencil a distance away from its point, you can produce a pale tone with relative ease (see fig. 3.15). I usually take several sharpened pencils

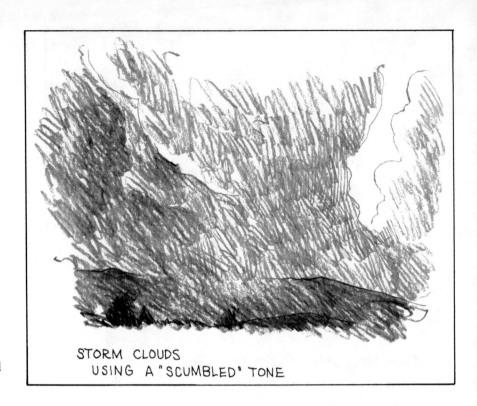

STORM CLOUDS
USING A "SCUMBLED" TONE

Figure 3.14
Tone can be achieved using scumbled strokes.

along, to avoid resharpening a pencil in the middle of a sketch. (For this same reason, I have taken to using micro-point mechanical pencils.) When the first series of strokes begins to produce the desired tone, it is tempting to achieve a smoothly blended tone by rubbing. With charcoal or Koh-i-noor's Negro pencil, rubbing with the finger will effectively blend the tone. Rubbing yields an uneven tone with graphite, as the oils present in your skin act as a solvent. A light buffing will give better results than rubbing here.

Gradated Tone: The Key to the Illusion of Volume. A smooth white rock in sunlight will have surface that is illuminated and surface in shadow. Within the shadow, next to the illuminated area, an apparent core of darker shadow may be visible. Opposite the source

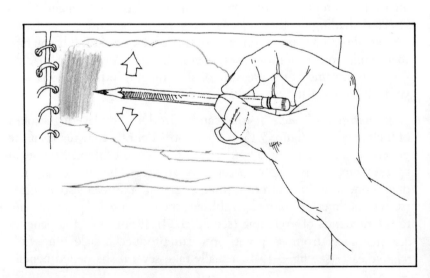

Figure 3.15
A method of producing pale tones. Grasp the pencil farther from its point. This permits a lighter touch.

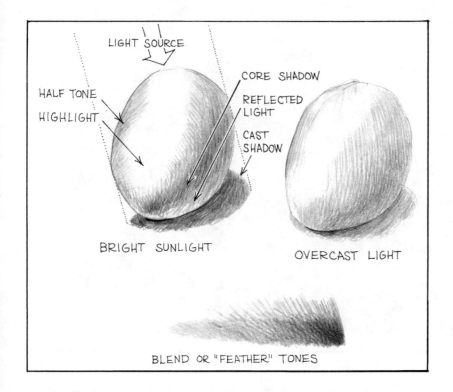

LIGHT SOURCE

HALF TONE

HIGHLIGHT

CORE SHADOW

REFLECTED LIGHT

CAST SHADOW

BRIGHT SUNLIGHT

OVERCAST LIGHT

BLEND OR "FEATHER" TONES

Figure 3.16
Qualities of light and shadow. Note how the qualities of core shadow and reflected light are less obvious in diffused or overcast light.

of light, reflected light may produce a radiance within the shadow. (See fig. 3.16.) The different levels of light and shadow blend into each other; there are no crisp, sharp edges (unless the rock possesses facets with sharp edges). With practice, you can learn to recognize the broader divisions of light and shadow, and to recognize the nuances. For example, take an egg from your refrigerator and shine a light on it from the side. The broad divisions and nuances of value can be easily seen.

An Exercise in Blending Value. To build the skill of blending one value into another, practice sketching the gradated value scale shown in figure 3.16. You can make a tone darker by pressing harder on the point, but more control is achieved by producing your darker tones gradually, by layering the strokes. As you create layers of strokes, be mindful of overlap so as to avoid unwanted bands of darker value. Become accustomed to working both darker into lighter values and lighter into darker values. Values produced with hatching or close-knit strokes have greater luminosity than rubbed tones because a degree of white paper continues to show through even the darkest values.

Understanding and practicing value progressions help you to determine them for individual sketches. When you sketch a green leafy plant with a pencil that produces only grays and black, you are faced with the problem of deciding equivalents. The green of the leaf will be pale, dark, or somewhere in-between. This is affected by the opacity, transparency, or reflectiveness of the leaf, and by light and cast shadow. All this "lightness" and "darkness" becomes various grays in your sketch, different grays at different steps on the value scale. However, you may elect to sketch only the gray representing the true color of the leaf, making it lighter and darker to suggest the effect of sunlight and shadow, as in figure 3.17.

Figure 3.17
Qualities of light and shadow in a
leafy subject.

Equating the colors in nature to the grays of a monochrome
sketch is the first step in learning to see the nuances of color in
nature. Equating a perceived color to a particular step on the value
scale has its difficulties. A green will look greener next to a reddish
background. It will look paler when it is seen next to an area of deep
shadow. To effectively judge the identity of a color, its intensity, and
its equivalent to gray, we must see it in isolation. John Ruskin, who
himself painted, advocated cutting a small round hole in a piece of
white cardboard or stiff paper.[5] The hole should be small enough to
isolate the color area you wish to judge. The light of the sun should
fall on the card. (In shadow the white of the card becomes gray.) You
can then compare the color to the value white. Several practice
sessions with this unusual tool teach a vivid lesson. You will learn to
make your judgments without the card, ultimately.

A Word about Technique. As you include areas of tone in your
sketch, you will encounter two distinct qualities of texture: the
texture produced by hatching or strokes and the texture present in
your subject matter. (See fig. 3.18.) If you wish to show that a surface
is smooth, as in weathered stone, you will need to blend the pencil
strokes completely. A light touch and a consistent manner of laying
down the pencil stroke are the keys to doing this successfully.

Technique is a matter of individual style and personality, and at
its best is flexible—suited to the subject at hand. It can be vigorous
or sensitive (see fig. 3.19). I am left-handed, and that determines a
directional tendency my strokes will have.

TEXTURE

In combination, the two principal elements in drawing—line and
value—create texture, an element basic to nature sketching, *texture,*
as a term, is used to describe not only the quality of real surfaces in

PENCIL STROKE USED
TO SHOW TEXTURE

PENCIL STROKE USED
TO SUGGEST SHADOW

Figure 3.18
Pencil strokes may indicate a real texture, or they might simply suggest shadow on a form.

A DELICATE HANDLING

A BOLDER HANDLING

Figure 3.19
Qualities of the pencil stroke.

nature, but the quality of the strokes, hatching, marks, or scumbling you may use to suggest the surface of the natural forms you sketch.

Pen and ink gives us an excellent example of a medium that in its strokes and marks (stippling) has a definite texture of its own. The peculiar challenge of the medium is the problem of using varying combinations of strokes (crosshatching) to suggest textures in nature. A rugged rock formation will lend itself beautifully to the harsh clarity of pen hatching, but if the amorphous quality of a cloud is attempted, the medium seems unwieldy. An attempt to resolve this problem is illustrated in figure 3.20. In sketching, pen and ink is used

Figure 3.20
The texture of pen and ink. Pen strokes easily portray the solid mountain, but can only suggest the quality of a cloud. Broken contours and stippling are used.

boldly, with little attempt to hide the shorthand nature of its hatching. (See chapter 4 for more on the technique of pen and ink.)

As mentioned earlier, it is necessary to balance the texture characteristically produced by your drawing tool and the texture that is the surface of your subject matter.

Qualities of Texture

The bark of a tree and the surface of a rock present obvious textures. However, the leafy crown of a tree and the undulating surface of a grassy meadow are also textures. Here, the eye does not focus on all the leaves at once. It sees a totality, a texture that reflects the inherent character and identity of the object.

There are as many textures as there are phenomena in nature. Clouds and rolling sand dunes, for instance, are both smooth and permeable, one rippling; the other billowing or drifting. The problem for the sketcher is to keep the forms from looking solid.

Perhaps the most elusive of all is the texture of water. Water is a reflective surface, and therein lies the secret of how to represent it on paper. The surface of a lake might be smooth on a windless day and reflect the clouds above or the banks nearby. When the surface is disturbed by wind or the wake of a craft, the reflection is shattered or fragmented into many more or less parallel sections. When the surface of the water is turbulent, it is a myriad of light and dark shapes. (See fig. 3.21, and the comments on surf in chapter 6.)

The leafy crown of a tree and the rolling surf are similar problems. In both situations you have light-reflecting surfaces, translucent surfaces, and surfaces in shadow, whose interplay combines to suggest the sensation of movement, a vivid indication of the presence of the wind (see fig. 3.22).

COMPOSITION: ORGANIZING A SKETCH

Sketching individual subjects—a flower or a bird—involves line, shape, and perhaps shading. In this instance, arrangement on the page may be completely random. However, if you decide to sketch a meadow, or any other complex environment, you will need to consider the limits involved in your sketch. What are you going to

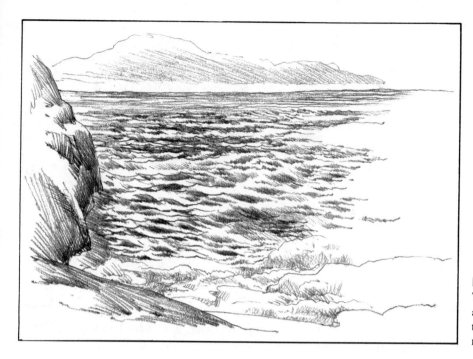

Figure 3.21
The surface of water. In stillness it is an imperfect mirror. In motion or turbulence it is a surface of broken reflections.

a eucalyptus in a February storm '86

Figure 3.22
The texture of foliage. The suggestion of leaves purposefully has a directional unity to imply the action of the wind.

Figure 3.23
A sketch emphasizing the horizontal.
The long axis of the rectangle of the
page gives emphasis to the limitless
horizon.

include? What are you going to omit? Will a horizontal page or a
vertical page best suit your subject?

Format

Format is a term I use for the size and shape of a page. It directly
affects your sketch. A horizontal format gives emphasis to the horizon
and the ground plane, as in figures 3.23 and 6.1. A vertical format
emphasizes stance (as in a figure) or the upward reach of a tree. It

Figure 3.24
A sketch emphasizing the vertical.
The long axis of the rectangle of the
page gives emphasis to the towering
grandeur of the redwood and the
canopy of the clouds.

may emphasize the sky, as in figure 3.24. The shape of the sketchbook page may not suit the emphasis you wish a sketch to have. In that case, you can draw another border inside the page. (See fig. 3.25.)

Figure 3.25
The format of the page in a sketch-book can be changed by drawing a border.

Composition

Composition is arrangement and selection. What to include and what to omit are questions of selection. Standing before a meadow or forest, it can easily seem imperative to draw all of it, to draw it as it is. However, we accomplish more if we first draw what most catches our eye, and then draw what gives additional meaning to our sketch.

First sketch the broad general outlines of the larger forms you intend to include in your sketch. Lightly sketched lines give you the opportunity to see in advance the overall composition. It might seem that you can think out the composition beforehand, in your mind's eye. However, until concrete lines appear on the page, you have no way to anticipate what the sketch will look like. After you have sketched in the first lines, you can better determine whether you wish to include more or less of the landscape in your sketch. You are thinking out loud, thinking visually—right on the page. (See fig. 3.26.)

Sometimes it will happen that your first lines don't match what you had in mind, but offer a possibility you had not considered. This can be a delightful discovery. Don't ignore it.

It is how we frame our subject (study the possibilities of a landscape before our eyes as though through a frame) that first involves us in composition. You can look through a frame formed by your hands or by two **L**-shaped cardboard cutouts clipped together (see fig. 3.27). The frame should be adjustable so that you can test a

Figure 3.26

The steps shown here illustrate how I sketched figure 8.2. Lines 1, 2, and 3 established a **Y** shape. Before I sketched them, I considered where I wanted them to occur on the page. I intended to include the rocks (lines 4) and some of the scrub oak (lines 5). These steps were easily visualized beforehand, and allowed me to use pen and ink without guidelines in pencil. This is an informal approach, appropriate to a sketch.

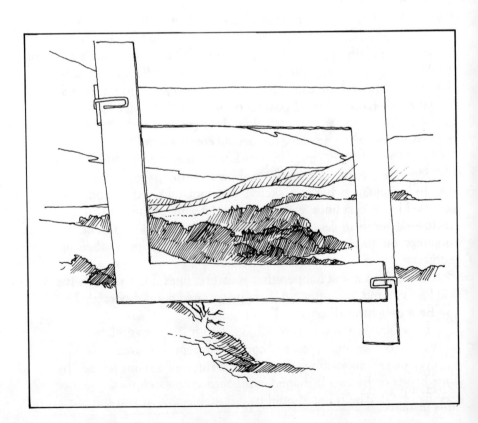

Figure 3.27

This can easily be made from scraps of cardboard. It can be adjusted to different proportions. Forming a frame with the hands is less precise, but in the end works just as well.

variety of formats. As with Ruskin's device for judging color, you outgrow the need for it as you gain experience.

Tension and Balance. Sketching landscape from memory is conducive to experiment. You may alter relationships, create a sense of what you saw, rather than struggle to create an exact reproduction. When we use our imagination to arrange nature, we will become aware of the tensions created by the balance (or the lack of it) in our arrangement.

The term *balance* can be puzzling. It becomes clearer if we think of our sketch as having two halves, left and right. In perfect balance, the left half is identical to the right. Shape sizes, the amount of dark and light, vertical and horizontal lines, and the distribution of texture will all be the same on both sides. Perfect balance is static; it implies changelessness. It will engage neither the eye nor the mind. A degree of imbalance produces tension, like a tightrope walker who teeters but does not fall. A degree of imbalance implies life and change. (See fig. 3.28.)

When sketching directly from nature, balance is one more factor—like format, arrangement, and selection—that helps us to organize our sketch, to embody in it a sense of the totality of our subject.

Truth to Nature. As mentioned earlier, sketching from memory allows us—invites us—to arrange, to be less literal. Standing before the grandeur of nature, it may seem a deceit to rearrange or edit it. You are likely to ask yourself how true to life you must be. The answer lies in another question: what is your purpose? If you wish to illustrate a species of wildflower, or a particular bend in the Colorado River, any rearrangement would counter your purpose. The sketch, in this instance, is a process of getting to know your subject. However,

Figure 3.28
A sketch with a symmetrical and asymmetrical balance. The symmetrical choice is frequently labeled a bad choice because of its tendency to be static. It is, however, how I chose to do the sketch this illustration is based on. It can be a legitimate choice.

when you draw from memory, you are drawing from your mind's eye. You interpret and alter. The truth to nature in this instance is an inner truth. In the world's first landscape art, the landscape art of China, this was a guiding principle.[6]

The Illusion of Space

How is the enormous distance in a landscape conveyed on a small sketchbook page? This is the illusion of space. The illusion is created by slight exaggeration of the layers of space: foreground, middle ground, and background. These layers are called *planes.* The foreground is whatever is close to your vantage point. The middle ground is everything in the intermediate distance. It can sometimes heighten the illusion of space to further divide the middle ground into two more planes, a nearer and a farther middle ground. The background is the final plane of distance. Land formations at the horizon (or the sky itself) constitute the background plane. (See figs. 3.29, 1.10, and 1.11.)

Perspective. It is the horizon, ultimately, that gives us the sensation of space. The banks of a river or the edges of a road will appear to converge as they near the horizon, as we see in figure 3.30. This optical phenomenon is called *perspective.* It is based on how the world appears to a single and unmoving eye (an optical lens). This is a confusing concept at first, because we have two eyes and, as noted earlier, we see by scanning, by moving our eyes. Perspective, the basis for representational drawing in the Western world, becomes a compromise between optical principles and the experience of seeing.

Applied to an isolated architectural form such as a chair, perspective is an elaborate procedure because the eye has no easy frame of reference. Applied to natural forms, the approach is simple. What must be observed is how all the components of a landscape

Figure 3.29
The spatial planes of a landscape. We will naturally include both background and middle ground in a landscape sketch. It is the inclusion of foreground, however, that gives completeness to the sense of space.

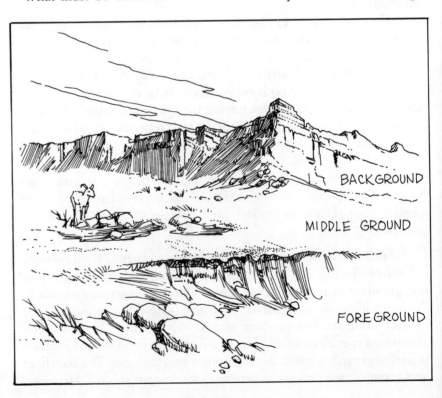

BACKGROUND

MIDDLE GROUND

FOREGROUND

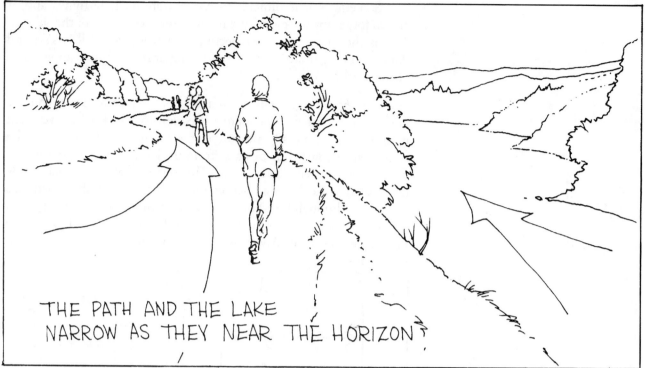

THE PATH AND THE LAKE
NARROW AS THEY NEAR THE HORIZON

relate to the horizon, the horizon line. Position the horizon line as it occurs behind a tree, a rock formation, or a hill. How much of the tree, rock, or hill extends above the horizon line; how much does it extend below? Note how trees of a similar height will appear to grow smaller as they occur in the farther distance, nearer the horizon. When we judge the placement of the horizon line, we are also making a judgment about our own eye level (or vantage point). If our eyes are five and a half feet above the ground, the horizon line will pass through all forms at a height of five and a half feet above the ground, all the way to the horizon (see fig. 3.31).

Figure 3.30
Perspective in a landscape. Things appear smaller as they are nearer the horizon.

Figure 3.31
The true horizon may not match the horizon of the landscape.

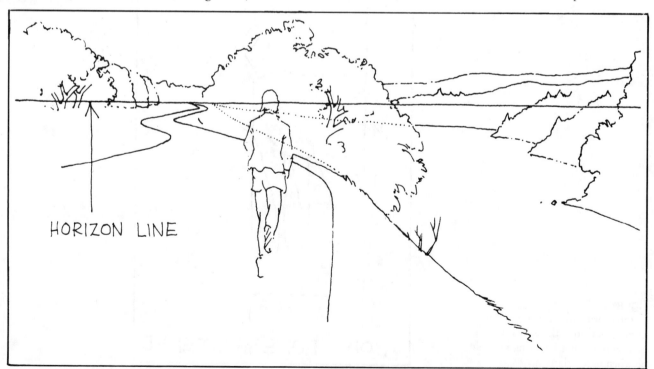

HORIZON LINE

Sometimes it is difficult to concentrate on how things appear and to forget for the moment what we know to be true of the subject. This is the dilemma of perspective, which is—after all is said and done—nothing more than a system to organize the visual appearance of the world.

Foreshortening. This is an aspect of perspective we encounter in sketching animals. The animal is easiest to sketch when we see it in profile. We can easily measure its height and length. But when the animal turns toward us or away from us, its length appears shorter, while its height remains as it was. The long axis of the animal's body has turned toward us and causes the body to be foreshortened (see fig. 3.32). Although foreshortening may occur in the limb of a tree, in a leaf, or in an earth formation, it is in the animal form that we are most conscious of it. And it is here that we must solve the problem it presents.

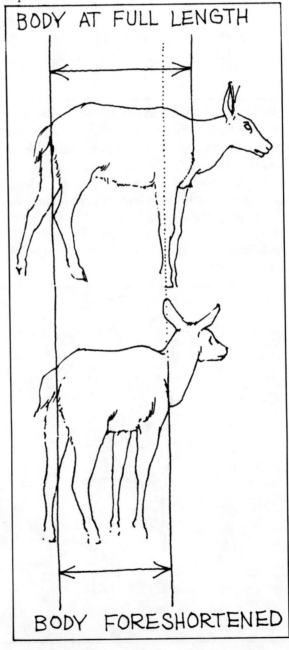

Figure 3.32
In foreshortening, remember to determine how long the animal's body *appears* to be, not how long it would be when unforeshortened.

Atmospheric Perspective. This is another aspect of the illusion of space, but it is not a part of every landscape. Humidity or moisture in the air, acting as a filter, will cause trees or hills to appear paler the farther they are into the distance. Smoke in the atmosphere or visible air pollution will cause the same effect. Leonardo notes, "You know that in an atmosphere of equal density the remotest things seen through it, such as mountains in consequence of the great quantity of atmosphere between your eye and them, will appear blue and almost the same hue as the atmosphere itself when the sun is in the east."[7] (See fig. 3.33.) Choices about reflecting perspective of this kind are emotional as well as technical. As Thoreau comments, "We love to see any part of the earth tinged with blue, cerulean, the color of the sky, the celestial color."[8]

When the atmosphere is dry or arid, as in desert or mountain regions, the phenomenon is absent. The distance of mountains on the horizon is difficult to judge. Without veils of mist, they seem very near. (Irrigation and air pollution have brought misty atmosphere to many desert and mountain areas that were formerly clear.)

Overlapping Form. This may suggest the illusion of space, especially in more limited landscape views where the horizon will not be included in the sketch (see fig. 3.34). In early Chinese landscape art, perspective was rejected as a conceit.[9] The overlapping of landscape forms in Oriental paintings successfully created a sense of space.

SUGGESTED EXERCISES
Control of the Drawing Tool

Select an interesting natural object, such as a stone or leaf. Position it just beyond your sketchbook. Sketch its contours using each manner of holding the pencil illustrated in fig. 3.1. Neither manner is necessarily better than the other, and each will lend itself to different qualities of line. Try not to hold the pencil too firmly. A gentle but definite grasp is usually best.

This is an experiment that will show you how the ability to direct a line is affected by how you hold the tool.

If you are nervous, you are likely not to apply enough pressure

Figure 3.33
Atmospheric perspective. As elements of the landscape are more distant, they are paler. The original has pale gray washes to demonstrate atmospheric perspective.

Figure 3.34
A sense of space can be achieved by overlapping.

as you sketch the contour. The line will be too pale. Use enough pressure to easily produce a dark line, or accent, when needed. You might have the opposite problem—pressing too hard. *All* the lines will be dark. Lighten the pressure on the point and see if you can achieve a fine line with a sharp point. (Maybe you are holding the pencil too close to its point.)

The habits you form in the manner of holding the drawing tool have much to do with the character of your sketches.

Practice drawing lines up, down, and across the page (the tree trunks and horizons of your future sketches). Starting from any side of the page, attempt a moderately straight line. As soon as you feel a loss of control—the line beginning to curve—stop. Reposition your hand so that you can comfortably continue the line. If the line looks choppy, it doesn't matter. You do not want a mechanical appearance to your line in the sketching of most natural forms. With continued practice you will not have to reposition your hand as frequently.

Practice drawing curved lines (the clouds, flowers, hills, and animals of your future sketches). Try simple curves and S-curves. When you can, use the natural arc formed by the movement of your wrist. Don't hesitate to pivot the position of the page in order to do so. (See fig. 3.2.) Sketching the curves in connected segments, repositioning your hand as necessary, is the method to follow here as well. Take your time; don't allow yourself to be hurried. Sketching is both responsive and investigative, but it is not a race. (Yes, animals will not hold still. But that is a problem in using your memory, not a matter of speed.)

Seeing Basic Shapes

Practice reducing trees and smaller plants to the simplest shapes you can use to define them. Here, you are using a concept as well as perception to sketch. For a moment you ignore the detail, and use a

generalization to rough in what you see. For instance, you might sketch a triangle with light lines, to guide the size, shape, and placement of a pine tree. As you sketch darker lines describing the detail of the pine, the guidelines will no longer show.

The use of a shape concept is particularly useful in sketching animals (see chapter 7). With practice, you will find that you can envision the simplifying shape without literally having to sketch it on the page.

There are natural forms that cannot be reduced to a simple geometric shape. A juniper tree has a form that is irregular. In effect, it is composed of a number of indefinite shapes. Here there is no single correct solution. It's up to you. Use whatever configuration of shapes that will allow you to indicate the broad contours of the tree and control its size and placement on your page. (See fig. 3.3.)

Hand and Eye Coordination: The Basic Skill of Drawing

Practice the exercise described in the text under "Blind Contour" and illustrated in figure 3.9. You will discover here that seeing need not be a passive perception. It is an active examination, and an important key to the enjoyment of sketching.

Memory Drawing

When you are wondering what to sketch, take a simple natural form, like a snail shell or a leaf, and place it before you. Don't sketch it; just look at it—study it. Then put it out of sight. Sketch what you can remember of it, making sure that you don't sketch anything you really do not remember. At first, attempt only contours. As you become more able to recall the form, add shading. This is a skill, and it *will* grow. If you have a serious interest in sketching animals, it is an essential skill.

The first results in this exercise may resemble the primitive efforts of childhood, and for this reason can be particularly frustrating. Allow for this, and stick with it. Even if you are never able to arrive at a pleasing image from memory, the practice will improve the sketching you do from life.

Shading

Take a white rounded stone (or an egg from your refrigerator) out into the sun. Sketch its form with a very pale contour line; sketch it on a slightly enlarged scale. Using a medium gray tone from the middle of the value scale (see fig. 3.12), add shading to the sketch, placing the shadow where it appears in the actual object. In *this* practice exercise, do not try to reproduce all the different levels of shadow; sketch the medium gray as evenly as you can. (See fig. 3.13.)

This exercise has two purposes. First, you will find that you can suggest volume (and the presence of light) with one value of gray, provided you soften the edge of the sketched shadow where it nears the light side of the object. Second, you will discover that the sun moves quite rapidly across the heavens, causing the patterns of light and shadow to alter quickly. You can readily understand how valuable it is to use one value of gray when you wish to suggest the pattern of light and shadow in a sunlit landscape.

When you can sketch an even gray tone to suggest the shadow on the stone as in the previous exercise, try sketching all the values you see on the stone, blending the darker into the lighter values. (See fig. 3.16.) The skill of blending takes practice, and that is the purpose of this exercise. You may wish to attempt this indoors, where your light will not change. As you gain practice, try it outdoors.

4
PEN AND INK, WASH, AND COLORED PENCIL

In this chapter I'll cover some techniques that can add to the experience of sketching, although they are not essential. Elaborations of basic drawing skills, they present special challenges, and should be undertaken with the realization that some time will be devoted to practice.

Pen and ink is a positive, direct medium. It gives immediacy and vividness to a sketch. Applied with a brush, *wash* (a watercolor or diluted ink tone) complements the quality of a pen line. It can capture the momentary configuration of a cloud, or suggest transitory effects of light and shadow. Delacroix's sketches are good examples of this magical combination (see figs. 1.7 and 1.8). Delacroix used watercolor to create the washes in his pen sketches. A more convenient tool for color notation is the modern *colored pencil.* It is easy to work with and easy to carry.

These tools involve technique—specific kinds of working procedure—more demanding than straightforward sketching with pencil. Some simple exercises will build the necessary skills. Once you become comfortable with these tools, you will delight in the variety they bring to the sketching experience.

Especially when introducing pen and ink to a group of beginning students, it is dismaying to see the look of consternation that collectively crosses their faces as they envision the demands of the process. Once practice has begun, however, what seemed complex or clumsy ceases to be so. I can reassure the individual in the classroom the moment I see that expression. But I cannot see *your* face. I can only assure you that the ability to manipulate pen and ink, touches of watercolor (or diluted ink) wash with a brush, and colored pencil is an accessible skill when some of the mystery attached to the techniques has been dispelled.

PEN AND INK

Even if you choose to use the common ballpoint pen, review these pen techniques. Although they may seem to apply only to flexible pen points, they contain useful observations for any pen work.

The Self-Contained Pen

The most convenient pen to take outdoors is one that has a built-in ink supply. A ballpoint pen is simplicity itself. The porous-point pen is a bit more responsive. The ink supply of either type is rarely light-fast, and some inks will bleed through the paper. The convenience is at a price.

The technical pen is the best compromise for convenience and ink that will not bleed. It is designed to use specially formulated waterproof drawing ink, and is refillable. It is manufactured to accept a variety of numbered points. Each produces a line of specific width. (I use the No. 1, which produces a .5 mm line.) It is a matter of taste. The abrasion of paper is enough to wear the fine needle within the point after a time, and replacement will be necessary. India ink is not recommended, and even the specially formulated inks can cause the pen to clog. A gentle shaking action will sometimes loosen the dried ink inside the mechanical point. (See chapter 2 for more comments on all of these pens.)

The Pen Point in the Penholder

For me, part of the appeal of pen and ink is the flexible pen point. Its irregularities—often unintended—give it a distinct and vital quality. I remember vividly how unpredictably it behaved before I had gained some experience with it. But, even in my frustration, I found this unpredictability appealing.

This is not a tool casually carried outdoors. I do use it on field trips, and you may wish to try it. If it appeals to you, take some time indoors to become acquainted with it.

The Penholder. The first consideration is the penholder itself. It is well worth the effort to find one that feels comfortable in your hand. It should feel elegant, not clumsy. A wooden holder usually has a better balance, a better feel than plastic or metal. (A calligrapher of my acquaintance made one out of bone that fit beautifully in the hand.) The Gillott Company makes good penholders, but these may not be easy to find.

Some pen points, like the crowquill, require special penholders.

The Pen Point. The point has two chief characteristics: a degree of flexibility and a fineness or breadth of line. Add the unique touch of the individual to this recipe and you can see that it is difficult to predict how you will respond to a given point. They are manufactured in a bewildering variety. Figure 4.1 is based on a chart I made for myself to test the points I have accumulated. Buy a limited variety of points and make such a chart. You will quickly become aware of the nuances of the different points.

Crowquill is a generic term applied to a point long favored for pen sketching. Because of its small diameter, it requires its own holder. It is quite flexible in some numbers, less so in others. Its special appeal is in its fineness and its property of yielding a highly variable line. I recommend the Hunt No. 108. Figure 4.2 illustrates some of the characteristics of this point (see also fig. 9.19).

The Gillott No. 303 point is sometimes used in the art school classroom as an introductory point. It is slightly less flexible than the

Figure 4.1
A pen-point test chart. If you test these same points, your chart will look different insofar as your individual touch governs the results.

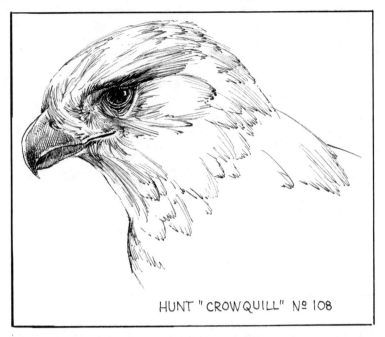

HUNT "CROWQUILL" Nº 108

Figure 4.2
This point is very responsive.

crowquill, and far less frustrating in the hands of someone who has not touched pen and ink before.

Pen points have a protective oily coating to retard rust. This must be removed or ink will not adhere to the point. Use a solvent such as mineral spirits.

Black Ink. There are two types of black drawing ink: waterproof and water soluble. These distinctions apply to the properties of the ink after it has dried on the paper. Most waterproof black drawing inks, sometimes called India ink, contain shellac, which can ruin a good watercolor brush. Pen work is usually done with it. Drying waterproof, it allows subsequent application of watercolor or dilute ink washes if desired.

Water-soluble ink does not contain shellac. It will not serve if you want your line work to dry waterproof. However, it is recommended for washes of dilute ink, as it will not harm the brush. Among the water-soluble inks are some intended for calligraphy. Avoid these, as they turn blue (not gray) when diluted with water.

Brown Ink. The antique quality of a brown ink has a distinct appeal, much softer in its effect than black. Brown ink is a colored ink. Colored inks fade quickly (should you frame the sketch, or pin it to your bulletin board). The Pelikan Company offers a "Special Brown," a rich luscious brown that *is* lightfast. Although it does not fade, the brown changes as it ages, becoming duller.

The Oriental Ink Stick and Slate Grinding Stone. This is an ink that has both practical and aesthetic value. It is easy to carry around, as there is nothing to leak. You grind the ink when you need it, right on location. When you are finished, you dispose of what's left. On your sketch the ink dries waterproof. Used to produce dilute ink washes, it will not injure your brush. Diluted, it yields the subtlest grays of any ink, possessing a quality all its own.

Mixing the ink is simple. Place a small amount of water in the shallow depression at the end of the slate or *suzuri* stone. Hold the

Figure 4.3

Grinding ink. This might seem exotic, but it is a highly satisfactory way of producing your ink.

ink stick vertically between your fingers. Use it to bring water up onto the flat grinding area of the stone. Grind, using a circular movement, periodically bringing up more water (see fig. 4.3). When the ink begins to take on an oily sheen, it is probably dark enough. Yes, it takes several minutes to prepare the ink, but the quality of the grays you can produce with it makes it well worth the effort. The time spent grinding the ink becomes a moment of quiet thought, an appropriate preparation for sketching in nature.

It is important to purchase an ink stick of at least moderate quality. The less expensive sticks produced for student use do not noticeably differ in quality from bottled ink.

When you employ washes, remember to lightly wet your brush with clear water before dipping it into the ink. When you are finished, the brush need only be rinsed with water. Don't use soap. Clean the stone in the same manner; dried ink will clog its pores.

The ink stick and the stone are usually the companions of the Oriental brush and rice papers (materials—and techniques—that I don't discuss here, which I would be remiss in not mentioning). As your competence grows with the materials common to sketching, you may wish to experiment with these less-common tools.

Inking the Flexible Point. This need be no more complicated than dunking the point in the ink bottle and tapping off the excess ink. If you have an impetuous temperament, and the sketch has a rugged quality, there is no reason to do otherwise. And in the out-of-doors it makes perfect sense. However, if you wish to have more control over the inking of your point, use the dropper stopper, placing one or more drops of ink on *top* of the point (see fig. 4.4). Unwanted drops of ink are less likely to find their way onto your page. (It is no tragedy to have spots!) You will also be better able to anticipate the character of your line—truly important when cross-hatching. Wiping the point with a small piece of chamois skin (as a penwiper) every now and then will prolong its usefulness and ensure consistent performance.

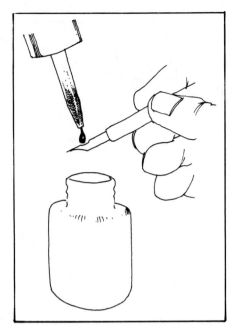

Figure 4.4
Inking the point. If you are doing quick sketches, and don't mind a few ink spots on the sketch, dunk the point directly into the ink. Periodically clean the point of the dried ink that accumulates.

This begins to sound tedious, but let me assure you that it isn't. A little thoughtful procedure will let you concentrate on the sketch.

Technique

Whatever pen you decide to use, the pen line is a positive, unequivocal mark. Once drawn, it is difficult to erase, and it is better left where it is. As you evolve your approach, make the most of this, its chief beauty.

The most troublesome aspect of pen drawing is the scratchy feel of the point as it moves across the paper. Don't push the point, but rather pull it (either toward you or to the side) as you draw a line (see fig. 4.5). This minimizes the scratchy feel and gives the greatest degree of control. (It doesn't matter whether you are left- or right-handed.)

Use smooth paper for pen drawing. No sketchbook made has a paper that is ideal for all materials. If the paper is smooth enough for the pen, it probably is not heavy enough for use with the washes described later in this chapter. Compromise will be necessary. But for practice with the pen, get yourself the smoothest paper you can find.

Figure 4.5
The technique of handling a flexible pen. Develop the habit of pulling rather than pushing the point.

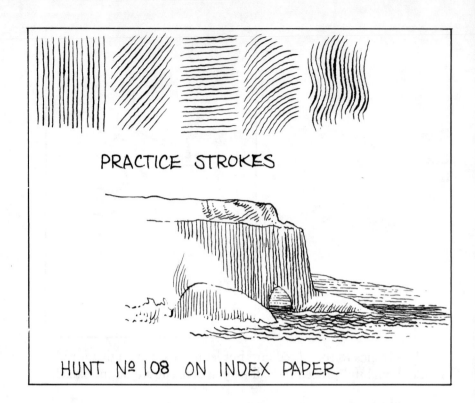

Figure 4.6
Practice these lines, and the cross-hatching illustrated in figure 4.7. This is the basis of fluency with pen and ink, even if you use ballpoint or porous-point pens.

Practice sketching lines as shown in figure 4.6. First accustom yourself to drawing unvaried lines. Then try varying lines and controlling how they vary. This is an important exercise that will give you fluency with the pen.

Crosshatching. Crisscrossing a series of lines to suggest tone is called *crosshatching.* Unlike graphite or charcoal hatching, which can be blended into an even tone, crosshatching with pen and ink remains obvious for what it is, a kind of shorthand notation with a texture all its own. (With a fine point and some sustained effort, crosshatching *can* produce illusionistic results.) It is the notational element that lends itself to sketching.

When you practice the crosshatching exercises shown in figure 4.7, draw the series of lines slowly and deliberately at first. As they become easier to do, allow yourself to draw them more spontaneously. Don't labor to reproduce the examples exactly. You will evolve your own method. We all do. This becomes personal, in the way your handwriting is personal. Carry a small notepad-size sketchbook. Take it out during idle moments and doodle the crosshatching patterns with a ballpoint pen. Soon crosshatching will become as natural as any other aspect of drawing.

Crosshatching definitely has a character or a quality that will assert itself. Obviously, it will work best with those forms in nature that are coarse-grained or rugged. (See figs. 3.20 and 6.1.)

Figure 4.8 illustrates how form might be suggested with a crosshatching technique. The basic principle is explained earlier, in chapter 3, and illustrated in figure 3.16.

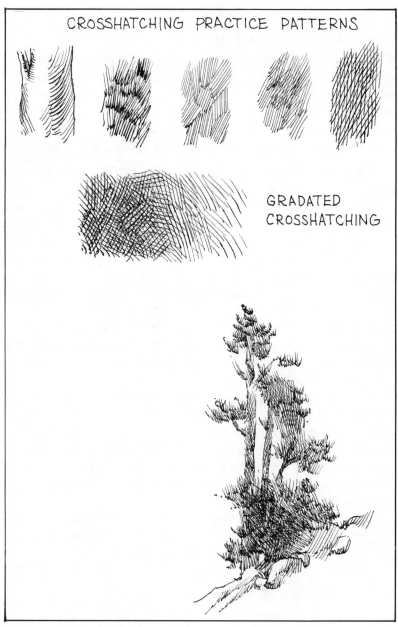

CROSSHATCHING PRACTICE PATTERNS

GRADATED CROSSHATCHING

Figure 4.7
Crosshatching. Bracelet shading, scumbling, herringbone, an interwoven pattern, and true crosshatching are shown here.

Figure 4.8
Puma skull. In a sketch, crosshatching can produce the illusion of volume, but the soft, delicate tones of a smooth surface are more difficult to achieve.

WASH

Applying Tones with a Brush

The uncomplicated technique of applying watercolor (or dilute ink) wash gives increased dimension to sketching. Many of the sketches reproduced in this book contain tonal areas that were applied as a wash. *Wash* is a term that indicates tone or color applied as a fluid, ink or watercolor mixed with water. A touch of wash can be applied with a fingertip. Areas of wash are usually applied with a brush.

Materials. A round sabeline watercolor brush is suitable for applying washes. A No. 8 is the best median size if you are covering sizable areas on a sketchbook page, No. 6 if your need is to add local color to small shapes (such as noting the colors on the plumage of a bird). *Sabeline* designates a brush composed of ox hair, and sometimes including second-grade sable hair. These hairs have good reservoir properties: they will pick up useful amounts of fluid when dipped into it. Also, these hairs are durable and resilient; they hold their shape when wet. Less expensive "camel's hair" brushes should be avoided. They become limp and splayed when wet, and hold little water. They will frustrate your efforts. They are generally supplied with beginner's watercolor kits, ensuring that beginners remain beginners.

A thin paperlike typing paper will pucker and wrinkle when a wash has been applied to it and has dried. The color or tone will puddle and dry unevenly, as shown in figure 4.9. The paper is too thin and it has too much sizing (glue) in it for our purposes. Many sketchbooks and journals have thin paper, permitting only limited use of wash. So long as you are aware of this, there is no other reason not to use them.

Some sketchbooks have 70-pound paper, which is heavy enough to be receptive to limited amounts of wash. This is the paper you will be sketching on. Use it to practice laying washes.

Figure 4.9
Watercolor applied to typing paper. It *can* be done, but the results are irregular and unpredictable.

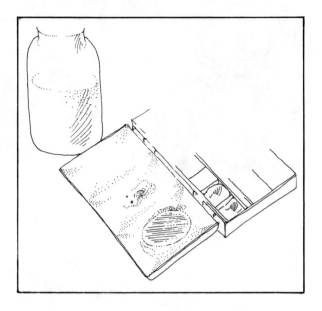

Figure 4.10
The lid of a watercolor set can be pressed into service for mixing washes of color.

Method. You will need enough water to prepare the wash mixture, and additional clear water to rinse the brush when you have finished. A watercolorist will carry a gallon or more, to ensure the clarity of wash mixtures. But for sketching you need not carry more than a pint (500 ml), and I usually carry only half a pint, to keep the weight of my pack to a minimum. I carry the water in a leakproof unbreakable container (see fig. 2.9).

Mix the wash in a shallow container. The depressions in the lid of a watercolor box will do nicely (see fig. 4.10).

Either watercolor or ink may be used to color or tone the water. If you use watercolor, it helps to prewet the color cakes or the dried color you have previously placed on your palette. If you use ink, wet the brush before dipping it into the ink—and be sure to use the water-soluble type—to avoid damage to the brush.

The technique of wash is to produce a more or less even area of tone within a desired boundary.

1. Draw simple shapes, as shown in figure 4.11, to practice controlling the wash, confining it to definite boundaries.
2. Place enough water in your shallow container to cover the entire shape or area in your sketch. (Mixing additional wash takes time, and *any* delay will cause the wash to dry unevenly.) How much color or ink is needed to give the depth of color you desire is a matter of trial and error. Every pigment has a different capacity for staining the water, and experience will teach you how each will act. Test your wash on a piece of scrap paper, or at the edge of your sketch.
3. When you are satisfied with the color or strength of the wash, dip the brush into it. The brush should be fully charged—dripping wet. Put the brush to paper with the heel of the brush within the interior of the shape you have drawn and the tip of the brush at the uppermost edge of the shape, as in figure 4.11. Move the brush horizontally across the edge of the shape. (Your book or pad should be inclined slightly toward you.) This will leave a stroke of tone. Some of the fluid in the wet

Figure 4.11
Practice shapes for applying washes of color. Place the point of the saturated brush at the boundary of the shape as shown, and apply the color in slightly overlapping bands.

stroke will run to the bottom edge of the stroke. As you apply the second stroke, immediately below and parallel to the first, allow the point of your brush to touch the wet bead at the bottom of the first stroke. The two strokes will blend. Repeat the process with the third stroke, and so on (see fig. 4.12).

4. As you begin to exhaust the charged brush, dip it again into the wash mixture. (If the mixture has settled, agitate it with the brush.) If the brush contains too little fluid, the wash will not dry as a smooth tone and will appear scrubbed or streaky.

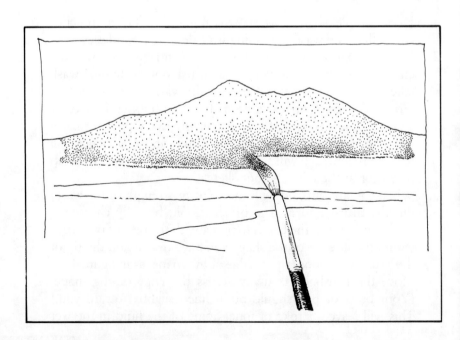

Figure 4.12
Applying a wash of color. Inclining your sketchbook slightly allows the fluid to run to the bottom of the shape as you lay it in with the brush. Move the brush from left to right and then right to left. Keep it saturated.

After the wash has dried, a deeper tone can be produced using the same wash mixture, laying a second wash over the first. It is always possible to deepen a wash when you are unsure just how dark you want it to be. It is much more difficult to lighten it.

Resist the impulse to even out any irregularities in the wash by going over it or scrubbing it while it is still wet. Especially when working on sketchbook papers, this can only make matters worse. If you are using color, you will discover that each pigment will act differently in wash layers. Some will go down evenly, while others will be grainy. Some pigments (like ultramarine blue) will betray your individual strokes no matter how proficient you become.

Wash can be freely added to a sketch without necessarily adhering to an outline. But before you put brush to water, know where you want to use tone or color in your sketch. Little adjustment is possible; make the best of any miscalculation. There is something of the spirit of adventure in any method that partakes of watercolor. Too much caution will avail you little, and usually hinders your progress. As you practice and develop confidence with wash, you will bring more control to it. Give in to the fluid play of the brush. Washes do not have to be smooth and featureless—and rarely are.

Dry-brush

If you begin adding touches of wash to your sketches, it will not take long before you realize that a brush with its reservoir nearly exhausted becomes a drawing tool. The dry strokes can look as though they were the product of a pencil or crayon. The small scale of a sketchbook lends itself to this approach, especially when the sketch is approached in a leisurely way. The term *dry-brush* is a little misleading; a better one would be "slightly moist brush."

In watercolor painting, dry-brush is a lengthy technique, involving hours of glazing thin layers of color. In the hands of a lively practitioner, the results are beautifully luminous. In less-experienced hands, the results can be drab in the extreme. This has given the method a bad reputation. For sketching, however, a more directly executed dry-brush can be useful and effective, even if you have had little experience.

Materials. A *round watercolor brush,* No. 6, of synthetic hair is ideal. It has a poor reservoir—which here is an asset—and holds a good point for the more specific manipulations dry-brush allows. A *smooth paper* is my choice with this approach, usually index. With its lack of texture, the color in the brush will go further on it.

Method. There is a mystique attached to dry-brush, a sense of almost arcane technique. However, it is quite uncomplicated. Small mixtures of wash are prepared, and the brush is charged in the usual way. Next, some of the color is removed from the brush by pressing it across the edge of your mixing container, or by making some initial strokes on a piece of paper towel (see fig. 4.13). Gauging the amount of color on the brush will require practice and experience. A quick test on the edge of your sketch can save needless frustration. You develop a knack for knowing when the brush is dry enough to yield a light and airy stroke.

Apply the strokes of dry-brush as you would pen or colored

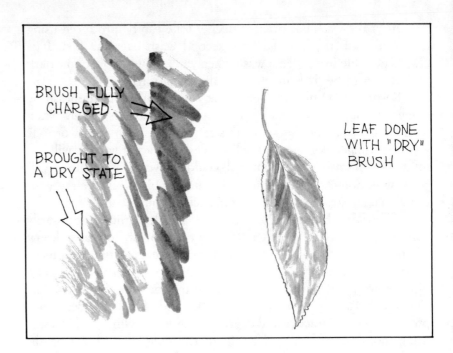

Figure 4.13
Dry-brush application of color. See also figure 2.7.

pencil. If you wish to adopt a more impressionistic attitude, scumbling can be effective. The following review of the colored pencil covers the fundamentals of adding color to your sketches, ideas and methods that can readily be applied to your use of dry-brush.

COLORED PENCIL

As a vehicle for adding color to a sketch, nothing is less complicated than colored pencil. Although it is not quite so direct a medium as watercolor wash for applying an area of color, its technique is more accessible, more easily mastered. It will easily produce the variegated colors of birds, and is favored by artists like Keith Brockie, who devote special attention to birds.[1] It can convey the luminosity, the vibrancy of color in the petals of a wildflower—sometimes more successfully than watercolor.

No small part of the appeal of some brands are the attractive and easily carried tins they are packaged in. Colored pencil is a graphic arts medium. As with other graphic arts media, it is marketed for brightness of color—immediate visual appeal—and not for subtlety. The greens and blues, for instance, may have a brash quality, whereas these colors in nature are more subdued. Use a green out of the box to denote the green of a leaf and you may find that the result looks artificial. (Large selections of pencils include more-subdued colors.)

The brash quality of a color is easily modified, subdued, by combining two colors—layering them. This is the essence of colored pencil method: knowing what two or three colors will produce the desired result when layered.

Permanence to light may be a concern. If you sketch in a bound volume, and there is little likelihood of placing any sketch in a frame, the concern is no concern at all. It is only if you plan to exhibit the sketches—or sell them—that you must concern yourself with the permanence of the color. At the time of this writing, Berol Prisma-

color, Caran D'Ache (the non-water-soluble type), and Derwent Artist Quality colored pencils are all reasonably lightfast. (See chapter 2 for more information.) You can test all this for yourself. Sketch representative bands of all of the colors you use across a sheet of 100 percent rag bristol board. Cut the sheet in half, yielding two complete test sheets. Place one on a wall that does not receive direct sunlight. Date the other and place it in an envelope. In six months, compare the two sample halves. If fading is going to be a problem, you will see it clearly in the comparison (see fig. 4.14).

Methods

Local Color. Adding color to a pencil or ink line drawing is by far the simplest procedure. You need only develop an eye for the nuances of *local color.* This term indicates the color possessed by the subject matter, apart from the effects of light, shadow, or reflected light.

Glazing. As already mentioned, the colored pencil in the box will not always match the color we wish to depict. Usually, it takes the combination of at least two different colored pencils to achieve this, the color of one pencil layered in thin strokes upon the color of another. I call this thin layering *glazing,* as it produces effective optical mixture of the color.

If there is a technical secret to be confided, it is this: It requires a very sharp point on the pencil to produce a thin, almost transparent layer of strokes. A blunt point produces a cruder, less blended tone. I usually sharpen the pencils well in advance with a utility knife (mat knife) or Swiss Army knife. Sharpeners break the weak leads too easily. (Sharpening is discussed in chapter 2.) I take my time, and I fuss with paring the point. (See fig. 2.4.)

Each layer of tone is created by a series of more or less parallel strokes. I draw them quickly enough so that soft strokes are the

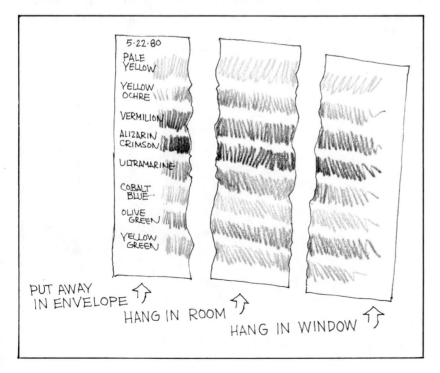

Figure 4.14
Testing the lightfastness of colored pencils. Exposing the second strip for six months will usually reveal whether fading is going to be a problem. The third strip represents an extreme test that will fade even so-called permanent colors, and you may wish to dispense with it.

result, not deliberate and individual lines. They can be made in one direction or back and forth, whichever seems more natural. A certain boldness is appropriate to sketching, as you are not striving for "finish."

Creating a Wash with Water-Soluble Pencils. A tone produced with water-soluble pencils can be blended with a water-laden brush, as described under "Wash" earlier in this chapter. I enjoy using an adaptation of the dry-brush method—blending with a lightly moistened brush (see fig. 4.15). It is important to work on paper that is heavy enough to withstand some wetting.

Basic Ways to Mix Color. With each particular watercolor pigment or colored pencil, you may wish to adjust or even change the qualities of the color. There are three aspects of a color that may be changed by mixing. You can alter its hue (change a yellow to a yellow-orange); you can change its saturation (change a bright blue to a dull blue); you can adjust its value (make a red paler or darker).

Hue refers to the unadulterated color as it occurs in the spectrum. Yellow, red, and blue are called *primaries,* because they cannot be obtained by mixing other hues together. Orange, violet, and green are called *secondaries,* as each is the product of mixing two primaries. You can mix red and yellow to create orange. If your palette of colors contains all the primaries and all the secondaries, you can mix the hues that occur in intermediate positions on the color wheel. With a true yellow and a true orange, you can mix all of the intermediate steps of yellow-orange.

Saturation refers to the intensity of a hue. A "bright" blue is a fully saturated blue. In watercolor, superimposing washes of cobalt blue will increase the visible saturation of the hue. For the most part, it is easier to lessen the saturation of a color. This is done by mixing the hue with a small proportion of the hue opposite it on the color wheel. Opposite hues are termed *complements.* Green and red are complements. (The artificial green in colored pencil assortments can

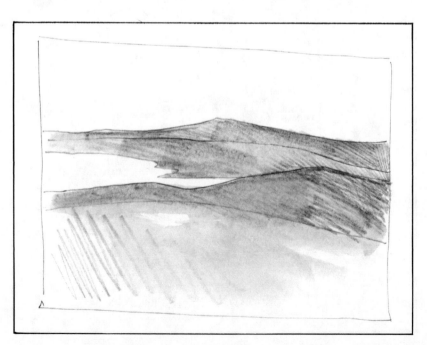

Figure 4.15
Using water-soluble colored pencils. As you can see from the foreground portion of the sketch, strokes of the pencil can be completely dissolved with a wet brush.

be toned down by combining it with its complement. Sketch pale tones of red and superimpose tones of green.)

The **value** of a hue or color refers to its position on the value scale. (For more on the value scale, see chapter 3.) Each hue has its full saturation at only one position on the value scale, and the position is different for each hue (although two hues can occupy the same value level). Yellow, at full saturation, is high on the value scale (is pale). Blue, at full saturation, is moderately low on the value scale (is dark). Therefore, the range of tints possible with yellow is small, while the range of tints possible with blue is much greater.

To add white to a color is to **tint** it. This can be achieved by allowing the white of the paper to show through your glazes of color.

To add gray to any color is to **tone** it. The muted quality of toned colors resembles much of the color found in nature. Mixing a sufficient amount of the complement with a hue will also have the effect of adding tone. In some instances, this can be a preferable method of adding gray.

To add black to a color is to **shade** it. The effect of adding *small* amounts of black to some hues resembles the effect of lessening saturation. Adding any amount of black has a tendency to give colors a dirty appearance. This is especially so with hues that achieve full saturation higher on the value scale. Yellow with a little black mixed into it suddenly turns greenish. Use black with discretion. Very few natural forms are as black as they seem at first glance.

Pencil Assortments

Most selections of colored pencils contain some that are pure hues, unadulterated colors of the spectrum. There may be one or two hues that are less saturated, duller. Several may be tints or tones of a color. In addition, they may also contain some earth colors, made from pigments that are natural earth clays. Yellow ochre is a brownish yellow. Burnt sienna is a reddish brown. Both are very useful, as they are colors frequently found in nature. Although they are not spectrum hues, they can be usefully tinted, or mixed with hues like the greens and blues. It is a good idea to arrange the colors in the order in which they occur on the color wheel. It will make it easier to learn the systems of mixing them.

How large an assortment you will require for sketching is a matter of personal choice. Probably, most sets containing eighteen colors (including black, white, and gray) will allow you to mix what you need.

Achieving Unity of Color in a Sketch

One of the least-understood principles of re-creating the colors in a landscape, even in a sketch, is that it is the relationship of one color to another that creates atmosphere and a sense of visual truth—that achieves unity.

The sky is always the palest, most luminous element in a landscape. It is, of course, the source of light. What is not so obvious is that clouds—even storm clouds—will also be lighter than anything on the earth below, while at the same time remaining slightly darker than the open sky.

Observe carefully how pale or dark each part of the landscape appears when compared to neighboring parts. Note also how one area of foliage may cause another to appear more greenish or reddish by comparison. Giving attention to such comparisons, even in a brief sketch, gives the result unity, a feeling of atmosphere. A tree might appear to be as green as the top of a pool table. But place a swatch of the green you estimate the tree to be on the edge of a sheet of paper, then place the edge of the paper across your field of view as you look at the tree. Compare the greens. This simple test teaches you much about color. How green the tree seems to be depends greatly on the color you see behind and next to it. This kind of observation should guide your decisions whether you use colored pencil or watercolor.

One additional way to achieve unity of color is by employing papers that possess a toned (grayed) color. The sketch of mountains by Leonardo (fig. 1.2) was done on a sheet of paper to which he had applied a reddish tone (appearing gray and murky in reproduction). Thomas Moran (fig. 1.11) favored a medium-gray surface that allowed the use of opaque white. You can purchase small pads of charcoal paper in tones if you wish to experiment with this possibility.

5
SKETCHING
ON LOCATION

Venturing out into nature to sketch is always exciting, and can also be a bit daunting. For one thing, it is easy to be too critical of the first sketches. Suddenly, you are aware of the wealth of visual detail in nature, and you feel overwhelmed by it. Relax, take one thing at a time, and you will discover a unique pleasure in seeing the world through the medium of your sketches. If you have visited the locale before, sketching will give you a new appreciation of the familiar. If you are traveling, sketching will heighten the sense of discovery and give you an intimacy, a deepening of the experience of new surroundings.

It is not at all unusual to be overwhelmed by your first attempts to sketch the outdoors, especially if you have lived all your life in urban surroundings. You might even experience a feeling of "shutting down," a sure sign that you are asking too much of yourself too soon. Start with short excursions. Your back yard or neighboring parks are excellent places. Sketch uncomplicated subjects. Sketch one tree, not the whole park. A sketch of a forest begins in drawing one tree. Much depends upon your noting what you respond to; sketch what you enjoy sketching.

Until you have actually begun to sketch a subject, it is not always possible to know if it will interest you or not. Don't hesitate to make many beginnings. Stop the moment your interest lapses. When you are inspired by what you sketch, the effort of making the sketch is no effort at all.

A TRIP NEAR HOME

A place you can revisit easily allows a more considered attitude in your sketching. Take time to explore, to just look. (This is good advice when sketching far from home, too, but there is not always enough time.) Ideally, the first occasion should be this exploration and nothing more. But few of us—including me—are content to come to the end of an outing without something more tangible. In small rectangular shapes—say 3-by-5 inches—make simplified notations of the large vistas or areas of interest (see fig. 5.1). Sketch only

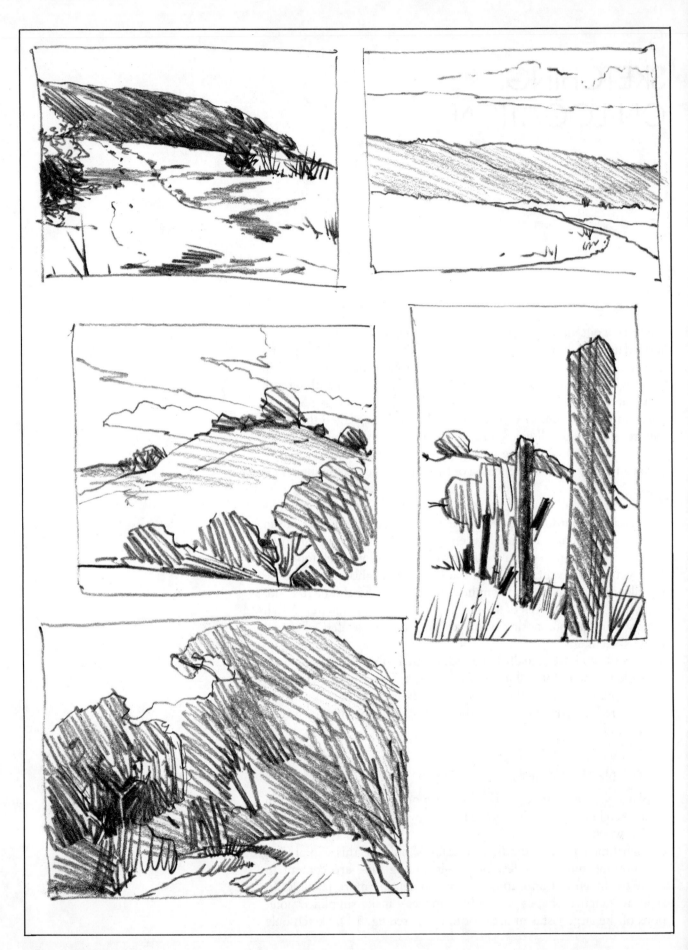

the large shapes, the simple divisions that separate sky from forest from field. This was Constable's approach (fig. 1.6). If a small plant or flower catches your eye, sit down—briefly—and make a simplified notation of it. Draw with a tool that you use easily; a pencil is a natural choice. This was my approach to sketching the cactus (see fig. 9.8).

Make yourself comfortable; you will not sketch long or attentively if your back is strained. Remember that you are in the open air, sitting or standing relatively still for a time long enough to get sunburned or suffer heatstroke or hypothermia. Suntan lotion, a hat, and adequate clothing must all be considered.

When you have returned home, sit down in a free moment and try a few brief sketches from memory. This will strengthen the mental images formed on location. "Broad and simple" is the attitude to take here (see fig. 5.2). You become aware of what truly impressed you, of what interests the place has touched within you. This is especially useful when you return from a location to which you cannot easily return.

THE RETURN VISIT

The return to a place deepens your perception of it. Different times of day, changing seasons, varying weather all introduce new facets. Taken altogether, these conditions all affect how you see a place. Knowing the harshness of winter in a region will affect how you see it in summer.

Returning, there are more likely to be definite things that excite your interest—subjects you want to draw. These may have been remembered from your first visit or have been thought about in the intervening time. Plant, hill, flower, bird, or any combination of these may have excited your curiosity. A quality of light and shadow or a character of color may be among the more intangible aspects that have intrigued you.

With a more definite purpose, more definite choices, time must now be planned. Consider the movement of the sun and how quickly the patterns of shadow can alter. Are there predictable changes in weather during the day? Does a wind usually come up in the midafternoon? Set reasonable goals for a day's time.

A SKETCHING TRIP FAR FROM HOME

Traveling into a distant region, into a new landscape, is a pleasure to savor. You ultimately return home with a treasure trove of sketches redolent of the experience. They renew the memory of being there, and may even inspire artistic endeavor. But a sketching trip of this kind can have its frustrations. There may not be enough time to sketch all that you want to sketch. It is especially difficult if you are stopping for moments here and there as you travel, not knowing what lies just ahead. This is when it is tempting to reach for a camera.

Using a Camera

Most of us pack cameras for a trip. Looking through the viewfinder, snapping the shutter, rushing to have the film developed the moment

Figure 5.1
Exploratory sketches. These were done in a matter of moments, looking at five prospects from one location on a chaparral hillside. These are helpful in becoming acquainted with a new subject. They point the way for subsequent sketches.

Figure 5.2

Memory sketches. I made these
sketches soon after a visit to the
Sierra and to Mono Lake. They fo-
cused on impressions I had formed,
and strengthened memories of places
that had stirred my interest.

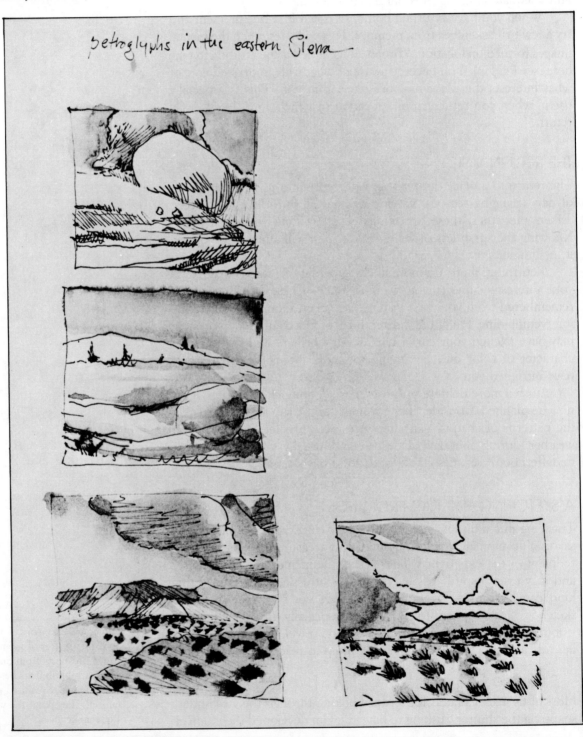

we return home are all part of capturing and preserving the experience. You are not likely to want to leave your camera at home until you have developed confidence in your sketching, and perhaps not even then. But I want you to consider some of the less-obvious differences between a snapshot and a sketch.

There is no denying that a photograph or slide records an acutely focused visual record. Within the limits of aperture, shutter speed, and the light sensitivity of the film, it records everything in front of the lens. I cannot assert that a sketch renders more information than a photograph, but a sketch does render a record of what you really looked at, what you noticed. Sketching induces you to concentrate on what you see. Even if the sketches fail to meet your expectations, you will remember far more of your experience than you would by just aiming the camera and pressing the shutter release.

I am not suggesting that there is no art to photography or that you abandon your camera. I am suggesting that you use it more thoughtfully and less often. Taking multitudes of snapshots can deflect your attention from truly seeing. (Photography is also discussed in chapter 12.)

Sketching While Traveling

If you must keep to a schedule, it is best to sketch directly and simply. As you gain experience you will find that you can return to the sketch later (perhaps at your lodgings in the evening) and add to it. Thomas Moran worked in this way (figs. 1.10 and 1.11), and his was a less-hurried journey than most of ours. His "secret" lay in his use of a contour line, drawn decisively but unhurriedly. Moran adopted this approach to achieve a clear description of form *and* to produce a sketch that evokes as much as it describes. Knowing that he could not immediately return to reexamine his subject, he did not rush; he observed carefully. (It is surprising how quickly a sketch can be executed when we do that.) Moran also made color notations on his sketch to aid him in adding watercolor touches to it at the end of the day, back at base camp. This can be seen on many of his sketches.

Read about the natural history of the places you will encounter as you travel. If you familiarize yourself with the plants, animals, or geology of a region, the dizzying parade of impressions of a first visit will be less overwhelming. A guidebook might mention local wildlife that you might look for, but simply the act of observing can bring unexpected rewards.

Try keeping a journal of a trip. Paul Kane kept a simple daybook as he explored the West (see chapter 1). It does not need to be literary, just a record of what caught your notice. It gives you a moment to reflect upon your day, and if a distinct mental image arises as you write, you might add it as a simple sketch. This gives additional meaning to the sketches of the day.

SOME BASICS OF PLANT, LANDSCAPE, AND ANIMAL FORM

A little preparation in the broad categories of subject matter will sharpen your observation. If you decide to sketch a poppy, a coyote, or a juniper on a rocky outcrop, it helps to know a little bit about the

basic forms—the elements of which your subject is composed—even if your inclination is to sketch an impression. With the subject in front of you, it can be difficult to put aside a concern for accuracy. Look at your subject before you sketch. Study it. What shapes, what forms is it composed of? How does it move (if an animal)? Does it move in the wind (if a plant)? Such questions help you to know what interest the subject holds in your eyes. You will begin to know whether you want to illustrate it accurately or create a poetic impression of it.

Field Guides

Field guides are usually based on visual keys, and are thus of considerable use in sketching. A guide asks you to notice shape, texture, size, numbers of parts, and patterns. The text (which you can consult when you return home) communicates something of the conditions of life associated with your subject. All of this gives you a better understanding of your subject, and may direct your attention to observations you would otherwise miss. Ultimately, field guides help form useful habits for the study of nature.

How much science do you need to know to sketch in nature? Do you need to be a naturalist?

If you feel intimidated by the science that has produced the field guide, take heart in the fact that for all the information the natural sciences have amassed, much remains either unknown or a matter of theory. Given time, sketching in nature will make you a thoughtful observer, a naturalist of a kind. It a result, not a prerequisite.

Trees, Shrubs, and Flowers

Plants are a component of the living landscape. Coast, meadow, forest, mountain, or desert—each is a specific community of plants and animals. Leonardo, Constable, and many others have frequently turned their attention to making studies of plants to gain insight into their form. This, in turn, becomes the basis for drawing an entire landscape. (See fig. 1.4 and then fig. 1.3.)

A plant is its roots, stem (or trunk), branches, leaves, flowers, and fruits (fig. 5.3). Flowers and fruits are reproductive parts, and do not occur in all plants in the same way. For example, some trees produce cones rather than flowers. Note the parts of a plant when you sketch it. While the branches hidden in a leafy tree or shrub may not show in your sketch, they affect the distribution of leafy masses that do show in it. The trunk has much to do with the character of a tree. Is the trunk a single tall stem, as in the California redwood tree? Or is it branched and irregular, as in the oak? Compare figures 7.6 and 8.7.

Leaves. In our first sketches out in a landscape it will not be long before we encounter the problem of sketching complex leafy plants, of sketching what seem to be ten thousand leaves. The crown of an oak, a field of grasses, needles on a pine—all seem too much to encompass in a sketch. You don't really sketch so many leaves; you learn to imply them.

The leaf of each kind of plant has a character all its own. First, draw one leaf. Notice its shape and proportion. Then draw another

Figure 5.3
Parts of a plant. When you note the pattern of the stem and branches, you in effect study the character of a plant.

NOTE THE PATTERN OF
BRANCHING IN A PLANT

BRANCHES

SEEDS

TRUNK

LEAF

LEAF

ROOTS

BRANCHES

STEM

AN ASH TREE

A COYOTE BUSH

from the same plant. Notice that while it possesses the same character as the first leaf, it varies slightly. The leaves of any one plant have qualities that unify them, but are never entirely identical. Note whether leaves grow singly from the branches, forming clusters, or in definite groupings, forming a pattern. The shape of a leaf and the way in which leaves form groups are two of the qualities that help distinguish one species from another (see fig. 5.4).

From this study of the shape of the leaf and the patterns in which they are grouped, you evolve a method to give the impression of many leaves in a sketch. Partly, you become accustomed to sketching the shape of the leaf and its clusters. You find that you can do so with a readiness that resembles doodling. You may suggest entire clusters of leaves with simplified shapes in the manner used by Constable (fig. 1.5), or with a sensitive silhouette such as Moran employed (fig. 1.10).

Leaves move with the wind. They are rarely completely still. For this reason, a gesturally sketched series of marks may be used to represent leaves. Leonardo was a very astute observer of nature. Note how he indicated the animation of leaves in figure 1.3. In an early landscape study he suggested pine trees with horizontal lines rapidly sketched across the vertical trunk.

Practicing leaf shapes can be done almost anywhere, anytime. It is a good doodling activity, always valuable in building your skill and self-confidence. When you have looked at many kinds of leaves and sketched them, try some from memory. As you do this, you are soon on your way to building a landscape vocabulary.

Wildflowers. The abundance of wildflowers in spring soon entices most of us to sketch one or another of them. A poppy is relatively uncomplicated; its forms are obvious. The lupine, on the other hand, is more complicated and tends to elude simplification in a sketch. It helps to have an understanding of the basic parts of a flower (see fig. 5.5). Zwinger (fig. 1.13) applied this understanding to

COAST LIVE OAK

MONTEREY PINE

MADRONE

Figure 5.4
Note both the shape of the leaf and how it is a part of a pattern as it grows from the branch.

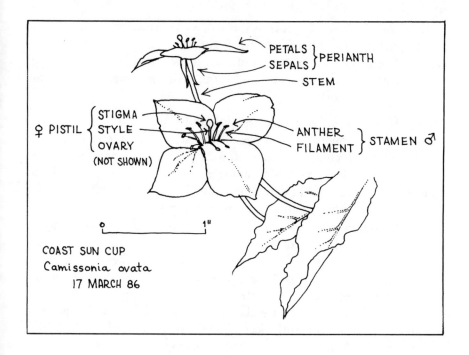

COAST SUN CUP
Camissonia ovata
17 MARCH 86

Figure 5.5
Parts of a flower. Knowing what to look for is only a key, a guide. Notice how each species of a flower varies from the pattern in the diagram.

a study of a lupine. But beware—a diagram of basic flower parts is useful only if you are aware that flower species vary enormously, and that not all flowers possess all the parts shown in the diagram. Just as leaves may form characteristic groupings, many flowers have numbers of blossoms forming what is called an *inflorescence,* a pattern of growth distinct to its species. The blossoms of a California buckeye tree form a raceme, a long stalk of inflorescence (see fig. 8.11).

Rocks, Cliffs, and Mountains

Geologic form is the core of the landscape. Traces of volcanic activity, mountains thrust upward from ancient seabeds and the torn crust of the earth along faults, are evident in the West of North America. In some places the workings of both weather and planetary forces are starkly evident. Suddenly we are impressed with how small a creature we are. The overworked phrase *monumental grandeur* regains real meaning. It can inspire you. It can transform you.

Unlike the leafy form we considered earlier, geologic form appears to be unmoving and stable, at least in the context of a sketch. But it is a mistake to consider rock, a cliff, or a mountain inanimate. Look closely. You will see unmistakable traces of the driving forces of wind and rain, heat and cold. We may not see it happening, because it occurs gradually over months, years, or centuries. However, when winter seas batter a coastside cliff of sedimentary rock, the metamorphosis can be observed in a single season.

The face of a cliff and the shape of a mountain are history written in stone. The uplift of a shoreline, the crushing and cutting action of a glacier are clearly marked—if you look.

There are three broad categories of rock: igneous, metamorphic, and sedimentary. Igneous rock emerged from the earth in a molten state and then cooled (see fig. 6.12). Metamorphic rock has been subjected to heat and pressure within the earth, cooling there. Later, forces thrust the rock upward, or the earth eroded away from it (see

fig. 9.23). Sedimentary rock is formed, as its name suggests, from the compacting of sediment (see fig. 6.10).

The physical appearance of rock is governed by two factors. It may weather to a softly rounded form, or it may fracture and break into a faceted form.

Sketching a Rocky Surface. Rounded rock has weathered or worn down slowly. The surface lacks distinct facets, and it tends to have a smooth contour. Fractured rock is faceted, having broken into fragments with the action of slippage along a fault line, or with the formation of ice within cracks gradually breaking the rock apart (see fig. 9.24). It is an irregular form with sharp edges.

Sketching rock with line alone is accomplished most easily by emphasizing planes—the top surfaces, side surfaces, and under surfaces. Note especially the lines formed where these planes meet (fig. 5.6). Distinguish between those lines that define cracks in the rock and those that indicate the meeting of two planes.

Some rock surfaces are elaborately fractured. A sketch of them can easily turn into a study occupying the better part of a day. Editing is necessary. At first glance, Moran's drawing of the canyon (fig. 1.11) appears quite detailed. Close examination, however, will reveal that he has left much to our imagination. Moran omitted many of the lines that showed only texture (the cracks), but not those that defined planes. This is not an absolute distinction. When actually facing rocky formations, it becomes, at least in part, a subjective decision. It is the act of making the decision that will develop perceptive sketching.

Whereas leafy forms are textural and airy, rock forms are

Figure 5.6

The planes of a rounded rock surface. Some edges are omitted and others emphasized to give clarity to the sketch of the rock form. This analysis is based on the sketch in figure 12.1.

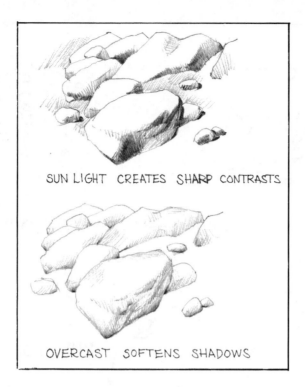

SUN LIGHT CREATES SHARP CONTRASTS

OVERCAST SOFTENS SHADOWS

Figure 5.7
Rock may serve as a good indicator
of the quality of light.

massive and solid. Sketching shadow suggests this mass. It also creates a sense of the sun's position in the sky (the time of day) and the quality of light on a particular day. A bright sun throws distinct, almost impenetrable shadows. An overcast day yields a misty light with low contrasts and form visible even in shadow (fig. 5.7). Leonardo favored this latter condition for the study of landscape forms (see fig. 1.3). He says, "The best method of practice in representing country scenes, of I should say landscapes with their trees, is to choose them so that the sun is covered by clouds; so that the landscape receives a universal [diffuse] light and not the direct light of the sun, which makes the shadows sharp and too strongly different from the lights."[1] One might not get many days of sketching, however, waiting for overcast skies.

Clouds

Clouds are the substance of weather's drama, the visible breath of a living planet. Across the dome of sky they form an ever-changing panorama of infinite variety. In 1820 in *Climate of London*, L. Howard classified cloud forms by the names we use today. Cirrus, cumulonimbus, and stratus are three among some of the basic formations (see fig. 5.8). Constable, influenced by this study, produced numerous sketches of cloud forms. In figure 1.5 the clouds hold his attention as much as the landscape below.

On a clear day after heavy rains clouds seem to materialize before your eyes. At the altitude where they form, the clouds appear to have a flat base, especially when viewed from a distance. The condensed moisture continues to billow up forming ever-new cloud as the wind carries it away.

With thoughtful observation and a little practice, adding the suggestion of cloud to a sketch is a simple matter. A broken line may be used to suggest its billowing form (see fig. 8.1). The contours of

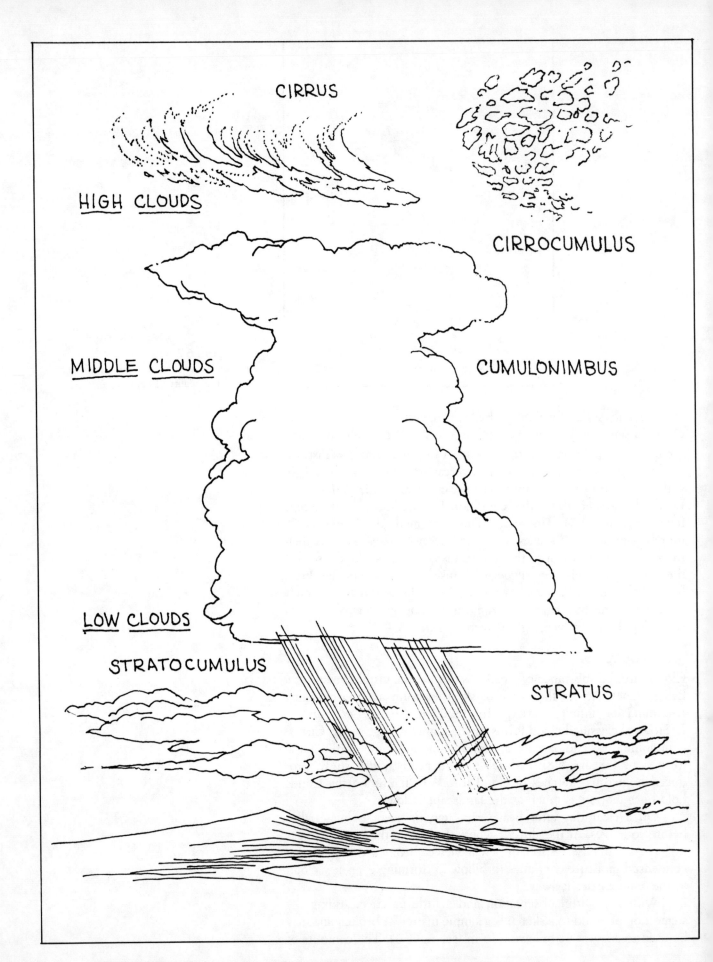

CIRRUS

CIRROCUMULUS

HIGH CLOUDS

MIDDLE CLOUDS

CUMULONIMBUS

LOW CLOUDS

STRATOCUMULUS

STRATUS

clouds alter quickly. You will be studying the silhouette of one, look down to sketch it on your page, glance back up, and be unable to locate the cloud you were sketching. It will have metamorphosed into another shape. It is best to try to capture only the character of the clouds you sketch, and not attempt too exacting a silhouette.

Keep in mind that a cloud is an ever-changing configuration of water vapor. It should not appear to be solid. A cloud's large billowing forms will appear white where they are less dense and reflect the light of the sun. In its dense or moisture-laden portions, especially as such portions face away from the sun, the forms will appear dark, sometimes leaden. However, it is always startling to realize that the darkest cloud is still paler than the landscape below. In this fact lies the secret of sketching the tones successfully (see figs. 1.5 and 5.9). No matter to what extent the sky is filled with lowering cloud, it remains the source of light in a landscape. (Render the cloud darker than the earth below and the cloud will look like the smoke of an enormous fire—see fig. 8.17.) Note, too, that clouds cast shadows.

Animals

An animal in a landscape sketch adds life and a sense of the specific moment. It may be sketched with no more than a simple suggestion of its form. You can easily find that the animal subject becomes a consuming interest, that your field trips become geared to the study of the animal in its natural surroundings.

The discovery of the beauty of birds often has precisely this effect on individuals who undertake the sketching of animals in the open. Add a field guide and a pair of binoculars and a birder is born. Few amateur naturalists are more observant than those preoccupied with bird study. Few subjects in nature have a more avid audience. Sketching birds can lead from a leisure study to a vocation. The audience is, however, a critical one. Represent a species with one feather too many and you will be informed of your error of observation. If your subject is birds, and your object is poetry, be prepared!

Birds are in evidence just about anywhere. The simplicity of their shape and the abundant opportunities for study make them an excellent subject for first animal sketches.

Mammals are another matter. Most are wary of humankind and thus are, at best, only glimpsed. You *can* travel to locations where herds of deer or elk graze. Early-morning or late-evening treks in chaparral may reward you with the sighting of a gray fox or a coyote. If mammals become your special passion, a more concerted effort and some preparation are required.

Visits to zoological gardens and to natural history museums will give you the opportunity to practice sketching animals. In urban areas and elsewhere, squirrels are frequently tame enough to provide an experience similar to that of drawing an animal in more natural surroundings—drawing an animal where observation is brief. Your pets are a good source of practice. It will come as a surprise to discover how alert your animals are to your attentions. Try to sketch and they will move around more than you thought possible. Not until they become accustomed to your activity will this cease to be a frustrating exercise.

Figure 5.8
Cloud types. These are a few of the more easily recognized types of cloud formation.

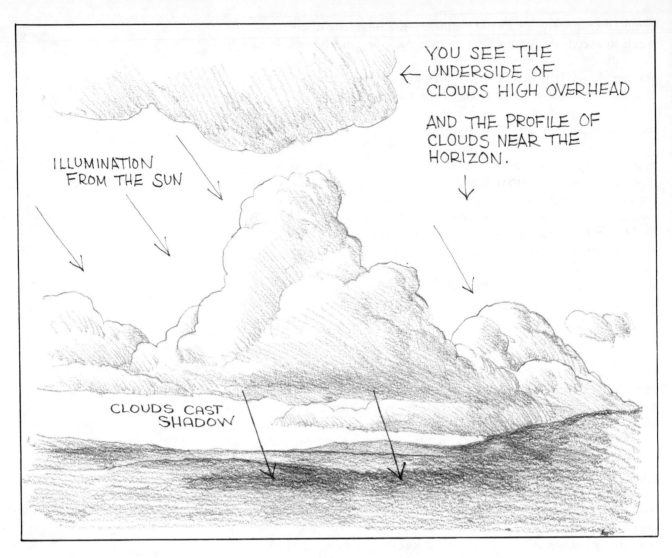

YOU SEE THE
UNDERSIDE OF
← CLOUDS HIGH OVERHEAD

AND THE PROFILE OF
CLOUDS NEAR THE
HORIZON.
↓

ILLUMINATION
FROM THE SUN

CLOUDS CAST
SHADOW

Figure 5.9
Light and shadow in cloud forms.
The position of the sun in the sky
determines which portion of a cloud
will be shaded and how shadows will
be cast. (Clouds containing much
moisture may appear uniformly gray
against other clouds that reflect the
light of the sun.)

Animal Anatomy. How much does sketching an animal depend on knowing anatomy? There is no simple answer. In fact, the question provokes controversy. You may possess a good intuitive feeling for the form of an animal and need little formal study. On the other hand, you may benefit greatly from understanding the basic structures that influence the appearance of an animal. Some people may become bogged down in a concern for technical accuracy.

Anatomy in sketching is an understanding of the location of the principal bones, the larger masses of muscle that cover them, and a sense (gained from study of the living animal) of how the joints move. It is no less than this, and no more. If it adds to your comprehension and does not confine your imagination, study it. If it inhibits your natural response to what you see, give it scant attention. The study of artistic anatomy is only a tool. (See the Bibliography.)

Sketching Techniques. Gestural sketches from live animals are a healthy first step, whether you draw domestic pets or zoo animals. Gesture is the suggestion of movement (see chapter 3), and is often all that you will need to sketch (see fig. 7.26).

Follow a series of gestural sketches with uncomplicated line drawings of the silhouette of the animal. (This step is undertaken when you are observing an animal for more than a moment.)

Eliminate texture and shading. This narrows your attention to the shapes of the body parts, their proportions and relationships. Compare the size (or the length) of the head to that of the body. Is the neck very short (as in a squirrel) or long (as in a wolf)? Compare figures 7.27 and 10.6. Where do the legs bend, and in what direction do they bend? If the first lines you sketch are wrong, erase them. Animal subjects do move, making this kind of study a bit trying. Observe, commit to memory, and then draw only as much as you really remember. At first you will remember only small portions at a time. If you find that you are erasing more than you are drawing, start all over. Attempt side, front, and rear views (fig. 5.10). In this way you come to know the animal in the round.

Analytical contour sketches of an animal are easier to do if you simplify the shape of each of the major regions of the animal. The squirrel's head in profile is a simple oval. The shape of the wolf's head in profile is more tapering, a rounded triangle. As you can see, two different species will have different shapes. Drawing manuals tend to be dogmatic in offering basic shapes as an aid to drawing. In practice, you evolve your own basic forms on the basis of personal experience. In figures 5.11 and 5.12, the basic shapes illustrated are intended only as a point of departure.

The basic shapes serve two functions. First, they help you organize what you see when the live animal is before you. Second, and more important, they aid your ability to retain an image of the animal when it moves or is gone. Basic shapes help you to form a mental concept of the animal, where the contour sketches of its silhouette provided you with the direct experience of seeing its shapes.

Texture. The final step in animal sketching is to combine a sense of the underlying structure and proportion of the animal with the suggestion of its outer qualities (its texture) and its movement.

Figure 5.10
Three basic views of an animal. Sketching an animal involves the use of memory. Knowing these three basic views is helpful.

Figure 5.11
A possible way to interpret the basic shapes of a bird. As you sketch them you will evolve your own.

Pisanello's sketches of the monkey (fig. 1.1) are good examples of this. Note especially how texture has been sketched to imply contour. A vocabulary of shorthand marks suggesting texture is a large part of sketching both birds and mammals (fig. 5.13). It is helpful to study the patterns formed by hair (or fur) as it grows. The feathers on birds form very definite patterns (fig. 5.14). It takes only a suggestion of this pattern to achieve a reasonable sketch.

Movement. As an animal moves, its shape alters. The bird unfurls its wings and moves them through a definite sequence (figs. 5.15 and 5.16). As the mammal moves its limbs and spine, its body shape alters (see fig. 7.28). Its forelimbs bend in different ways from the hind limbs (fig. 5.17). The animal will also assume a variety of positions: standing, crouched, seated, and reclining.

Ease in sketching animals is not so readily achieved as an ease in sketching landscape subjects. It will take a little more time and patience. Review the steps in sketching a gull given in chapter 6 and the steps in sketching a squirrel given in chapter 7.

Figure 5.12
Possible ways to interpret the basic shapes in both a large and small mammal.

Figure 5.13
Shorthand marks for feathers and fur. The contours of an animal are softened by its fur, the contours of a bird by its feathers.

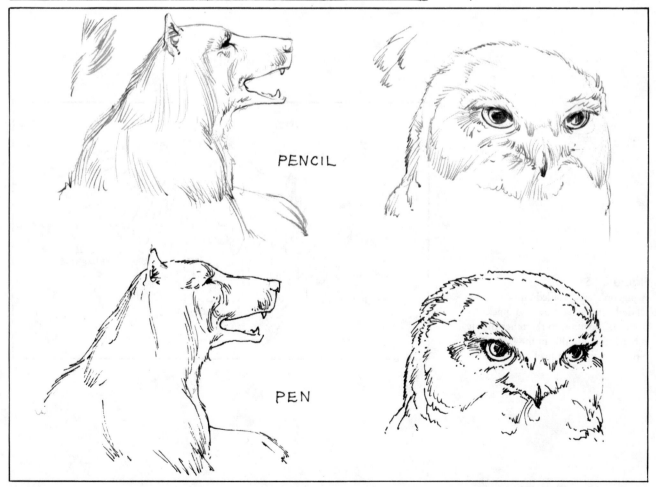

PENCIL

PEN

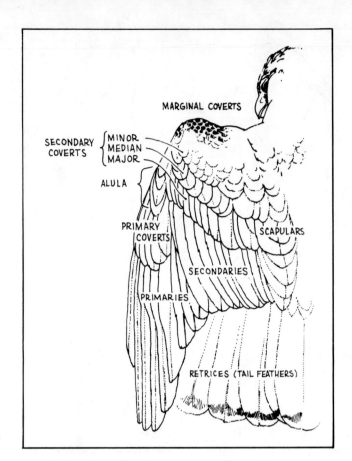

Figure 5.14
The feathers on a bird's wing fall into a definite pattern of regions. Although you may not sketch a wing in such detail, it is helpful to understand the configuration.

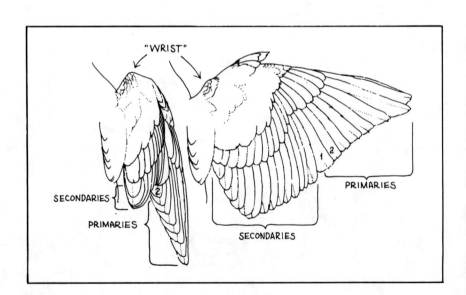

Figure 5.15
A pigeon's wing folded and extended. The wing moves so quickly from one position to the other that it is hard to study this in the living bird. This diagram may aid you.

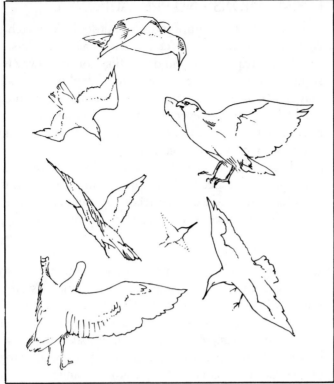

Figure 5.16
The shapes of wings during flight. These are culled from sketches I have done of live birds, using the unaided eye. I cannot guarantee accuracy as to species (and therefore have not labeled them). I can guarantee only that they were fun to do.

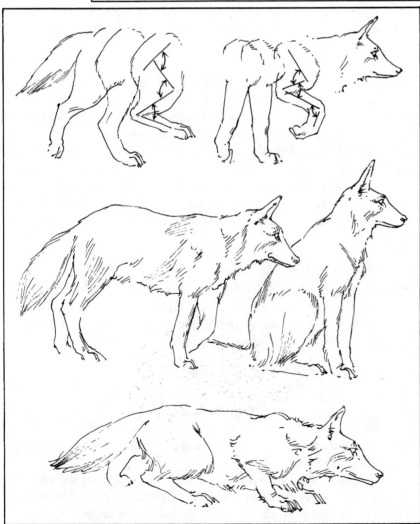

Figure 5.17
How animal limbs bend, and some basic postures. Knowledge of how the limbs bend is combined with an awareness of the firm shape of the trunk and the flexibility of the spine to sketch the animal in movement.

PREPARATIONS AND PRECAUTIONS

The success of a venture into the outdoors to sketch depends upon certain common-sense preparations. This is no less true of even a simple day trip. When you drive, bike, or hike away from urban and suburban areas, services are limited. Telephones to call for assistance may not be nearby. Conveniences you take for granted may be little available—if at all—even when your destination is not a wilderness area in any sense of the word. Sketching trips involving more than a day's journey should be carefully planned.

Each of the next chapters ends with practical suggestions concerning the specific landscape region, precautions that bear on personal safety as well as successful sketching. Take a moment to review the more general suggestions in the following paragraphs.

Weather

It is always good sense to pay particular attention to weather reports on the evening prior to a trip. Form the habit of studying clouds and noting wind direction. (On the Pacific coast during winter, a heavy cloud cover and wind out of the southwest can often indicate the likelihood of rain.) Although it is impossible to know with certainty how the weather may turn, it is important to be alert to the movement of storms or anticipated temperature changes. It is surprising how easy it is to become chilled as you sit quietly sketching in the mountains on an overcast summer day.

Clothing

Sitting to draw for any length of time, you are more affected by both sun and cool air. Cool air that normally would be tolerable can thoroughly chill. In winter, a knit cap, mittens (with the fingers removed on the drawing hand), a scarf, a warm coat, and a sweater go a long way in making the cold tolerable. Similarly, the hot summer sun is easier to take (and safer) with a broad-brimmed hat. Layers of clothing, which allow you to shed or add clothing as needed, work well. If you hike for any distance, have good comfortable footwear. Be prepared for muddy trudging through fields, meadows, and forests.

Food and Water

Extra water (hot tea in winter) and high-energy snacks are always sensible. Even brief hiking to a location can require extra nourishment. (On one occasion, having forgotten a canteen, I found myself drinking my watercolor rinse water.)

Poisonous Plants and Insects

Learn to recognize poisonous plants such as poison oak (fig. 5.18). Field guides will contain other such plants.

Insects can be a nuisance, and insect repellent will help. Bites from mosquitoes can be a health hazard; sitting to sketch near stagnant waters is risky.

The natural world has many deadly little traps for the unwary. Remain reasonably alert and you are unlikely to fall prey to them. The modern "civilized" world is full of risk; so is the natural world.

POISON OAK
Rhus diversiloba
0 ⊢———⌐ 1"

Figure 5.18
Poison oak. Contact with the oils on the leaves of this plant causes severe skin irritation, which should have medical attention. Learn to identify this plant.

Property Rights

Observe the rights of private property. If you plan to sketch in sight of an isolated residence, explain your presence. (Someone standing off by himself easily appears suspicious.) When given access to private land, show courtesy by collecting your refuse and closing any gates you pass through.

Collecting

Collecting specimens (shells, flowers, rocks, and even dead birds) is variously prohibited, and such prohibitions should be observed. I have collected rock at roadsides, and flotsam of various kinds along the coast. However, I am never completely easy in my mind when I do. Public collecting has stripped some areas and left them barren. Even as we purchase seashells we are contributing to the destruction of creatures of the sea.

Safety

In Leonardo's time an armed guard was necessary on any extended journey outside the city gates. Although this is no longer true (as it once was) in the American West, it would be foolish to underestimate how vulnerable we are when we visit a remote location. Mischance can take many forms, and a solitary venture is a considered risk. It might be better to sketch with a companion, but if you must travel into isolated areas alone, let someone know where you are going and when you expect to return.

All the preparations and precautions I have listed here could easily put a damper on your enthusiasm for sketching in nature. When you have been on location a few times, the prohibitions are far outweighed by the excitement and pleasure of the undertaking and the sense of all such preparation will be obvious.

6
SKETCHING ON
THE PACIFIC COAST

A DAY ON THE COAST

On the West Coast a continent confronts the sea. The current geological theory of plate tectonics pictures continents as floating earthen plates. The North American plate, on which the Pacific coast rests, is advancing westward. The Pacific plate, underneath the Pacific Ocean, moves northeastward. At the moment, the two plates move horizontally past each other along the San Andreas fault. In the distant past the Pacific plate moved downward (subducted) below the North American plate. Portions of the Pacific plate were scraped upward and formed what is now California, Oregon, and Washington. The result is a rugged coastline.

Coming to the end of a road that dips steeply down to the shore, my wife and I park, gather up our materials, and start off down the dunes. The sea stack just offshore is barely visible through the morning fog, and I hope it burns off, or at least thins, so watercolor studies will dry easily. I check to be sure that I have the lunch, and that we didn't leave the extra water in the car.

This is a fishing beach, swept by prevailing northwest winds, with a vigorous surf, and there are few bathers. Today is a minus tide (a periodic tide that is lower than usual), and people fishing stand in a file along the shore, smelt nets in hand, tossing them into the surf like Grecian discus throwers. We move past them toward a portion of the beach that is cut off at high tide. We long ago developed the habit of checking the tide tables before making our plans.

The waves pound at the wall of the towering sea stack that stands just offshore, the southern boundary of the isolated beach where we plan to spend our day. Between the cliffs on the north and the sea stack to the south, the beach is enclosed in a cove. Here waves are funneled into stormy proportions, often spectacular during the rising tide.

Brown pelicans, their silhouettes resembling bowling pins, stand on the rock beyond the surf. Another group glides northward, parallel to the shore; their extended wings are impressive, even at this distance. Their long bills give them a primitive appearance, bringing to mind fanciful illustrations of flying reptiles. A common tern darts

in the sky between the cliffs, making angry sounding piping noises, and then dives abruptly into the surf as a morsel catches its eye. Western and Heerman's gulls stand on the sand as though stationed behind the people fishing, masters waiting for their human servants to fetch the morning meal.

Through the constant roar of the surf, over the piping of the tern, we make out what sounds like barking. Then our eyes fall upon two harbor seals. They, too, are fishing.

I open my sketchbook, lay out my tools, and settle back into a small beach chair. I watch the tern for a while, trying to memorize its shape as it dives. I sketch a simple silhouette. No, it isn't quite right. I look again. This time I catch nuances of its shape that eluded my notice the first time. I sketch the lines of another silhouette. This time it *is* the tern that takes shape on my page. I have come a little closer to understanding its form.

The fog has begun to burn off. Out to sea I can see banks of fog hanging close to the water. Above it there is the contour of dark cumulus clouds, perhaps the forerunners of approaching winter storms. I settle back once more, take out a pen, and sketch the sea stack (fig. 6.1).

The sea has fascinated many who have tried with varying success to represent it. There is no denying that many of these representations are only clever and lack substance. But, sketching along the coast, you will discover subjects and vistas that have never become part of stereotyped imagery. If you open your sketchbook with the desire to see the world afresh, your images are more likely to be original, one of a kind.

SKETCHING SEA AND SKY

At the coast you have a clear view of the horizon, where the sea meets the sky. A vast panorama of cloud might move toward shore or pass

Figure 6.1
A sea stack, technical pen. Examples of my sketches are on 8½″ x 11″ index paper, or—as here—on the pages of a 7″ x 8″ sketchbook. In this instance I used the two facing pages, yielding a 7″ x 16″ format. Exceptions to these sizes are noted.

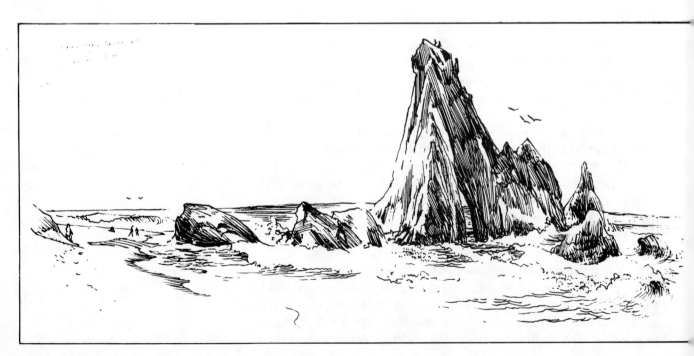

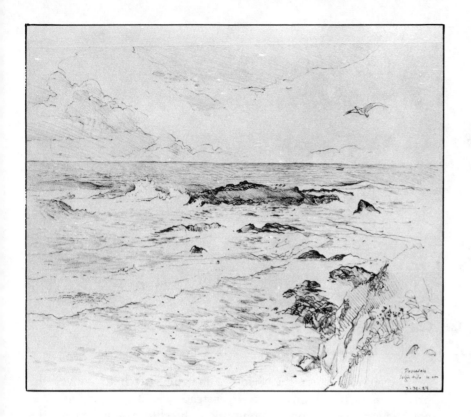

Figure 6.2
A sea view at high tide, pencil. Most of my pencil sketching is done with a B or 2B micro-point pencil. In an exception to my use of index paper, this sketch is on typing paper.

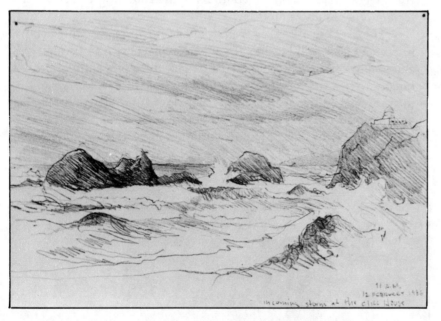

Figure 6.3
An approaching winter storm, pencil, 3″ x 5″. Unexpectedly, I found myself near San Francisco's Cliff House as what turned into a devastating winter storm made landfall. My wife loaned me her small Constable-size sketchbook for this quick sketch.

down the coast (see fig. 6.2). Low clouds of coastal fog, or towering majestic clouds that pour winter rains, each present their distinct mood above the surface of the sea. Winds may come out of the western horizon carrying the approach of a powerful storm (fig. 6.3).

Each season in this region has a characteristic sky. In spring the broken clouds cast quilted shadows and animated patterns along the shore. The intense light of midday summer sun brings the coastal cliffs into sharp relief. Floating masses of morning fog make apparitions of the cliffs and pass like phantoms across the waves. In fall, overcast flattens the landscape with diffused light (see fig. 6.4).

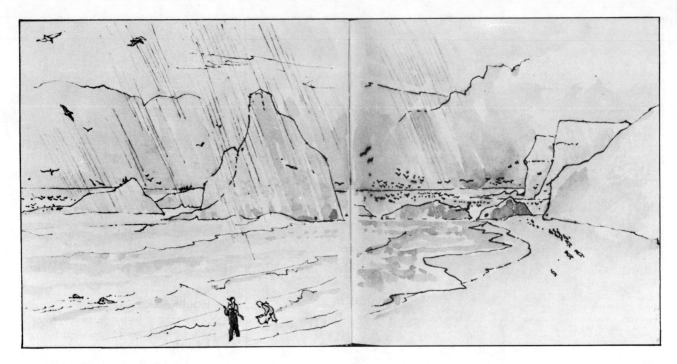

Figure 6.4

Rain, birds, and fish at Martin's Beach, August 30, 1984. This was a special day. The anchovies were running, and literally thousands of birds were feeding on them. The rain was unexpected, causing us to dash for cover. In this sketch I used a porous-point pen, and touches of muted blues and earth tones were added in watercolor.

Give contrast to the shadows in your sketch to convey the brightness of the summer sun. If, instead, you sketch pale grays as you suggest shadows on the contours of the cliffs, you will create the feeling of a cloudy winter day.

The expanse of the sea is an irregular mirror of everything above it. Sometimes it will be smooth, almost still. There may be no wind, and you will hear only the quiet lapping of the waves at the shore. At times like this the sea reflects the deeper blue of the sky above. But the sea may be broken and choppy, with gusts of wind, spray hanging in the air above cresting waves, a crashing chaos of water (see fig. 6.5). At such times it presents a glittering pattern of interwoven contrasts, islands of light and shadow meandering through the tumult.

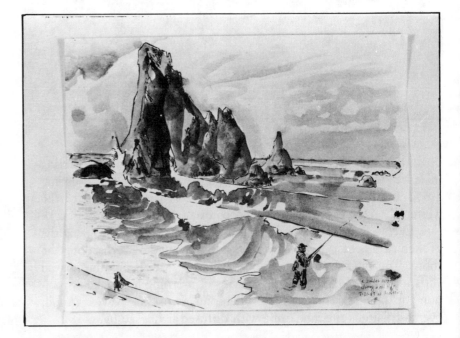

Figure 6.5

A surge of waves during ebb tide, brush pen and watercolor. When I use the brush-pen or a porous-point (fiber-tip) pen, I don't use penciled guidelines, as I might if I were doing a careful drawing. I favor the directness of this approach even though I may find myself making a number of attempts to achieve a useful sketch.

Depicting the Motion of Water

With its rolling, churning movement, the sea is one of the more difficult of natural forms to sketch. I never tire of trying it. Look at its surface, quite apart from the forms of the waves. It is a rippled surface, with facets reflecting the light of the sky, and other facets transmitting the shadows of the depths. Sketch this variegated surface attentively and the image of the water will convey movement. In my sketch of the water's surface (fig. 3.2) I used a .5 mm micro-point pencil with a B lead. I spent twenty minutes looking carefully at the surface of the water, trying to remember the pattern of the ripple shapes when I looked away to sketch.

The breaking sea wave is among the most common—and hackneyed—of water subjects. But if you sit and study the surf for a time, and observe the varying patterns of the waves, the outworn portrayals fade from mind. Watch the changing wave action for any period of time. You will soon see that winds, storms far out to sea or near shore, the rising and falling of the tide, the position of the sun and moon all affect the height, shape, and frequency of the waves. Some gather great momentum, crest at considerable height, and collapse into an explosion of foam; others seem to fade away before reaching shore. Waves are the pulse of the sea.

If you stand and look directly out to sea, you can sketch the crest of an approaching wave as a more or less horizontal line. The water as it foams and falls from this crest forms an undulating curve. As you sketch the bouncy quality of this curve, realize that it conveys movement as well as foam. As you begin to turn, looking along the coast, the crest of advancing waves may resemble a curving diagonal (see fig. 6.5).

The wave approaches, crests, breaks, rushes the shore, and slides back. Usually, all of these things are happening at once. Dying waves slide down the slope of the beach, frothing, sudsing, and bubbling as they meet newly advancing waves (fig. 6.6). This sketch was done

Figure 6.6
Surf study, technical pen. Fog lingered near the shore, blurring the boundary of sea and sky. A rocky point that at low tide reveals a world of tide pools causes a crisscross of waves at high tide.

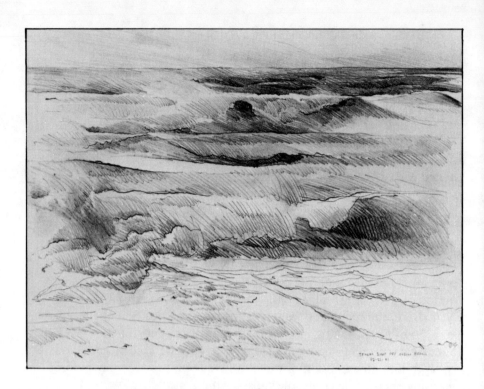

Figure 6.7
Surf study, pencil. Here I sketched
with an ordinary nonmechanical
pencil.

with a technical pen. I looked at the patterns formed by the rippling surface of a windy sea to suggest the turmoil of the surf. The curl of the breaking wave is shown with curved lines, rapidly drawn in sequences of five or six lines. The cascading foam is a series of billowing contours in broken line. To suggest fog and mist, I sketched the waves at the horizon with dots. Such a sketch could also have been done with a ballpoint pen.

Surf can also be sketched with pencil, using tones (fig. 6.7). Here I looked out upon a winter sea during an approaching storm. The afternoon light was gloomy, diffuse in the overcast sky. I avoided blatant whites and strong contrasts. The pencil strokes were deliberately wielded in a diagonal manner to suggest onrushing movement (and remember that I am left-handed).

COASTAL CLIFFS AND ROCKS
Sea Stacks

Large portions of the Pacific coast are composed of sedimentary rock, formed—as the name suggests—of compressed sediment. It is soft. Some of it you can crumble in your hand. It is no surprise that pounding seas will reshape such a coast, winter by winter. Portions of this sedimentary rock are denser, erode less quickly, and become isolated as the softer adjacent rock is worn away. Left towering in the surf where the softer coastline has been eaten away, these portions are called *stacks* (see fig. 6.4). Sometimes arches are produced in this way (fig. 6.8). The arch will eventually fall or be worn away, and another stack will be born.

Eugene Delacroix sketched along the west coast of France at a place called Etretat. The coastal cliffs and rocks are quite similar to those in figure 6.8. Delacroix communicates a keen response to his rugged coast, a response that inspired the efforts I have made along the Pacific coast.

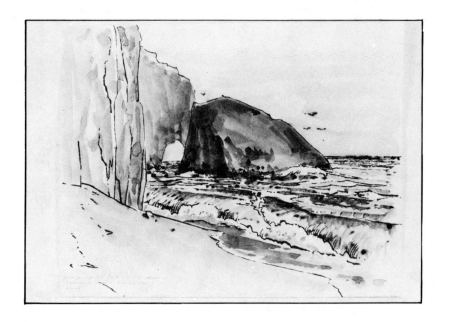

Figure 6.8
A sea arch, brush pen and water color. This was the fourth time in five years that I sketched this area of the cliffs. I never fail to think of Delacroix when I see it.

Cliffs and Sea Caves

Cliffs of sedimentary rock possess a scaling surface, the encrusted layers falling away to collect at the base. In some places it almost appears as though the cliff is slowly melting (fig. 6.9). Encapsulated in fragments that fall away from the cliffs are fossil shells (fig. 6.10) that give evidence of the gradual uprising of the coast from the sea. (Such fossils are found high in mountain strata, and this fascinated Leonardo: "Make a drawing to show where the shells are at Monte Mario."[1])

The power of the tide to sculpt rock can be intensified by the channels in the marine terraces below the surface of the water. Such a force may carve sea caves in the cliffs (fig. 6.11). The relentlessly surging crosscurrent of waves breaking at the mouth of the large dual caves brings on a rising tide in one's own pulse.

A Shore of Lava Rock

The Pacific coast is not altogether formed of sedimentary rock. Less-mutable metamorphic and igneous rock is present here as well. Lava flows reached toward primeval seas and hardened into curious mirrors of the sea waves that now pound upon them. These shapes can make an interesting sketch (fig. 6.12).

Sketching Cliffs and Rocks

In figure 6.9 the patterns of light and shadow played an important part in guiding the sketch. Where shadow occurred, I placed line or hatching. A strong raking sunlight brings out the texture of the surface of a sea stack or a cliff. When you have visited a locale several times, you will become attuned to the times when the light plays beautifully on the surface of the cliff. You will work quickly, for the patterns are fleeting—steadily metamorphosing as the sun moves across the heavens.

Figure 6.9
A shell-encrusted sea cliff, detail of a 7″ x 16″ sketch, technical pen. Of sedimentary rock, the weathering cliff face sometimes appears to be melting away as curious afternoon shadows cross its surface.

fossil bivalve
in sedimentary rock, broken away from
cliff face Martin's cove
August 1985

Figure 6.10
Fossil shell study, 7″ x 6½″, pencil. The fossil shell forms a dome atop this fragment from the cliff in figure 6.9.

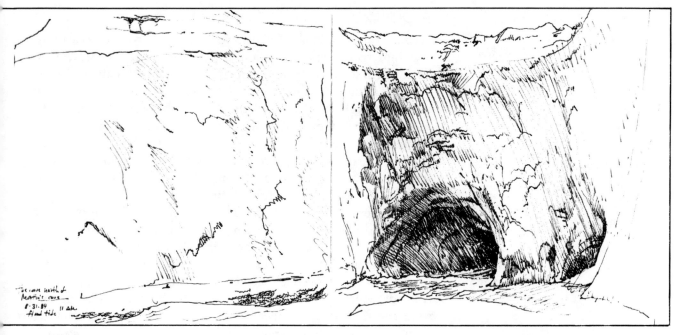

The cave north of
Martin's cove
8·31·84 11 AM
flood tide

Figure 6.11
Sea cave, porous-point pen. The
mouth of the larger cave is twelve to
fourteen feet high. Standing near its
entrance in the shadow of the cliffs
that surround it, with a maelstrom of
surf rushing into the channel, there
comes upon you an ominous aware-
ness of raw nature. The human scale
of our civilized world falls away, and
you feel vulnerable and somehow
transformed.

Figure 6.12
Lava rock on the shore, technical
pen. Most rock is old beyond reckon-
ing by the standards of a human life-
time. But, studying the frozen fluid
forms of this lava, it indeed seemed a
primeval fossil.

SHOREBIRDS

Several years ago, in late August, we went to the coast on one of our sketching trips. Our destination, invisible from the highway, was a quiet beach at the foot of an enclosing wall of high cliffs (the place depicted in fig. 6.4). The day was overcast and seemed to threaten an early rain, well in advance of the usual rainy season. There was a sultry feeling in the air. As I sat by the edge of a cove and prepared to draw, I noticed what seemed to be thousands of birds flying very near the ocean's surface, several hundred yards offshore. Out of the south they came, flying in a bustling file, teeming into a circle just outside the cove. Peering through binoculars, I could not make out what species the birds might be. Their size suggested terns or willets. It occurred to me that massive bird migrations must look like this. Gulls, pelicans, terns, and grebes were all wheeling in the air. The sketch only hints at the profusion of birds that filled the sky that day.

We later discovered that our sketching trip had happened to coincide with an unusually large run of anchovies. The shorebirds were eagerly following them in an ecstasy of unexpected feasting. (Maybe I'm anthropomorphizing a little, but that's how it seemed.) Local residents, who have lived on the beach for fifty years or more, said they had never seen a similar concentration of shorebirds, and evening found the beach carpeted with them.

The variety of shorebirds is a visual feast. There are a great variety of body forms, bill shapes, and feather patterns. Cormorants, herons, ducks, sandpipers, and many others are in abundance. Lest my enthusiasm be misleading, I should also say that many species avoid parts of the coast that are heavily used for human recreation and that the abundance is seasonal, with the migrations of spring and fall bringing greater numbers of species along the shores. (Contact your local Audubon Society for information on good sighting areas.)

Perhaps one of the most accessible birds for your first studies of shorebirds is the gull. It is large and easily observed, and you can get quite close, eliminating a need for binoculars. There are few markings to obscure the feather patterns, and they frequently lift and unfold their wings, offering an excellent opportunity to study the changing shapes of the moving wing. You could hardly have a better subject! Hawks or ducks might have more appeal to your tastes, but they are much harder to observe. Gulls are ideal for our purposes, and you may come to be as fond of drawing them as I am.

For any first sketch, always become acquainted with your subject. Study its behavior. Observe its movements, its various postures. Then begin with quick gesture studies, sketching the gull from a variety of viewpoints; side views are easiest. The bird is a good subject with which to begin sketching animals, as its shape is simple, (see fig. 6.13). Of course, you have to look away from the bird to form the sketch. This involves a certain amount of memory. You may wish to review chapter 5, where I urge the use of simplified basic shapes to aid memory. In the excellent *The Art of Field Sketching,* Clare Walker Leslie quotes the wildlife artist Eric Ennion: "If you have a choice between sketching and watching, watch and jot down what you remember later on after the animal has gone and you have gathered an assortment of accumulated memory images."[2] This

Figure 6.13
Gull gestures, culled from various pages I have accumulated. Many pleasant hours can be spent in such observation. On a typical page I get many sketches that are unreadable, misfired attempts to see a moving subject.

seems awkward at first. It is a critical skill in wildlife sketching, and requires practice.

A more painstaking sketch of a bird involves looking carefully at the parts, noting how they relate to each other, how the bird stands, and how it moves. The following steps represent a logical approach to making a study of a bird—in this instance a gull—or any animal, for that matter. But sketching is not always done logically. Sometimes there isn't time to do so. Sometimes you will not wish to make a sketch of the entire bird. The steps given here are intended only as a guide. I don't always follow them myself.

1. The body of the bird is the largest of its shapes, and I usually begin with it. Always note the axis of this shape, as it indicates the posture and balance of the bird. Just as you change your balance slightly as you stand for a time, a bird does also. The body shape is essentially an ovoid (see fig. 6.14). The shape is aerodynamic. (As the demands of moving through the medium of water resemble those of moving through air, sea creatures share this trait.) It can be a little disconcerting to look up from a sketch you have begun of a bird and observe a rounder or thinner bird than you had begun to sketch. The bird can actually alter the quality of its shape as it fluffs or flattens its feathers to regulate body temperature. When you sketch the bird's body shape, note the length of its legs (how far it holds its body above the ground) and leave space to sketch them in as the drawing evolves.

2. Next, compare the size of the head and neck to the body. I note shape. You may find it easier to sketch the neck as one shape and the head and bill as another. Here also, the bird can amazingly

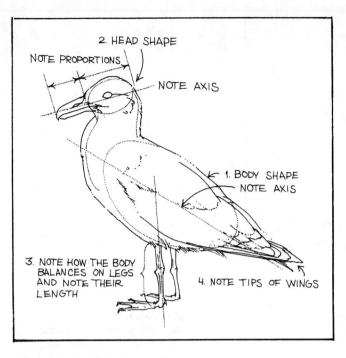

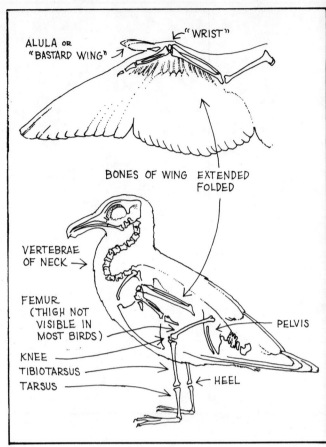

Figure 6.14
Steps in sketching the study of the gull in figure 6.16. Delacroix observed in his *Journal* that Leonardo used oval shapes to sketch animals. Nowhere are they more appropriate than in sketching birds. Sketch the shapes lightly, using the gestural line described in chapter 3. Then add refinement and detail with darker contour lines.

Figure 6.15
The relationship of the skeleton to the contours. The hatchet shape at the chest is the sternum, or breast-bone, well developed in birds that rely on extended flight.

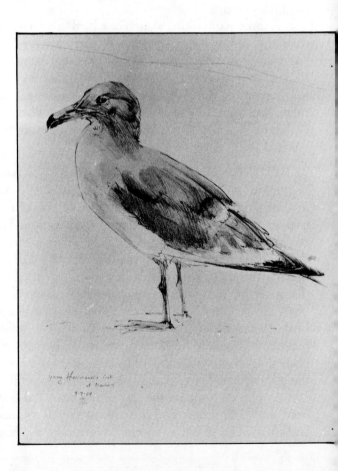

Figure 6.16
Heerman's gull, pencil and watercolor. The plumage in gulls is less distinct than in the hawk that served as the basis for the illustration in figure 5.14.

alter its configuration, periodically lengthening or shortening its neck. As shown in figure 6.15, there are more bone segments (vertebrae) supporting a bird's neck than there are in the neck of a mammal. This adds flexibility and variability. Individual gulls will vary the length of their neck depending on their rank in the pecking order at a particular moment. Other behavioral factors influence this also.

The gull's head, like its body, is an ovoid shape. Here too, it is important to note the long axis. Does it incline? Is it horizontal? If you are sketching a profile of the head, compare the length of the bill to the width across the head shape. Note the size and position of the eye. A line can sometimes be discerned just behind the eye, defining the upper limits of the auricular feathers—looking a bit like a cheek. Note the distance from the gape (the corner where the upper bill joins the lower) to the eye—an important reference in sketching the face of the bird.

The gull's bill has a saberlike shape. Depending on the species, there are colorations or markings near the tip. Note the line formed by the meeting of the upper and lower bill. Also, observe the relationship of the forehead and chin. Does the forehead seem to protrude outward over the bill, and if so, how much?

3. Carefully note where the legs seem to emerge from the body. This is more problematic than it sounds, and a slightly askew placement can make a sketch look comical. (My first sketch of a gull looked more like a duck.) Here, as in the neck, it helps to understand the skeleton (see fig 6.15). In most bird species the thigh portion of the leg is hidden within the plumage of the body. (It helps to remember that most animals stand with the leg bent at the knee.) The true knee area is at the side of the bird's body—unseen. The part of the leg we see emerging from the body can be compared to a human calf. The slightly swollen shape that looks like a knee turned in the wrong direction is the bird's equivalent of our heel. Extending to the ground from this heel is the tarsus, roughly equivalent to the arch of the human foot. However, unlike us, most animals do not apply this—the metatarsal aspect of the foot—to the ground. They stand on their toes.

The "foot" in the gull is a splaying of three toes with intervals of webbing, common to water-living birds. A vestige of another toe faces backward, slightly higher on the tarsus. At that, the gull does not rest squarely on its webbed feet. It lifts slightly, as though in contemplation of walking on tiptoe.

4. Finally, sketch the shape of the wing and (if you can see them) the tail feathers. The first four or five of the flight feathers called the primaries (see fig. 5.14) form the hindmost tip of the folded wing. This tip often crosses the tip of the opposite wing. Sometimes these overlapped tips of the outer primaries will obscure the tail feathers.

The contour feathers of the breast may hide the foremost portion of the folded wing. The gull has "tucked" in its wings—a sure sign that it is relaxed. As it readies for flight—or becomes apprehensive—the wings will be clearly visible as distinct shapes against the sides of the body. On many species of gulls the secondaries blend imperceptibly with the coverts. In other species of bird these may be discernible patterns in the wing of the bird (see fig. 7.23).

It will sometimes happen that you begin a sketch, and before you finish the gull has flown away. Another gull alights and assumes a similar posture, and you can resume your sketch. Nothing wrong in that—I have often done it. But it is important to realize that all living things are individuals. Never is one gull entirely identical to another. At first they might look very alike. But as you get to know them in your sketches you quickly discover individual differences. You begin to really see them.

Sketching a Bird in Flight

This demands concentrated observation. When you first study the wings in motion they will seem no more than a blur. Larger birds like the gull and the pelican are good subjects to watch. They not only have larger wing forms, they periodically use slow flapping flight. Study the various positions of the wing in flight shown in figure 5.15. With even a cursory knowledge of the changing shapes of the wing in flight, you will be on your way to comprehending the blurred form of the moving wing in the living bird.

The gliding bird is enthralling. The outstretched wing bespeaks the soaring spirit in us all. The wing is the arm and hand of the bird. Note the skeleton of the wing in figure 6.15, particularly the location of the carpus, equivalent to a human wrist. In the gull this forms the slight bend roughly halfway along the leading edge of the unfurled wing. Splayed outward like fingers, forming the outer half of the wing, are ten or eleven long flight feathers, the primaries. The inner half of the wing is a series of flight feathers called secondaries. The roots of the flight feathers are covered (on both upper and lower surfaces of the wing) by rows of smaller feathers, the coverts. There may be two or three rows, depending on the portion of the wing (see figs. 5.14 and 6.17).

Exploring the Variety of Birds

As you become familiar with the gull, attempt other species. By now you will know whether or not your interest justifies investing in optical equipment (see chapter 2). The birds sketched in figure 6.18 were observed using a 25X telescope. It was a cold November day, and hundreds of black-necked stilts were feeding along the shore of San Francisco Bay. As we would near a group, they would take to the air and alight farther along. Their wariness made the use of the scope essential. Peering through it, I also espied a lone sandpiper wandering among them—virtually invisible to the unaided eye.

Sketching while holding binoculars or peering through a telescope takes some getting use to. A tripod is needed for the scope, and it helps free your hands when sketching with binoculars. Field guides are important aids that help you to understand what you see. Excellent introductions to the birds of the West are found in Fred A. Ryser Jr.'s *Birds of the Great Basin* and Kevin J. Zimmer's *Western Bird Watcher*. (See the Bibliography.)

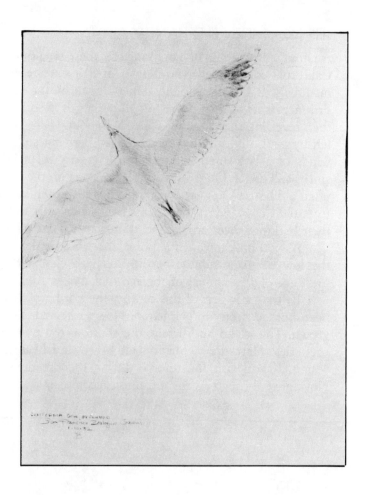

Figure 6.17
Gull gliding, pencil. Virtually resting upon updrafts along the shoreline, this gull posed overhead for a time, a white bird against a bright sky.

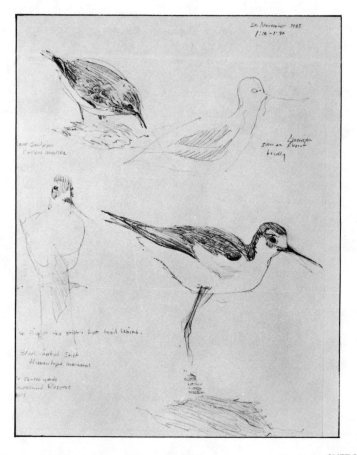

Figure 6.18
Shorebirds in an estuary, pencil and colored pencil. If you look closely, you can see a silhouette of the stilt in flight, just below the sketch on the lower left. The other bird, the avocet was there and gone before I could make more than the barest notation.

THE NORTHERN ELEPHANT SEAL

An hour's drive south of San Francisco, there is a point of land on the California coast called Año Nuevo. It is a state reserve for marine mammals. It is unique. Sand dunes driven by the prevailing winds drift across its open expanse, migrating north to south, covering and then revealing shell mounds. The shell mounds are kitchen middens left by the California Indians who lived here not so long ago. In the winds of a late summer afternoon, it is easy to imagine that their spirits still linger. On Año Nuevo Island, just off the point, is the ruin of an old house—appearing as though transported in space and time from old Cape Cod. Its occupants are harbor seals and sea lions, and their barking voices are carried shoreward by the wind.

As you hike toward the point, the wind carries another sound, the low resonant rumble of the northern elephant seal. It is the presence of this animal of the sea that makes Año Nuevo unique.

By the early part of this century the northern elephant seal had been hunted nearly to extinction. Now protected, its numbers have grown. The island and, lately, the shore at the point have become rookeries. Here the elephant seals breed and bear and raise their young. If you visit the reserve during the breeding season, from November through April, you must accompany a group conducted

Figure 6.19
Molting elephant seals on the beach at Año Nuevo Point, brush pen and watercolor.

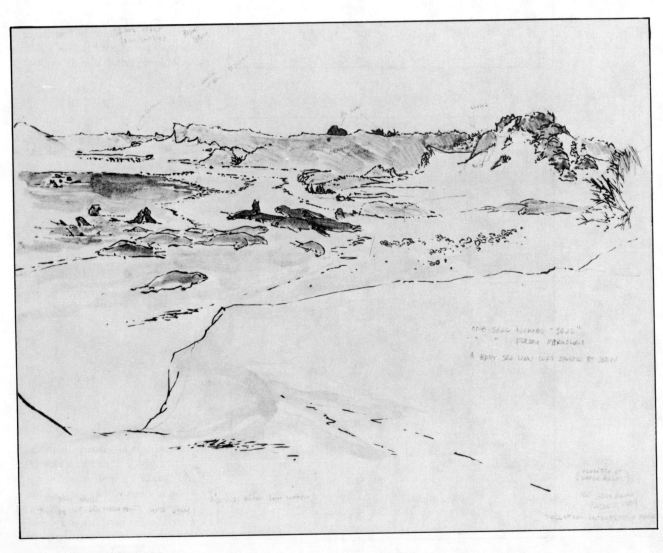

by a guide or lecturer. Human proximity and observation are strictly controlled at this time. (If you plan to visit the reserve you should call ahead.)

During the summer you can hike along trails in the reserve without an official guide, and this is when we have made frequent visits to sketch the bulls (the male elephant seals) that linger, molting in the hot sun (fig. 6.19). In recent summers pods of twenty to thirty bulls have been on the beach at any one time.

The elephant seal is a marine mammal, the largest of the pinnipeds (an order that includes the harbor seal), having a length of twenty feet. Rearing in challenge to another bull, the seal can lift his head seven feet above the ground. In summer these are usually mock challenges, but even so, you are well advised to keep your distance. In spite of their large size and apparent awkwardness upon land, they can move quickly.

Most of my sketches of the elephant seal began as pencil line drawings focusing on the shape that would suggest the posture the animal had assumed. Several sketches or studies would be done on a single page. Gestures, poses, and attitudes were all constantly reoccurring, and if one subject moved before I completed an observation, I had only to wait a short time before another would do much the same thing. (See fig. 6.20, and also figs. 12.6 and 12.7.) I was fascinated by the handlike qualities of the front flippers (see fig. 12.7). In many of the sketches I added descriptive elements with touches of watercolor.

I decided to add watercolor to the sketch in figure 6.20. I began with small puddles of color, mixed in a small portable watercolor box (see chapter 2) and applied with a No. 6 round brush of synthetic hair. The brush doesn't hold much fluid at a time, and can be applied only to small areas. Although this is not truly a dry-brush technique, it is similar. The paper I used was index paper, which accepts small

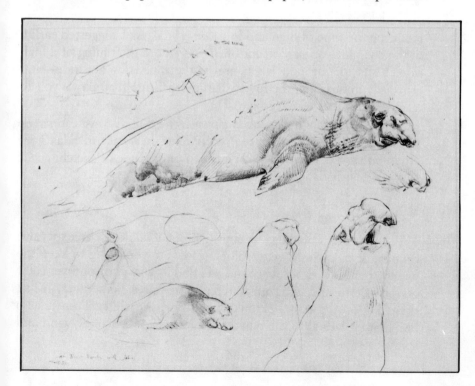

Figure 6.20
Studies of the northern elephant seal, pencil and watercolor. Despite its illusory clumsiness on land, the elephant seal has a commanding presence. This was sketched the same afternoon as figure 6.19.

areas of watercolor without undue buckling and acts much as does watercolor paper in the speed with which the color dries. I have found this method excellent for quick color notation.

To achieve the color of the molting pelts I mixed burnt umber with cobalt blue. It was a simple mixture, accurate, and quickly arrived at. In a watercolor painting this mixture would tend to seem dull, and I would use glazes of richer color.

PREPARING FOR A DAY AT THE COAST

Fog, the high cirrus clouds, mist, and the rain-laden cumulus clouds move about, changing the condition of the sky with the sleight of hand of the magician. You can sit down to draw on a coastal marsh, quietly noting the muted color of one hillside against another, or to sketch birds for an hour that seems like a minute. Then you gaze up into the sky and realize that the entire character of the day has changed.

It is impossible to anticipate what the weather will do during a day's sketching. The conditions on the coast can vary greatly from those just a few miles inland. Cool winds can arise in the afternoon, and a jacket makes good sense even if it seems warm and still when you leave home.

In foggy overcast you should provide yourself with suntan lotion, just as you would in bright sun. A rating of 10 to 15 is best. Although the fog may hide the sun from your eyes, it magnifies it and focuses it on your skin. Severe burns can result. I once made the mistake of baring my shins while sitting on the sand sketching a coastal cliff. Time passed quickly. Before I knew it, my ankles had become so badly burned that I couldn't walk for a week.

Tides

Knowing the time of high and low tide is vital. As I suggested earlier in the chapter, you can be cut off if you ignore the timing of a high tide. Visits to tide pool areas are best planned for low tide—and especially minus tide, the lower-than-normal tide that allows you to observe intertidal life (see fig. 6.21).

The sea, while beautiful, is also treacherous. A wave can sweep you off a rock, even when the sea is calm. It is easy to relax your attention as you sit perched on a rock in a solitude of sketching. Be aware that it is dangerous.

Sand and Wind

The sand is often blowing—a consideration if you carry an expensive camera, or plan to do watercolors. (How are you going to keep the paper from blowing away?) Sand will find its way into your wet color on the palette, and into your watercolor mixtures. Sometimes, as I sit sketching on the coast, I think of the English painter Turner, who had himself lashed to the bow of a ship to experience the wind and spray.

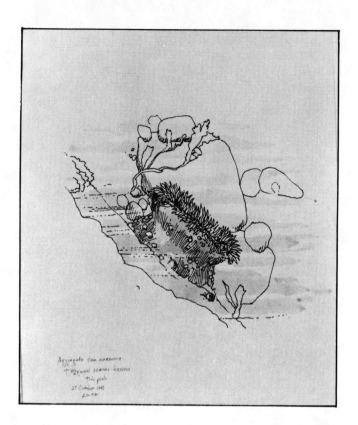

Figure 6.21
A sea anemone in a tide pool, technical pen and watercolor. See also figure 10.13.

Insects

Bright clothing, the bright colors on your palette, and the food you brought to sustain you can all attract bees. While beachcombing you can simply walk away, but when you are sketching, their attentions can be annoying. Usually I brave it out. However, there have been times when bees have successfully routed me from a chosen spot.

7
IN THE REDWOODS

All along the coast you see a landscape shaped by fog and high winds blowing landward from the sea. This is clearly evident in the twisted form of the Monterey cypress. The coastal fog belt of northern California and southern Oregon gives rise to forests of California redwood, trees that stand taller than any others in the world. Fog nurtures them, and is partly responsible for their very existence. In past ages, when the dampness of this climate extended eastward to the Atlantic, redwood forests grew across the entire continent. The present forests stand as survivors of another world. Enter the redwoods and you are transported to the dawn of the first trees.

The coastal redwood, *Sequoia sempervirens,* grows to heights of three hundred feet. The dampness of its understory is made green by moss and ferns. Streams fill the quiet air with a percolating sound, and birdsong echoes in the branches. Winds gently sway the tall trees and they creak eerily. Gray squirrels, brush rabbits, and short-tailed weasels rustle the undergrowth, and there are moments of their frantic squealing. Occasionally one of them will dart across the trail. A deer or a bear may be seen for a moment and then is gone. There is greenness, permeating dampness, a mote-filled half-light, and solitude.

The redwoods enchanted me from the first. In part, I was inspired by John Muir's words in praise of another California giant, the sequoia. As we drove toward a redwood forest near Mendocino, my wife read Muir aloud:

> The Sequoias are the most venerable-looking of all Sierra giants, standing erect and true, in poise so perfect it is invisible. Trees weighing one thousand tons are yet to all appearance imponderable as clouds, as the light which clothes them, so fine is their beauty. . . . They are antediluvian monuments, through which we gaze in contemplation as through windows into the deeps of primeval time.[1]

Fully taken with Muir's fine words, I began sketching the moment I set foot on a trail. Perhaps I first should have explored this environment, so new to me. It is often best to explore, to soak up the feeling of a place, before sitting down to sketch. Allow time for your impressions to take shape.

A FIRST VISIT TO THE REDWOODS

I have already given a brief description of the redwood forest, but what might your first impressions be?

Entering a redwood grove from coastside, you might see a stream and its outlet. Its fertile alluvium may support a stand of red alders. You soon notice that not redwoods but Douglas firs dominate the coastal slopes, the redwoods gaining dominance only as you proceed inland. Sword ferns seem to be everywhere, cascading down all the slopes in a stunning array. The stream winds back and forth across the progress of the trail, exposing shadowy corners with lichen-draped hardwood trees, dampness and decay interwoven with the flowing symbol of life that a stream suggests. Shoulder-high thickets of vine maple and berry bushes line its banks.

Soon the redwoods form a roof over the trail and you enter the forest. Undergrowth thins, it grows dark, and shadows fall between pillarlike trunks. Burned-out stumps rise like specters. In some, the charred walls enclose a space the size of a large room. It is hard to imagine the height of the giant that towered here. The trees that surround you are second growth. Enormous truncated stumps hint at the magnificence of the forest that stood before the loggers came.

Leaving the floor of the forest, the trail ascends a slope. There are fewer trees, and you may see rhododendrons. In spring their violet blossoms make a striking contrast to the airy green of redwood and fir needles. The haunting half-light and quiet solitude of the forest are in marked contrast to the mood of the seacoast you left only moments ago.

Above all else, the tall trees hold your attention.

A Sketch of a Redwood

A seventeenth-century manual of Chinese landscape art, *The Mustard Seed Garden Manual of Painting,* says, "To paint landscape, one should first know how to draw trees. To draw trees, one should be able first to draw the trunk and main branches, then to dot the foliage, and eventually to depict a luxuriant forest."[2] This may seem an unusual source for ideas on method, but it is to the point and useful.

Let us first look at the bark of a redwood. Get close. The bark has a definite texture of furrows and scaly ridges. The ridges tend to be vertical, following the trunk upward. Or they may trend in the direction of a spiral (sometimes on the same tree; see fig. 7.1). Either line or tone may convey texture (see fig. 7.2). The dark tones of the redwoods prompted me to use charcoal pencil. As in the cliffs we looked at in chapter 6, the shapes of shadow on the trunk's surface suggest where to draw line or tone.

Now sit a little distance from the tree, far enough so that you can see much of the trunk without having to look up sharply. An unusual form that occurs on many redwoods is the bole, or burl. It is often found at the base of the trunk (fig. 7.1). Sometimes it grows higher on the trunk (fig. 7.3) looking like a malignant tumor. At this distance you will not see much of the foliage high above, but you will see broken and ragged branches that protrude at all angles, in all directions. Sketch several of the trunk forms, as I have done in figure

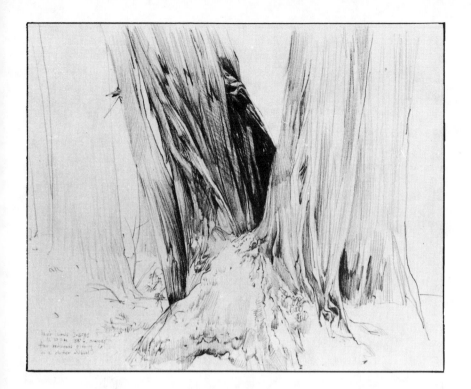

Figure 7.1
Redwood trunks and burl, Negro pencil. Four redwoods grow in a cluster here. If you look closely you can see them. I was taken by the burl and the texture of the scaly bark. I desired a dark emphatic tone to my redwood sketches, and therefore, alternated between the No. 2 Negro pencil and a soft charcoal pencil.

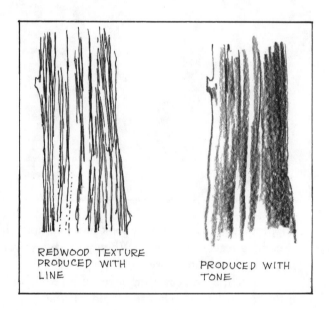

REDWOOD TEXTURE
PRODUCED WITH
LINE

PRODUCED WITH
TONE

Figure 7.2
Two approaches to the texture of the bark, pen and charcoal pencil.

7.4. Outline the trunks first, and take note of the shapes of the spaces between the trunks, if there are any. Then draw the branches. They remind me of a ladder with missing rungs.

In the redwood the leaf takes the form of a needle, much the same as in fir trees. Seedlings frequently grow from fallen trees, and provide an opportunity to study redwood foliage closely. Try a sketch such as figure 7.5. When you decide to sketch a mature tree, the scale in such a study will reduce the detail of the needles to a texture. Use a pattern of shorthand strokes or marks. (See fig. 7.6. Later in this

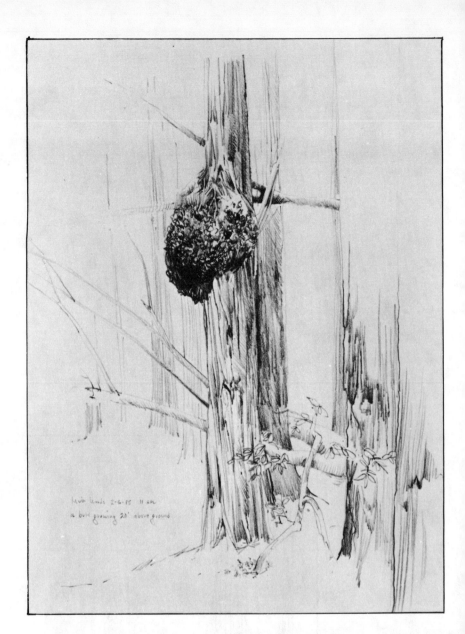

Figure 7.3
Redwood burl, Negro pencil. Red-
wood burls occasionally grow up
along the side of the trunk. I
sketched this one at Muir Woods
National Monument, one of the few
remaining virgin stands of redwood.

chapter and in chapter 8 we look more completely at the problem of
sketching leaves on a tree.) When you have solved the texture of the
needles, sketch an entire tree.

Sketching the towering form of a redwood is stimulating and a
little intimidating. The rectangle of the page should be turned
vertically to imply loftiness. In figure 7.6 I included a figure to suggest
the true height of the tree. An animal, such as a deer, could have been
used in the same way. If you draw a composition of trees and cannot
show them fully, height can be suggested by showing plants near the
base of the tree. The familiar size of ferns, although a tiny detail in the
sketch, serves as a point of reference in figure 7.7.

Sketching the Forest

As you begin to sketch entire groups of trees in the redwood forest,
you will become aware of the spaces between the trees. Redwoods
frequently grow in clusters, the younger and therefore slimmer trees
in a circle around the much wider girth of the mature parent.
Sometimes this parent remains only as a burned-out stump. Other

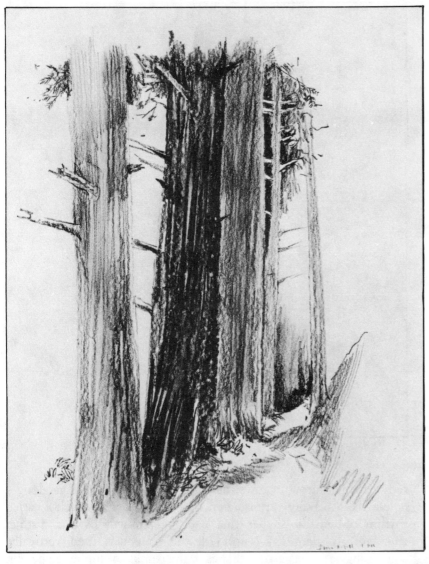

Figure 7.4
Redwood-branch whorls, charcoal pencil. Based on a sketch, this study illustrates the almost ladderlike intervals between the vertical columns of the trunks.

Figure 7.5
Regeneration, a redwood sprouting anew, Negro pencil. The leaf of the redwood is a needle form.

Figure 7.6
Redwood tree, Negro pencil. Scale
can be suggested by comparison, and
I included one of the many visitors to
Muir Woods to provide this.

redwoods will grow in rows, having sprung from seedlings along a
fallen tree. And there are isolated trees. All this offers such a varied
rhythm of vertical shapes that each sketch will have a distinct
character. In figures 7.7 and 7.8 the page was used vertically,
combining with the vertical shapes of the trunks to emphasize height.
I sketched the branch stumps and the fallen trees as horizontal
accents. The slope and the trail offered me diagonal lines to suggest
movement (the wind, an animal through the brush). Both sketches
were done along the trail. Figure 7.9, however, was done later in the
day, from memory. A shaft of sunlight passed through an opening in
the deep forest. There didn't happen to be time to sketch when I
observed it, but I had the other sketches to guide me.

In a number of his journal entries Leonardo instructs that to
represent a storm you should show many trees tossed upon the
ground. When I came upon the area in the redwoods sketched in
figure 7.10, I thought immediately of the storm he so vividly
describes. Subsequently I learned that conifers are shallow-rooted,
and a forest that is left in its natural state will have many fallen trees.
Looking out upon the tangle of redwoods, I felt the fury of a wind
and rain I had not seen.

In most of my sketches of the redwoods I used one and
sometimes two softnesses of charcoal pencil. In figure 7.7 I began
with an extra-soft grade, and added detail with a hard grade. The
details of the ferns were delicate; I used pen and ink here. Figures
7.8, 7.9, and 7.10 were all done with an extra-soft charcoal pencil. I

Figure 7.7
Redwoods and Douglas firs by a
stream in Fern Canyon, charcoal pen-
cil and pen and ink. I sought to sug-
gest the dappled half-light of this
second-growth forest, arisen on a site
that had been completely cleared for
timber.

Figure 7.8
On a trail in the forest, charcoal pen-
cil. I spent an hour on the sketch in
figure 7.7. Here I scrawled the sketch
quickly as we hiked into the forest.
The dim light makes dark sentinels of
the trunks, and the patterns of light
and shadow change from moment to
moment.

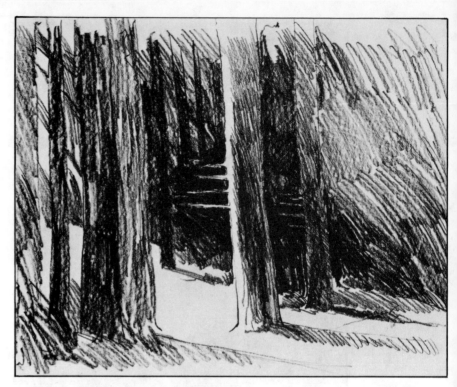

Figure 7.9
Forest light, charcoal pencil. We
chanced upon a stark avenue of light
in the midst of the forest. I was fasci-
nated by it and later did this from
memory, aided by sketches done on
the trail.

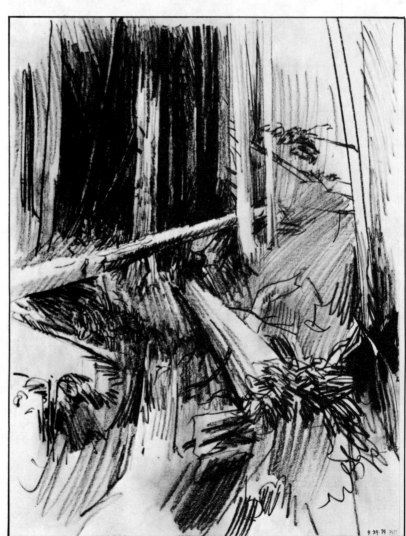

Figure 7.10
Relics of a storm, charcoal pencil.
Tossed as though a giant's bowling
ball had scored a strike on the tenpin
trees. I wondered if so many trees
would fall in the undisturbed soil of a
virgin forest.

rarely use this in sketching, but the redwoods are a world of shadows and dark shapes. No other tool would have allowed me to work as quickly and still have rendered the darks as faithfully. I used Berol's charcoal pencil. I endorse not so much the brand name as its working quality. It has a peculiarly smooth consistency. On index paper, smudging readily blends it.

Other studies, such as figure 7.1, were sketched with a Negro pencil, No. 2. It allowed a depth of black, but preserved a fineness of line. The tan oak in figure 7.11 was sketched with a 2B .5 mm graphite. This yields a delicate and sensitive line.

THE FOREST FLOOR: FERNS AND FUNGI

The light is dim at the forest floor, and little grows immediately beneath the redwood trees. There you find a litter of broken twigs, redwood needles, the small redwood cones, and leaves from nearby shrubbery. This decaying matter is called *duff* (see fig. 7.12). Near streams, in open areas cleared by falling trees, there are shrubs and berry bushes. The flower redwood-sorrel tolerates the dim light. And there are ferns.

Ferns

Ferns are plentiful and add a primeval quality to the redwood forest. The broad sword fern is usually the most abundant, and is the easiest to sketch. As you begin to identify them, you discover a visual enchantment in the variety of ferns. In the unrelenting dampness they will grow on the boughs of trees and on the trunks, as well as on the ground below. At first they may seem too complicated for an easy sketch, but examine them and they yield graceful lines and rhythmical shapes that are not difficult.

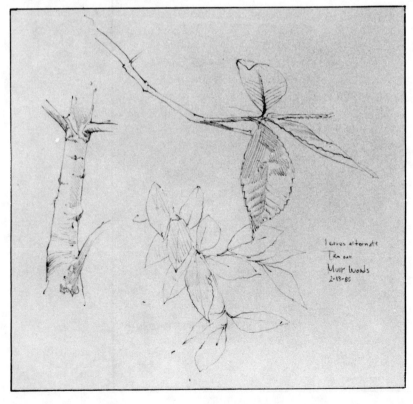

Figure 7.11
Tan oak (tanbark oak), pencil. This grows in great profusion near the banks of streams here. Sketching fragments is useful as an approach to learning; that is exactly why I sketched these.

Figure 7.12
Redwood-sorrel and duff, 8½″ x 7″, pen and ink. Doing a sketch of this kind is somewhat like beginning a jigsaw puzzle, daunting at first, but fun to do as the pieces begin to combine.

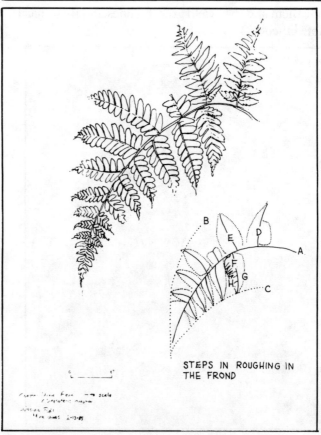

STEPS IN ROUGHING IN THE FROND

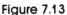

Figure 7.13
Coastal wood fern study, pen and ink over pencil. The tracery of a fern seems to defy quick notation in a sketch. Here I studied the frond to see what is "really" there, in parts and proportion, all to aid me in evolving a shorthand for sketching them. I first drew the axis A, noting the quality of its curve. I then sketched two guidelines to suggest the shape created by the leaflets, B and C. I then noted the intervals of the midribs of the leaflets, D, E, and F. Finally I sketched the leaflet contours, G and H.

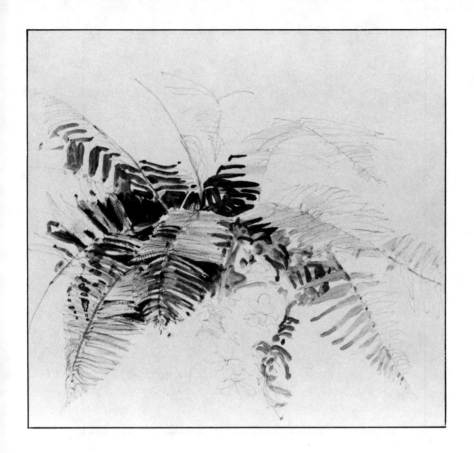

Figure 7.14
Fern fronds, 6″ x 6½″, pen and ink. I
allowed the pen to trace the contour
of leaflets, or the edge of shapes,
somewhat in the manner of the blind
contour exercise in figure 3.9.

When you sketch a fern, you confront a puzzle. The individual
leaf seems simple enough to draw, but there are so many of them!
The leaves of some ferns are large, and it is hard to reduce them to
a simple texture as we did with redwood foliage earlier in the chapter.
With ferns, strokes or summary shapes may answer.

If you want to sketch a simple impression, don't make the
problem more complicated than it needs to be. Figure 7.13 illustrates
a single frond. As you can see, it is a leaf composed of smaller leaves
growing from branchlets that are themselves growing from a main
stem. The fern plant is a number of such fronds. First, sketch all the
fronds as shapes coming from a common center. Then selectively
sketch some of the leaflets on each frond. An image of the fern soon
appears on the page. The sketch in figure 7.14 was undertaken in this
way.

You may want to create a sketch that explores all the intricacy of
a fern, or of any plant that captures your interest. This is a *study*. You
may want it to serve as a reference, or as an illustration. Sitting before
the fern, you will become engrossed and an hour or more will pass
quickly. Commit yourself to a period of time for the study sketch, as
it is important that you not feel rushed at the outset. This is a time
occupied by thoughtful attention to what you see.

There are three basic steps. First, pattern. What kind of patterns
are evident in the leaf, in how the leaf grows from the branch?
Second, variation. Variations that occur in a pattern give character to
your subject. Third, totality. The ten thousand leaves on a tree, the
complexity of a plant, can only be suggested. There is too much detail
for the mind to focus on all of it, so it perceives a texture. The steps

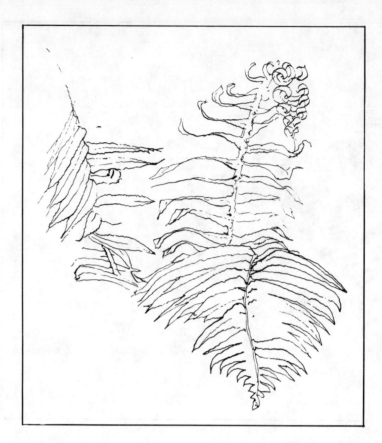

Figure 7.15
Sword fern along a trail, 7″ x 8½″, pencil and watercolor. I responded to the pattern of leaflets, withered fronds, fresh fronds, and broken fronds—a symphony of lancelike shapes. The watercolor was added after I sketched the pencil line, but I found myself sketching shapes anew with the brush. The darks are blue-green; the light grays are yellow-green and ochre.

are, in fact, three sketches: one of a single leaf; one of a branch with a number of leaves; finally, one of the entire tree or plant.

Let us examine the steps more fully.

1. As it grows, each kind of plant exhibits patterns unique to it. This serves as part of the basis for naming the plant. Note how the leaves grow from the branch. Are the leaves opposite each other, or do they alternate? What is the shape of the leaf—rounded, pointed, lobed? Is the edge of the leaf wavy, smooth, or serrated? In figure 7.13 this kind of analysis is applied to a single frond of a fern. The key illustrations in a field guide can be truly useful in pointing to useful observations. I have mentioned only a few aspects of pattern you might find.

2. The variations of pattern within a single, particular plant make it an individual. In a fern, the stalks may have different lengths. Some of the leaves will be fresh and green, others dying or withered, and still others will be bitten away—the site of an insect's feast.

Studying pattern and variation may be combined in a single sketch, using contour line and representing leaves selectively. Fronds of a fern can be sketched first as generalized shapes, then with definition added to each shape, as shown in figure 7.13.

3. When you look at a tree or plant, it has a totality of leaves. You cannot focus on each and every leaf. You are aware of detail, but not of everything all at once. Ruskin called this aspect *incomprehensibility*.[3] If you are sketching a hillside of ferns, it would be impossible to give detail to all of them. You can only suggest them, implying their complexity. Studying pattern and variation is the first

Figure 7.16
Looking down a slope toward a
stream, charcoal pencil. Without the
description I doubt that you could
"read" this sketch—and maybe not
even then. For me it vividly records a
moment on the trail. Remember that
your sketches are like a diary—for
yourself.

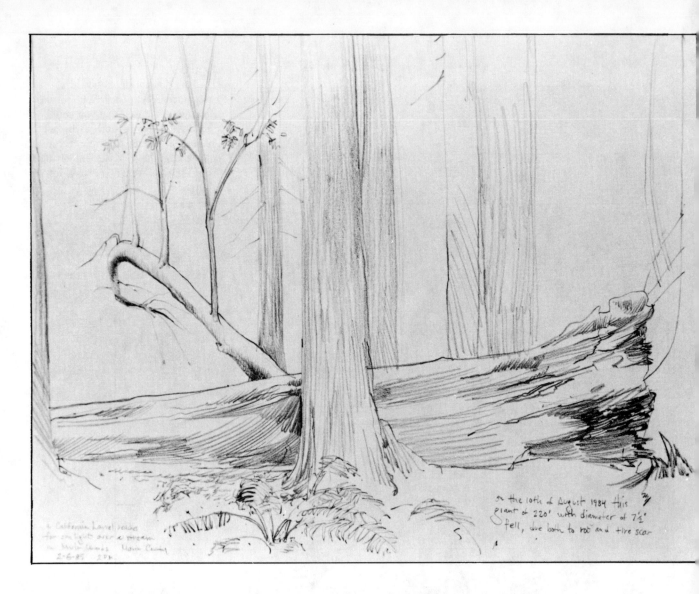

In the handwritten notes within the image:
on the 10th of August 1984 this
giant of 220' with diameter of 7½'
fell, due both to rot and fire scar

a California laurel reaches
for sun lights over a stream
in Muir Woods Marin County
2-6-85 20¢

Figure 7.17

A fallen giant, Negro pencil. On August 10, 1984, this giant of 220 feet (with a diameter of 7½ feet) fell, due to both rot and fire scar—this in Muir Woods. Note how the branches of the California laurel on the left of the sketch resemble trees in themselves.

step. Then sketch a pair of fronds (see fig. 7.15) or, if your subject is a tree or shrub, sketch a small branch. Use simplified shapes to give a sense of the form, and you will find that you can sketch the complexity with greater ease—even gesturally, as done in figure 7.16.

The fern in figure 7.15 was sketched in pencil, and touches of watercolor were added to suggest shadow. I used an extra-soft charcoal pencil for figure 7.16, using spirited marks in roughly spade-shaped series to suggest ranks of sword ferns. It was sketched high on a trail, looking down a slope toward a stream. It may look incomplete—even incomprehensible—but it vividly recalls my impressions of that moment on the trail.

A Tree over a Stream

The competition for light is part of the life of a forest plant community. Nowhere is it so evident as at a stream. I began the sketch in figure 7.17 with an interest in depicting a large redwood that had recently fallen. As I sketched it, I noticed, off to the left, a bay laurel tree that had gradually inclined—but not fallen—over a nearby stream. It had then sent lateral branches skyward. They stood on the

Figure 7.18
Lichen on a bough by a stream, pencil. The banks of a stream are rich in plant life. The leaf on the lower left was probably of the California box elder, common to such locations. You can see that I guessed wrong at the time.

main trunk, looking very much like individual trees. I had often heard of the competition for light in a forest. Now it took on meaning.

Fungi

The blossom of a wildflower suggests life; the excrescence of a fungus suggests death and decay. Fungi break down the substance of dead matter, and in this function become agents of rebirth—in effect, symbolic of the cycle of life and death.

Moss speaks of the nighttime fog and the winter rains. Many of the trees leaning out over the forest streams are draped with lichen (see fig. 7.18). We paused for a moment while hiking along a trail. Fascinated by the texture of the lichen, I sharpened my 2B pencils to a fine point and sat down to explore the delicate texture. On a later visit to Muir Woods I sketched a fungus growing from the stump of a fallen hardwood tree, growing like the steps in a garden stairway. Its shell-like form seemed to echo the sea, not so far away (fig. 7.19).

Figure 7.19
Fungi, Negro pencil. Neither animal nor quite plant, the fungi inhabit a world that bridges life and death.

BIRDS AND MAMMALS

Jays, thrushes, kingfishers, dippers (Muir's "water ouzel"), and woodpeckers live among the redwoods. Ravens add a dramatic presence high above, momentary and fleeting. I sketched one from memory (fig. 7.20). Hawks fly above the forest canopy and may briefly cast a shadow across the trail. With startling suddenness, a heron will ascend from the surface of a forest stream with a slow measured flapping of its enormous wings.

You may watch a bird working the duff for insects, or perching in song on a limb safely above you. You hear the sounds of more birds than you see. Sometimes there is a brief glimpse to tantalize you. Review the approach to sketching a bird outlined in chapter 6. Some glimpses are so brief that it is fruitful to sketch from memory, even if the results are somewhat disappointing.

Figure 7.20
Raven, charcoal pencil. A moment's vision sketched from memory, long after the event. It was not my purpose to depict the real; it was to depict the remembered.

A Bird Sketch

Recently, as I sat sketching, I espied a robinlike bird perched above me. Through binoculars I could distinguish a pattern of plumage—and, as you can see from figure 7.21, that was about all. A far cry from an elaborate bird portrait! The next step was to identify it. I looked through a field guide until I found a bird illustration that showed

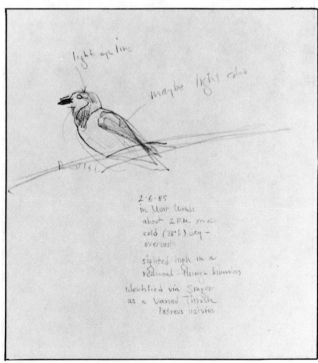

Figure 7.21
Quick bird sketch, 8″ x 6″, Negro pencil. I heard this bird as I sat sketching figure 7.17. I looked up, reached for binoculars, started the sketch—and the bird was gone a moment later.

similar markings. It was a varied thrush. It was said to be common to moist woodland, which was exactly where I had seen it. The following week I located specimens of the bird at a natural history museum. Figures 7.22 and 7.23 are the studies I drew there. As the bird is the size of a robin, I was able to draw it at its actual scale. I carefully noted the different portions of its wing and the character of its plumage in general.

My next encounter with the thrush will be important. I will remember its form more clearly as a result of studying the posed specimens. I will also be able to correct the never-quite-true image formed when studying a dead bird—for that is what a bird specimen is. Studying the dead bird gives you important clues to the appearance of the living bird.

Animal Residents of the Forest

To see and study the wild animals resident here requires that there be no obtrusive human presence. It demands quiet. In fact, you are most likely to see them when your normal movements have stilled, as you sit sketching a small plant or flower. Binoculars expand the number of opportunities to sketch animals, but are not absolutely essential. Patience is.

Mammals are elusive. I have caught glimpses of deer, off in the middle distance among the redwoods. Later I determined that they were probably black-tailed deer, but I couldn't be certain. My wife once observed a dark man-size form scratching at a tree a hundred yards off the trail from where we were sketching. I could not see clearly what it was, but I did not think that a man would be scratching at a tree. Prudence dictated a rapid retreat back down the trail.

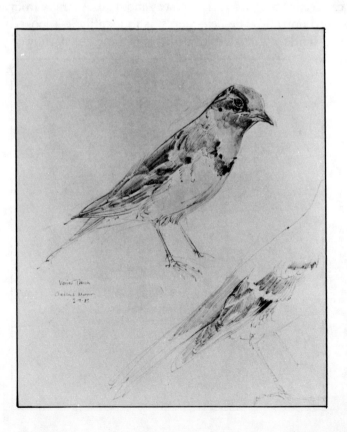

Figure 7.22
Varied thrush specimen, graphite pencil, Negro pencil, and watercolor.

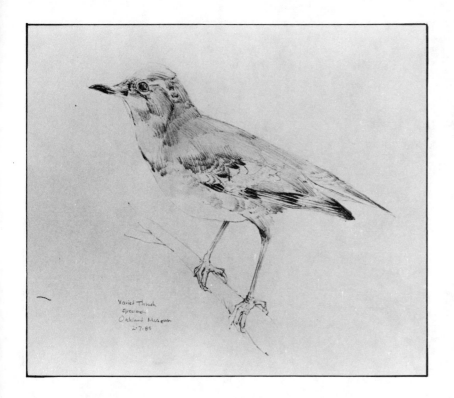

Figure 7.23
Varied thrush specimen, graphite pencil, Negro pencil, and watercolor. A good museum specimen will allow you to study the exact patterns of the plumage. The throat and breast of the male thrush are orange, and it was there that I added watercolor.

As we retreated along the trail we heard the squeal of a brush rabbit. We had heard it as we had come up the trail earlier in the day. Now, however, a short-tailed weasel was in hot pursuit. They rounded the bend in the trail; the rabbit dived between my wife's feet to make good its escape. The weasel, deprived of its prey, paused and seemed to consider us as a substitute. The sketch in figure 7.24 was drawn that evening from my memory of the incident. I used it, like a page in a journal, to write a brief description of the event.

The encounter with these denizens of the banks of the forest stream did not permit cold and calculated observation. My rendition of the weasel leaves something to be desired. But, for me, the sketch captures the flavor of the incident, and that is what matters.

Many mammals have become nocturnal in response to the presence of humankind. We were surprised to come upon a rodent jumping like a small kangaroo in the vicinity of the trail. These are creatures of the night, and we wondered at the seeming tameness of this one. As it jumped, we sketched (fig. 7.25). We wondered if it was fully healthy, and when on the following day we came upon its remains along the trail where we had sketched it, we assumed that it probably hadn't been. What we tentatively identified as a Pacific jumping mouse had become the meal for one of the other residents of the forest.

Sketching a Squirrel

The tree squirrel and the chipmunk may be seen frequently on a forest trail. They are excellent subjects for your first animal studies. Like the gull we studied in chapter 6, they will approach you and sometimes will remain close by. They are members of a large group of mammals (the order Rodentia) that includes ground squirrels, rats, mice, gophers, beavers, marmots, and porcupines. Although details

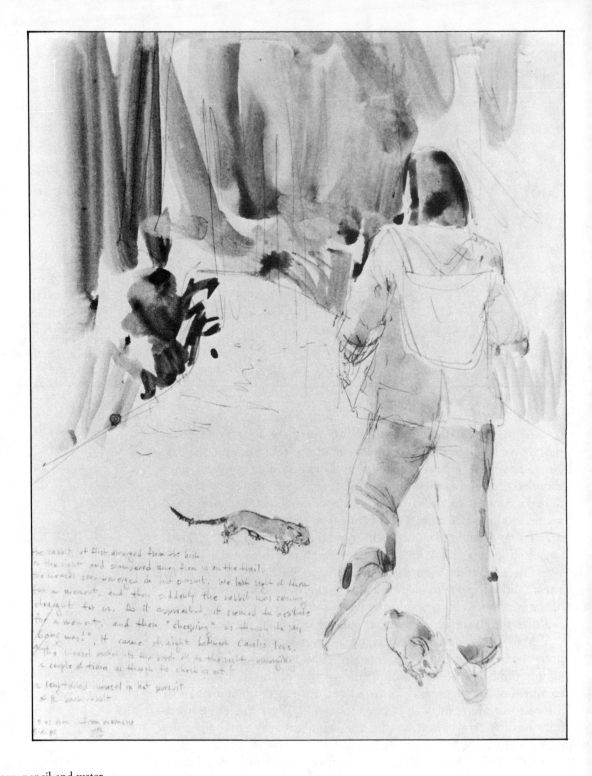

Figure 7.24

Predator and prey, pencil and water-color. As I followed my wife on the trail we heard a squealing commotion ahead of us. Two animals darted across the bend in the trail. Suddenly a rabbit jumped out of the verge and, pausing for only a moment, made a decision and came straight for us, passing between my wife's feet. It was quickly followed by a weasel. The weasel paused, seeming for a moment to consider us as prey, and then darted into the verge. I sketched the event later that evening.

of appearance differ, they are alike in their basic form. Learn to sketch one and you have begun to sketch them all.

Sketches of gestures are an important early step in becoming acquainted with any animal. In figure 7.26 I sketched the gestures of a gray squirrel crouching, stretching, and eating.

If you have already attempted such studies of gesture, you are aware that they are not so effortless as they might appear. Unfamiliarity with the shape of the animal's head, how it looks from different angles, or how the legs move makes gestural drawing a wild attempt to comprehend a bewildering confusion of shapes. You feel like shouting at the animal, "Hold still!"

The important first step of making rough sketches of the form of the animal is all too often overlooked. Don't attempt to show movement or a posture. Sketch the animal in profile, and look at the relative size and shape of the body parts. The animal is most assuredly going to move; don't let that discourage you. The sketch is a way of learning what the animal looks like. It is not a portrait.

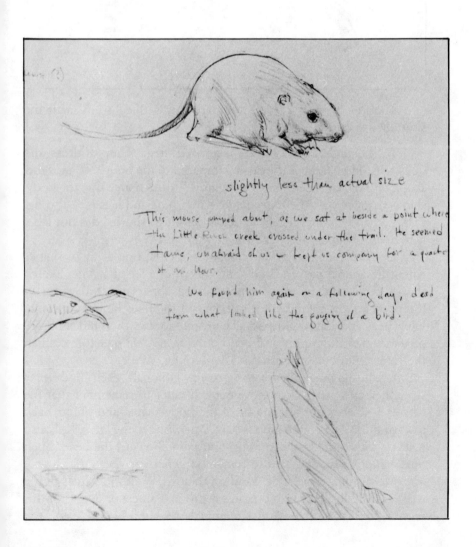

Figure 7.25
Rodent study, 4″ x 5½″, pencil. This surprisingly tame individual kept us company as we sat and sketched.

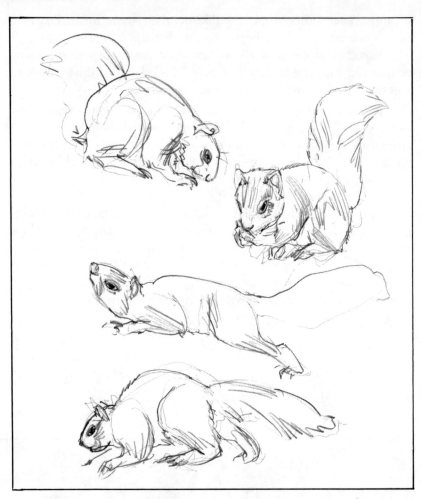

Figure 7.26
Gray squirrel gestural sketches, Negro pencil. These have been copied from pages in my sketchbooks, pages that contained other gestural studies that failed in one way or another to convey what I saw. I enjoyed sketching them nonetheless.

Look at figure 7.27 and compare the finished study with the simplified shapes used to begin it.

1. Shapes A and B are sketched first. They address the questions: How large is the head compared to the body? What *is* the shape of the head? Look back at figure 7.26 and notice that the body shape changes with the movement of the spine and legs (see also fig. 7.28). Small mammals do have necks, although short. I did not label it here as a shape, but suggest it in your sketch.

2. The four legs of an animal are a confusing array of shapes when the animal moves. Study and sketch one leg at a time. Sketch shapes C, D, and E, which represent the upper arm, forearm, and forepaw. Follow these with the shapes of the hind limb—the thigh, lower leg, and long hind paw. The forelimb and the hind limb are proportioned differently and bend differently. The skeleton is much the same as in our own arm and leg (see fig. 7.28).

Small mammals tend to crouch, although each limb may straighten as it extends in movement. It helps to remember that the elbow, J, is near to the contour of the body shape, and points back toward the tail when the limb is bent. Mirroring it, the knee, K, is also near or within the body contour, and points toward the head. Such observations may help you to remember what you see.

Most animals move or stand on their toes, with the areas of the wrist and ankle elevated. You can see this in your cat or dog. (For this reason, the wrist of the larger mammals resembles a knee, and the

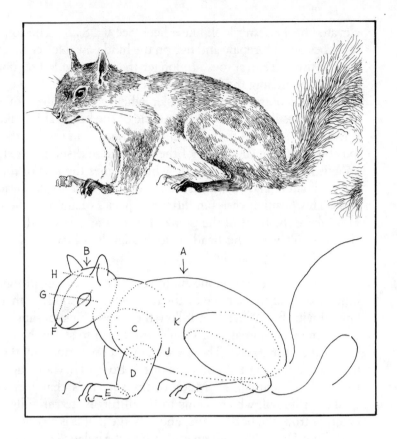

Figure 7.27
Sketching a small mammal. Shapes A through E approximate the parts of the body. The hind limb has longer, larger shapes than the forelimb, but is also composed of three basic shapes. Lines F through H are axis lines that determine the central axis of the head and the placement of the features on it. The elbow is at J and the knee at K.

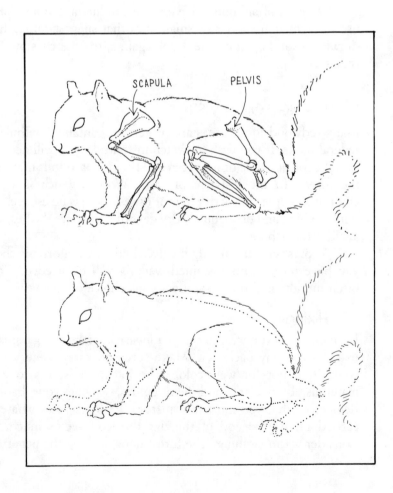

Figure 7.28
The skeleton of the limbs. Knowing the position of these bones may aid your understanding of the movement of the limbs. Movement of the limbs as shown by the dotted lines will cause the spine to straighten, as also shown by a dotted line.

elevated heel doesn't look like a heel. See fig. 8.28.) The squirrel has four toes on its forepaw and five on the hind paw. Notice that the two (or the three) central toes are longer than the two lateral ones.

3. Sketching the head and face of the squirrel—the eyes, ears, nose, and mouth—becomes easier when you visualize, or actually draw, an axis line, F, down the middle of the head. This makes sense if the head is turned toward you. If the head is in profile, the central axis becomes the silhouette of the forehead and snout. Next, sketch an axis line across the head, G, which defines the axis of the eyes—approximately midway, measuring from the back of the head to the nose. This position varies in different species of animal. The axis line H is where the front of the pinna of the ear attaches to the forehead. If you don't want the head to look slightly askew, axes G and H should be nearly parallel.

Ultimately there is one more step. The sketches in figure 7.26 hint broadly at the surface or the texture of the squirrel, that it is an animal with fur. When you follow the steps I have outlined to learn the form of an animal, you should also begin to study the hair tracts (also called fur tracts). These are the patterns formed by the hair as it grows, following the contours of the body. They are suggested in the study in figure 7.27. Much of the squirrel's character is in the quality of its tail, which seems to be all fur. Note carefully where it emerges from the body shape, and observe that it is a continuation of the spine. The tail is both an appendage for balance and a vehicle for communication.

Sketches of an animal have more validity and animation if you use a fragmentary series of small lines that suggest fur, rather than drawing a solid contour line. Look again at the sketches by Pisanello (fig. 1.1).

PREPARING FOR A VISIT

Many redwood forest areas are protected, contained within state or federal parks. If you wish to sketch in solitude, you will need to hike into the forest a mile or more beyond the campgrounds that neighbor the forest. In the instance of Muir Woods, which is visited by countless people who arrive in tour buses, there is no escape. The less bone-chilling and occasionally dry days of winter are the best times to avoid crowds here.

A forest visit frequently involves hiking. Comfortable shoes that you have tested with sustained walking will be needed. Trails are often muddy, and this may affect your choice of footwear.

Hiking

How much do you wish to carry? I invariably take along a small stool that fits into my backpack. Make sure you carry some water—for yourself, if not for watercolor. The backpack serves to carry art materials, binoculars, and field guides, leaving your hands free. Remember that you must return from the forest with whatever you carried in. At the end of the day the load seems much heavier. Consider warm clothing. The forest floor, lacking the penetration of

sunlight and cooled by fog at night, can be cold during the day, even in August.

Here, as in chaparral, poison oak grows in abundance. (See comments at the conclusion of chapter 5.) Learn to recognize the red-tinged, somewhat glossy, three-leafed form (fig. 5.18). The toxic oils can be transferred to your skin from your clothing, should it come into contact with the plant. In most people it causes severe skin irritation, and medical attention is advised.

Insects can be sufficiently serious pests to cause you to move some distance from an otherwise desirable location. Insect repellent will help.

Being alone in a forest places you in a position of vulnerability. Remain aware of your surroundings. As I have suggested earlier, in out-of-the-way places it is best to sketch in the company of another.

Summer and Winter Seasons

On the Pacific coast the dryness of summer and the rains of winter give the year two major seasons. There is spring with its adornment of wildflowers, and fall with scattered displays of color as the deciduous trees lose their leaves, but they seem more intervals than seasons. The atmosphere of the redwoods reflects the two major seasons.

In the summer the air is permeated with the dust of innumerable hikers, especially in Muir Woods National Monument north of San Francisco, where by late August a coat of dust has settled on everything in the neighborhood of the trails.

In the rainy season the forests quickly regain their freshness, but not without hazard to the hiker. During rains a lazy stream can quickly turn into a flooding torrent. Trees fall unpredictably in the winds that accompany the winter storms. In the depth of this forbidding season, the forest has itself to itself. The spring and summer, when the forest is passing from the wet season to the dry, is the most luxuriant time, the time I most like to sketch. It is the time for wildflowers and the richness of ferns.

The redwoods are a relic of a past age. Existing now only in isolated and protected areas, they represent a magnificence not only of the West, but of a forest that once spread across the continent and the world.

8
THE CHAPARRAL

A FOOTHILL LANDSCAPE

A century ago the naturalist John Muir wrote of gazing upon the broad Central Valley of California and seeing flowers growing in great profusion as far as the eye could see. That valley is now a vast farmland irrigated by the waters of the Sierra. On the east and west it is bordered by a foothill landscape called *chaparral,* a landscape tattered by suburban homes, businesses, and a network of roads. A morning or afternoon of sketching wildflowers on a chaparral meadow is likely to be within sound, if not sight, of a freeway and the roar of cars.

The El Camino Real, the trail along which the early Spanish missions were constructed, cut a path through a landscape notable for its dwarf evergreen oaks. The Spanish word for these oaks, *chaparro,* became the name by which this landscape is known, *chaparral.*

If, in late March or early April, you stand on a hillside near our home, you can look out upon a chaparral of rolling green hills dotted with oaks. The green meadows are sprayed with color, the spring wildflowers. It is breathtaking. Return in two months and all appearance of luxuriance is gone, vanished like a desert spring. The hills become a dry ochre color and look parched in contrast to the dark evergreen of oak scrub. Fog banks billow over the crests of the coastal mountains overlooking the meadows, but give little moisture to the arid hills. Gradually, the ochre turns gray and the hills look ashen. Not until year's end and the winter rains have come do signs of fresh green return. Then the dry dusty trails become sloughs of mud, deeply pocked by the hooves of horses, as these are equestrian trails as well.

In a parallel to the desert, there is hidden richness in chaparral. Wandering from dawn to dusk, walking the trails like a Thoreau, you will see a beauty and variety unrecognized and unseen by the casual hiker. The red bark of the madrone tree, the fragrance of the laurel leaf, and the white June bouquet of the buckeye tree all accompany the oaken flavor of the surrounding meadows. Thickets of coyote bush with their myriad small evergreen leaves and violet-gray

branches coat the more protected slopes. Poison oak, treacherous to the touch, adds a deep red shimmer to the hillsides in August. Red-tailed hawks soar on thermals of warm afternoon air. As afternoon gives way to dusk, the song of the coyote returns the hills to the province of their animal residents.

There is no better place to nurture your observations of the landscape than where you live. Living in and near chaparral, I sketch it day by day, and it ever reveals some aspect of nature I had not noticed before. Study the countryside around you in all seasons, at all times of day, and in all manner of weather. You may watch a flower form a bud, blossom, go to seed, and wither.

Not so long ago, as I returned from a morning of teaching, I noticed that the hillsides near our home had turned a bright pink. I stopped the car and hiked up onto a slope. A wildflower, one of the *Clarkia,* had blossomed. It blooms only briefly, and this was my first opportunity to see it. I was transported. My emotional response might seem exaggerated until you also chance upon an event in nature that goes largely unnoticed. You will be as moved as I was. Take regular walks into a field near your home and sketch what you see there. Notice the changes that take place over the passing months.

SKETCHING A CHAPARRAL PANORAMA

The chaparral near our home is bordered by coastal mountains on the west and by San Francisco Bay on the east (see fig. 8.1). At the foot of the mountains a narrow valley is formed by the San Andreas fault. Movement along the fault has littered the meadows with a rock, serpentine (see fig. 8.2), which gives the soil a gray-green color and dwarfs plant growth where such soil is concentrated. The rock is metamorphic, formed and transformed deep within the earth by intense pressure and heat. Gradually, the serpentine was extruded

Figure 8.1

Looking north on the Coast Range, porous-point pen and watercolor. Seventeenth-century Dutch artists loved the prospect of a broad and open landscape with a city in the distance. So do I.

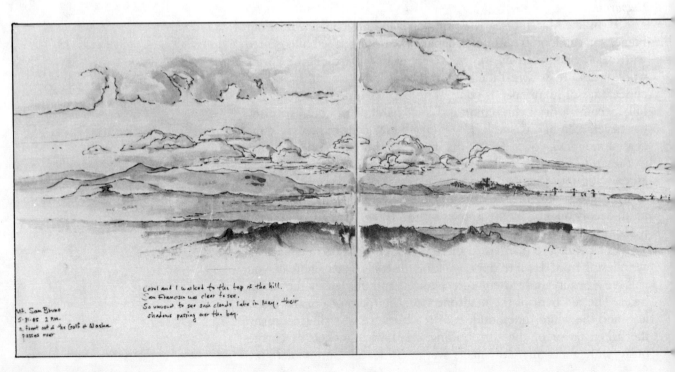

along the fault line as slippage occurred over the centuries. Standing upon outcrops of this rock, you can easily imagine the geological forces at work beneath you.

Much of the chaparral is foothills and meadows dotted with oak trees, acacia, eucalyptus, and scrub (see fig. 8.3). But there are also natural springs and creeks in shallow sheltered canyons adorned with a woodland of madrone, laurel, buckeye, and oak (see fig. 8.4).

The panorama in figure 8.1 was sketched as I stood atop one of the higher foothills. I sketched it across two pages, emphasizing the mountains on the distant horizon and the clouds blowing in from the sea. I used a porous-point pen, adding notations in pencil to indicate the colors I saw. Upon returning home, I added watercolor, guided by the notations. This is something I commonly do when I want to carry no more than a sketchbook.

Figure 8.2
Serpentine rock and scrub oak, technical pen. The starkness of pen and ink seemed appropriate to the flaking rock and the shrub on a hot, bright, dry summer afternoon. Figure 3.26 illustrates how I approached this sketch.

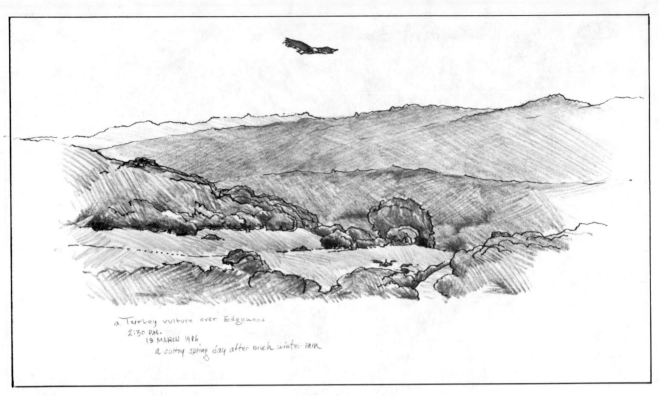

In the image, handwritten:

a Turkey vulture over Edgewood
2:30 P.M.
19 MARCH 1986
a sultry spring day after much winter rain

Figure 8.3
A chaparral meadow, 6″ x 9″, porous-point pen and colored pencil. The mountains at the edge of this chaparral rest on the Pacific plate, the chaparral on the North American plate, meeting at a line geologists call the San Andreas fault. On a spring day, sitting on a hillside sketching, it was hard to visualize the violent movement that can and does occur here.

Figure 8.4
A stream in woodland, pen and brown ink. Oaks and laurels attend this stream. Sketching a woodland, I select from an array of texture and focus on a few of them, here allowing the texture of the pen stroke to symbolize much of it.

TREES OF THE CHAPARRAL

There are varieties of both evergreen and deciduous oak in chaparral. Scrub oak, a shrublike tree, and coast live oak retain their leaves throughout the year. They form clumps, groves, and solitary silhouettes on crests of hills and across intervals of meadow. The crown of the tree is a dull green, a color that seems to absorb rather than reflect light. The older trees are supported by stout trunks (see figs. 8.5 and 8.6). These are interspersed with the generally much larger valley or white oak. Deciduous, it sheds its leaves in the fall and stands a tall silhouette of jagged branches during the winter (fig. 8.7).

Sketching the Oak

In chapter 7 we examined the redwood, a conifer. The oak is a flowering hardwood tree. Follow the same sequence of study steps we applied to the redwood. Look first at the bark, at the shape of the trunk, at the pattern of branching, and then, close up, at the leaves on a branch. In the oak, and in other hardwood trees, the leaves form discernible patterns.

Pattern. Compare an oak leaf and a madrone leaf (fig. 8.8). Both leaves are simple, which means that they grow singly rather than in groups upon a single stem. (The leaf of the buckeye is compound. It grows in clusters on a single stem.) Both leaves grow in an alternate pattern out of the branch (rather than an opposite or whorled pattern). The leaf of the coast live oak, however, is small and roughly ovoid, and has a spiny margin, or outline. The madrone leaf is larger, flatter, more elliptical, and has a smooth margin. Contrast the sketch of the oak in figure 8.5 with the sketch of the madrone in figure 8.9. Leaf size and pattern have a noticeable effect on the appearance of a tree, even from a distance.

Variation. There is a real feeling of discovery when you see beyond what defines a tree as a species and begin to see each one as

Figure 8.5
Coast live oak, brush-pen. The heat of a July day dried the ink on the brush pen and allowed a more delicate line than I can usually produce with this tool. This is a grand old tree, not destined to survive development of the land.

Figure 8.6
Coast live oak, quill pen and wash.
There is a romance in the quill. Rembrandt drew with it. In the hands of someone like me, who has used it little, it is somewhat unpredictable.

Figure 8.7
White oak, pencil. This was an experiment. I used a chisel-edge sketching pencil to create the twisting limbs and then added contour lines with a micro-point pencil.

Coast Live Oak

leaf
comparisons
1-20-86

Madrone

Figure 8.8
Oak and madrone leaves, Negro pencil. These leaves are from trees that grow side by side along a trail. The oak leaf is 1¼ inches long; the madrone leaf is 5 inches. The size of the leaf has much to do with the appearance of a tree. See also figure 5.4.

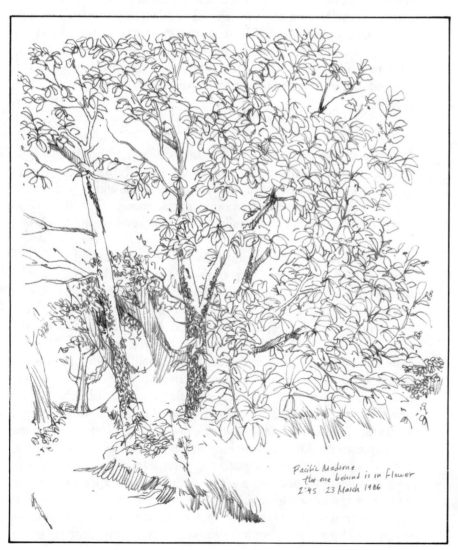

Pacific Madrone
the one behind is in flower
2:45 23 March 1986

Figure 8.9
Pacific madrone tree, pencil. With its large evergreen leaves and dark red-brown bark, the madrone is distinctive.

an individual. Figures 8.5 and 8.6 are both sketches of the coast live oak. The tree in figure 8.5 grows on a slope exposed to prevailing northwest winds and is bowed southeastward, almost to the ground. It is a mature tree. The one in figure 8.6 is much younger and grows on a more protected slope. It too leans away from the wind, but to a lesser degree. Both trees are of the same species. They bear leaves of similar shape and size, the basic pattern of branching is the same, and the quality of the bark is identical. But each tree is an individual. Each is subjected to different wind conditions, and each receives a different amount of moisture. The older tree is solitary; the younger grows in a small grove. Two oaks growing together in a grove will be subject to identical amounts of wind and rain, and their individual qualities may be less obvious, but here too there will be distinguishing variation.

Totality. The leaves in the crown of an oak are too small for the eye to focus on them all at once. We see instead a totality of leaves, a texture. Knowing how to sketch a texture, one that says "leaves," takes practice. A study of a small branch with its leaves is the first step. As you do small studies of the branches of different kinds of trees, you will be more prepared to sketch the variety of trees you will encounter. This approach applies equally to shrubs and small plants. Transforming the qualities of the leaves you have carefully drawn into quickly (or at least easily) executed gestural marks is accomplished in stages, and by experiment. Prescribed methods will tend to lead you to results that are superficial. Evolve your own method, one that is consistent with the length of time you give to a sketch.

A Study Sketch of a Coast Live Oak

Daily walks often take me past this impressive tree, bowed with the force of winter storms over the many decades of its life. The sketch in figure 8.5 was drawn with a brush-pen, a brush with a built-in ink supply. I sat in the warm afternoon sun, far enough from the tree so that I could easily see the totality of it, and sketched the trunk and leaves.

The silhouette of the total foliage of a tree is called its *crown.* Making small dots with the tip of the brush, I sketched the limits of the crown (fig. 8.10). The dots eventually blended with the leaves as I sketched them. I noted that the axis of the tree began on the right and bent to the left. Keeping this in mind, I drew the contours of the portions of the trunk and branches not covered by leaves. Working from the crown inward, and from the branch portions outward, I began sketching shorthand shapes that resembled the leaf of the oak. Some leaves appear in silhouette, as flat shapes, and others bend toward or away from you, looking truncated or foreshortened. Some leaves are in shadow, others are in light. The notion of doodling encompasses the kind of sketching involved here, where you do not consciously think about each and every leaf. Doodling, of course, can involve repeatedly drawing a series of small flat shapes such as the texture of leaves would require.

In your first efforts you may experience difficulty at this point—not in sketching leaves, but in sustaining interest in repetitively filling

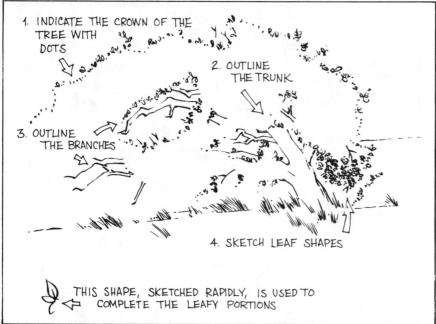

1. INDICATE THE CROWN OF THE TREE WITH DOTS

2. OUTLINE THE TRUNK

3. OUTLINE THE BRANCHES

4. SKETCH LEAF SHAPES

THIS SHAPE, SKETCHED RAPIDLY, IS USED TO COMPLETE THE LEAFY PORTIONS

Figure 8.10
Sketching a tree. The steps shown here illustrate how I sketched the tree in figure 8.5. Although I sketched the crown as one shape in this sketch, I could have included subordinate shapes as shown in figure 3.3. The step of sketching the leaf shapes was not rushed. I often paused and simply observed. A fifth step of using a moistened brush to dissolve some of the ink lines into tones was done after returning home.

an area with little leaf shapes. I suppose this separates the Dürers from the Rembrandts. In other words, it is a matter of personal preference or style. But it is also a matter of approach. I rarely draw an area of texture all at once. I work on different parts of the sketch, striving to bring it into focus gradually. This permits me to stop at any time. Thus, the sketch—or study, if you like—will have a consistent degree of finish at every stage. Also, I will pause occasionally to renew observation. Don't rush your sketches.

I returned home with the sketch. There I used a moistened brush to dissolve some of the ink, producing a wash (a tone or gray applied as a fluid). This softened some contours and yielded dark accents. (This was possible only because the ink provided with the brush-pen takes time to dry completely.)

In chapter 5, I refer to the shorthand methods employed by Constable and Moran to sketch the crown of trees. These are quick, easily used methods, but remember that they evolved from more painstaking study earlier in each artist's career. Have patience with your first efforts. Being unaccustomed to the leafy pattern, it will take some experimentation before you can sketch it effectively and with ease. Your own style will evolve.

Buckeye Flower and Seed: Symbols of Seasons

The California buckeye blossoms with a showy flower in May (fig. 8.11), and by late summer, its leaves already shed, it is adorned with a distinctive capsule that bears the seed (fig. 8.12) which gives it the name *buckeye*. I sketched both with pencil. The flower forms a raceme, made up of many small blossoms. Using a magnifying lens, I examined and then sketched two small blossoms off to the side of the page. I notated how much I had enlarged them, knowing that I would forget later. Having a better understanding of the small blossom helped me to complete the sketch of the total flower. I added touches of colored pencil at the same time.

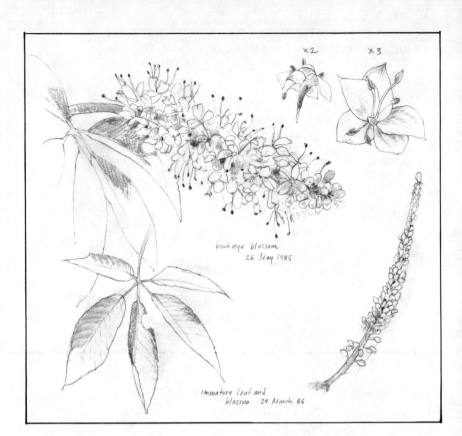

buckeye blossom
26 May 1985

immature leaf and
blossom. 24 March 86

Figure 8.11
California buckeye blossom, graphite
pencil and colored pencil. When the
tree comes into flower in April and
May, this blossom, half a foot long, is
quite showy—making it a simple mat-
ter to spot a buckeye. This sketch,
like a number of my sketches, was
added to at different times.

on the 4th of November 84
near Stanford
a "buckeye" amongst the eucalyptus leaves
the native
the alien

Figure 8.12
Buckeye capsule, pencil. This was
sketched below the tree from which I
drew figure 8.11. Nature may provide
its own still-life arrangements.

The capsule containing the seed (fig. 8.12) was sketched where
it had fallen, beneath the tree. I was taken by the shapes of the
peeling capsule, and with the fallen eucalyptus leaves. Although
planted, and therefore "alien," the eucalyptus trees grow in the
chaparral, often mute testimony to abandoned ranches or orchards.

CHAPARRAL SKIES

A cloudless sky and bright spring sun intensify shadow and make
chaparral a place of contrast (see fig. 8.13). The marine fog layer can
rise up over the nearby mountain ridge and be blown by the wind
into huge billowing shapes. In the dark hours before dawn, the full
moon may eerily illuminate the blowing masses of fog (see fig. 8.14).
The skies of winter and spring bring distinct moods to the landscape,
illustrated in figures 8.15 and 8.1.

The night sky in figure 8.14 was sketched from memory, some
hours after observing it. To convey the dark velvety and yet luminous
grays, I used slightly diluted Chinese ink (see fig. 4.3), applied on
index paper with a goat-hair Oriental brush. I could as easily have
used conventional ink and a standard watercolor brush, but I favor
the working qualities of the ink produced with the ink stick.

The rays of the setting sun shone through a break in the trailing
clouds of a passing winter storm in the sketch in figure 8.15. As dark
as the clouds were, the ridge of the coastal mountains and the range
of foothills were darker still. The tonal forms were sketched with a
No. 2 Negro lead in a holder, a thicker, blunter implement than the
Negro pencil. The phenomenon was transitory, but persisted long
enough for this sketch.

Figure 8.14
Fog and the moon before dawn, Chinese ink and brush. I was taken by the spectral shapes the setting moon illuminated in the fog blowing over the Coast Range. From memory.

Figure 8.15
Passing storm, Negro lead. Storm clouds are dark, but never darker than the landscape below them. The rays of the sun might be a cliché of landscape art, but no phenomenon of nature is a cliché when you see it for yourself.

The sketches in figure 8.16 began as contour drawings of the cloud forms with a technical pen. I made notes in pencil to help me remember the values (lightness and darkness) of the grays. When I returned home I added watercolor.

The skies of chaparral, and of dry western environments in general, are sometimes filled with another kind of cloud, the cloud of heavy smoke of a raging grass fire (fig. 8.17). Before there were

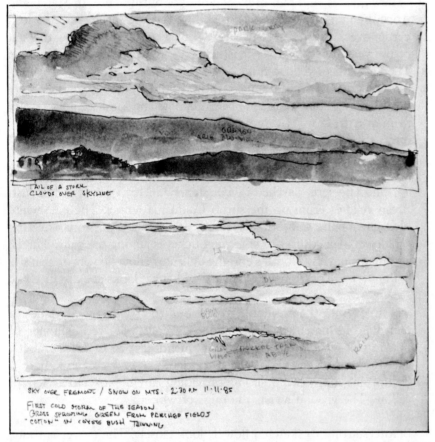

Figure 8.16
Cloud studies, technical pen and watercolor. Cloud forms never cease to fascinate me, and I "collect" them in my sketchbook.

Figure 8.17
Grass fire, pencil and watercolor. Although this fire was set, such fires occur spontaneously in chaparral, and are part of the natural cycle. Nevertheless, they are terrible to behold.

firefighters to control them, grass fires were a part of the normal cycle of growth and decay. Black was one of the many colors that might pass across the patchwork of chaparral during a year.

WILDFLOWERS AND THE COLORS OF CHAPARRAL

In January the hills are a collage of evergreen shrubs, the silvery boughs of valley oak, gray decaying grasses, hints of the fresh green of new grasses, and rain-drenched mud of burnt ochre. In March and April the rains are less frequent, and new grasses have created a lush carpet over the litter of last year's decay. The lupines, among the first of the year's wildflowers, splash blue-violet across valley and verge. Then accents of yellow in the glowing, almost glaring Scotch broom, the golden California poppies, the tidy tips, and the goldfields are spattered over the landscape. The numbers and kinds of flowers vary from year to year, but upon certain hillsides and meadows there is often an extravagant celebration of color each spring.

In early May the white lupines replace the blue-violet. Into mid-month the golden ochres and pale umbers of the drying grasses appear. The sere, parched flower stems and leaves turn a dull rust. Fresh yellows erupt on the shrub California fennel. The pale white blossoms of the California buckeye, numerous white tufts covering each tree, make it easy to spot the buckeyes among the oaks, laurels, and madrones. By month's end the delicate yellow flowers of chamise highlight large portions of chaparral with what looks at a distance like creamy frost.

Even with the inevitable drying out, the chaparral continues to rearrange its patchwork of color. By August, the red shimmer of poison oak gives notice of just how plentiful it is. Ochres, umbers, and dull greens now dominate the landscape. Here and there a California poppy will bloom, providing an unexpected touch of yellow. The ground awaits the rains of winter.

Before starting to sketch a flower, look closely. The flower is roots, stem, leaf, and inflorescence. Ann Zwinger frequently draws the flower in all its parts (see figs. 1.12 and 1.13). When the sketch serves to illustrate a botanical species, this is a common practice.

The basic parts of a flower are illustrated in figure 5.5. This can be only a general guide at best. In some kinds of flowers parts are combined, and in others some parts may be absent. Often which parts are which will be clear only to the botanist. However, it gives a sketch added subtlety and fineness when you look for them, even if you cannot always solve the puzzle. The small scale of many flowers makes it useful to carry a field lens, a magnifier called a *triplet,* with a power of 10.

Sketching Wildflowers

The exhilaration of floral color, the sinuous curve of stem, leaf, and flower petal inspire the wielding of pen, pencil, brush, and colored pencil. Conveying the silky insubstantiality of a flower petal takes a little practice. It quickly becomes no problem at all if you keep your pencil sharply pointed and sketch the contours slowly with a fine line.

Try to keep your touch (the pressure you bring to bear on the pencil point) as delicate as the form of the flower.

In an entry in his *Journal* Thoreau says of the lupine, "You passed along here, perchance, a fortnight ago, and the hillside was comparatively barren, but now you come and these glorious redeemers appear to have flashed out here all at once."[1] And indeed they do. I am thrilled with their blueness and their abundance, and sought to suggest it in the small sketch in figure 8.18.

The lupine, like the flower of the buckeye, has numerous blossoms that grow along a stalk or axis, forming a raceme. A number of leaflets, parts of a single compound leaf, grow from a common center near the base of the stalk. It is not an easy flower to sketch briefly, and in part to suggest their numbers and not lose them in a welter of detail, I decided to omit the grasses among which they grew.

The white globe lily (fig. 8.19) was growing on a wooded hillside in a dank canyon area. I lay down next to the flower to draw it from close up. Its delicacy is a delight of sinuous line. I used a .5 mm micro-point pencil with 2B lead on index paper. The touches of watercolor dried quickly as I worked in the noonday sun. Reclining there, I became aware of the ants (and other insects), the damp, and the unyielding hardness of the ground. But the view was worth the discomfort.

Miner's lettuce grows on the damp shaded slopes of streams and woodland near chaparral (fig. 8.20). The long undulating stems, circular leaves, and small white flowers are suited to the starkness of pen-and-ink line. I used a pen point, a Gillott No. 1068A, in a penholder, dipping it into a bottle of ink. It is not too flexible, and can be used easily—as I used it—when crouching uncomfortably at a bend in a hillside trail.

Chaparral shrubs bear flowers as well. The chamise has such small blossoms that, from any distance at all, their presence goes

Figure 8.18
Lupines, pencil and watercolor. This sketch, a 3½″ x 6″ insert on a sketchbook page, was my first attempt to depict an abundance of lupines, a plenitude that is a delight to the eye.

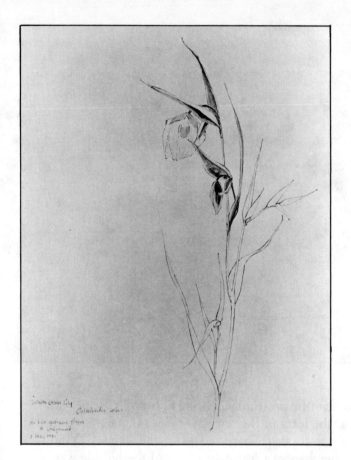

Figure 8.19
Globe lily, pencil and watercolor.
This flower's stem and bracts form
what I call a dancing line. I love to
sketch them. They grow on moist
wooded slopes, and look much like a
grass until in flower.

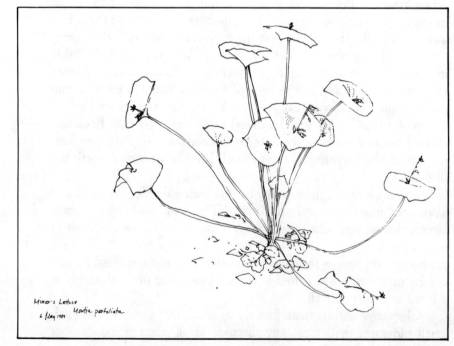

Figure 8.20
Miner's lettuce, pen and ink. The
flexible pen point might be a bit
more troublesome than a technical
pen, but it yields a deliciously vari-
able fine line, which served me well
here. The leaves of this plant may dot
the verge of a trail like clover—not
always so clearly the spreading single
plant sketched here.

unseen. It looks only as though the plant has changed color. For the sketch in figure 8.21, I collected a branch and returned home with it. (As silly as it may seem, I never do so without feeling that I have inflicted unnecessary injury upon the plant.) I placed the blossom under a binocular microscope and sketched it. As you can see, the size of the blossom is still quite small, even when enlarged in the sketch.

There is no pleasure quite so fine as meandering through a meadow with a field guide, identifying flowers, plants, and trees. In the throes of counting petals, determining leaf shapes, and examining textures, you develop a better sense of the form of the plant. Nevertheless, there is nothing quite so daunting as the first attempts. You are unused to the terms in the guides, and are unaccustomed to looking critically.

I still look back on one particular misidentification with some chagrin. I grew up in an eastern city, and the oak trees common to the West were not part of my childhood lore. Years ago, with my first field guide in hand, I identified some of these oaks as ash trees. This gave my wife, who knew very well what they were, some kindly amusement. I felt a bit foolish. My skills as an amateur naturalist have

Figure 8.21
The blossom of chamise, or grease-wood, pencil and watercolor. When many flowers grow from a single stem, botanists call them an *inflorescence.* This one happens on a miniature scale, a showy display when seen through a magnifier.

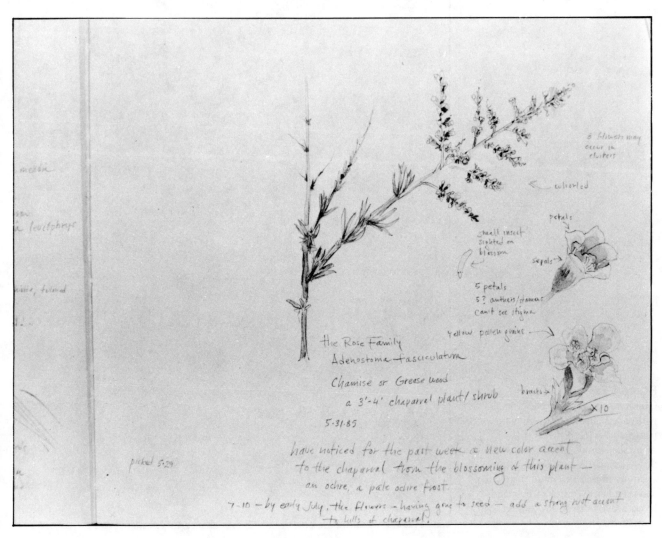

improved, but I can still get lost in the welter of references in a field guide. I enjoy the attempt at deduction whether I succeed or not, never failing to have my attention sharpened. The pleasure really begins when you have come to know four or five species of tree, wildflower, and shrub. You possess a basis for comparison, and become quite attentive to nuances of form and color that previously escaped your notice. The effects of the changing seasons are revealed.

BIRDS

In chaparral you are more likely to see a bird in flight than perched, and watching (and waiting for) birds can occupy the entire day. (Here binoculars really help to clearly see the details that identify the small songbirds.) It seems fitting to fill quiet moments of waiting with sketching, and if you reflect on my description in chapter 7 of a brief observation of a varied thrush, it is easy to see how useful sketching can be to jotting down the appearance of a bird new in your experience. Sometimes such jottings have failed me when I sat down and thumbed through a field guide to identify it, but not very often.

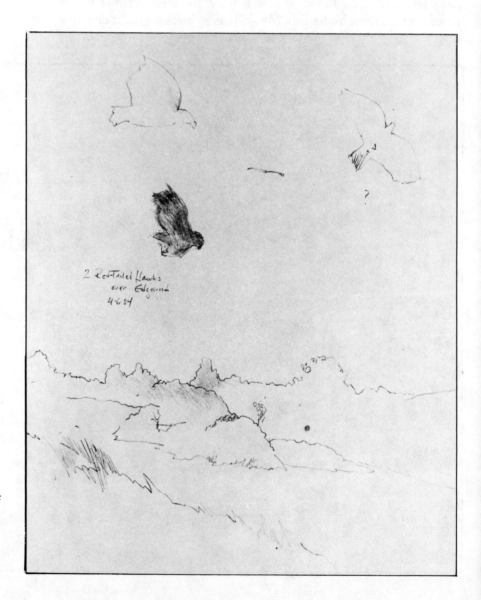

Figure 8.22
Quick silhouettes sketched from a pair of red-tailed hawks, graphite pencil and colored pencil. I have many sketchbook pages that look like this—not always successful, groping attempts to recall to mind that which was seen briefly. Birds of field and forest are a more elusive subject than shorebirds.

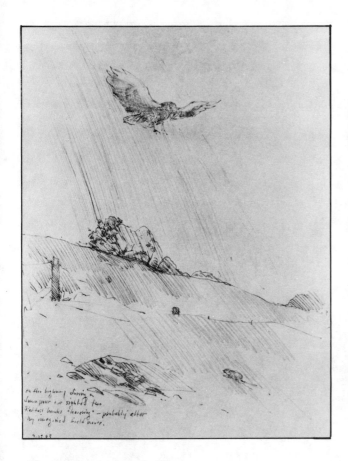

Birds of Prey

Walking the chaparral, you will frequently see red-tailed hawks soaring on thermals, warm air rising above the meadows. Or you may see them perched in the high branches of a leafless oak, watching for unwary small birds and mammals. The sharp curving talons and tearing beak are both common to birds of prey, birds termed *raptors*.

Here birds are seen at a distance. In the sketch in figure 8.22 a red-tailed hawk repeatedly surveyed the meadow near where I sat sketching. I would see it only briefly, and each small shape on my page was an attempt to remember the silhouette. I noted the reddish appearance of its form with a touch of colored pencil. In case the shapes seem small on the page, and the sketch incidental, I should mention that I did not use binoculars.

Driving on the highway one stormy afternoon, I was surprised to see a hawk attempting to hover just off the edge of the roadway. I was certain that the heavy rains had flushed out a pocket gopher in the verge below. The momentary drama impressed me, and I sketched it from memory soon after (fig. 8.23). I had to labor over the sketch to get it to look like a hawk. The eagle in figure 8.24 was also sketched from memory.

Sketching from memory is not a parlor trick; it is an effort to strengthen your powers of observation. I don't claim exacting accuracy for the memory sketches, and what success they do have is preceded by many failures.

Two small raptors, the American kestrel and the black-shouldered kite, have the easily recognized trait of hovering in the air above their prey. The wings beat quickly, appearing almost

Figure 8.23
Hawk in the rain, pencil. The rain and the hawk were observed. The field mouse was deduced.

Figure 8.24
Bald eagle, brush pen and watercolor. My youngest son and I spotted this one on our way to Año Nuevo (fig. 6.19). The local Christmas bird count lists only one—and this is the only time I've ever seen it.

Figure 8.25
Kestrel on Thanksgiving, colored pencil. An impression in memory is all that you see here. Had I defined all the feathers on the wings, I would have lost my vivid impression of the rapidly beating wings of the hovering bird, a small form against a bright blustery sky. This was my first close observation of a kestrel.

Figure 8.26
California thrasher study, pencil. This was my first sighting of this distinctive bird of chaparral. As with the varied thrush (see chapter 7), I followed up this quickly sketched, somewhat crude study with a study of a museum mount.

motionless from a distance. I never manage to have a sketchbook at hand when I come upon them, so the sketch in figure 8.25 is again from memory. (See chapter 10 for more on sketching raptors.)

Songbirds

Chaparral is alive with all manner of birdlife. Swifts and swallows dart through the air, moving so fast that following them with your eye is difficult. I have seen a swallow resting on a perch only once—at the edge of the desert, far from here (see chapter 9).

Many songbirds *do* perch and issue forth with song. The western meadowlark is frequently seen, and the elusive wren-tit, with its song sounding strangely like a bouncing ping-pong ball, is often heard. You never see the maker of this song, as it stays within the shrubs. There is also the California thrasher. In the sketch in figure 8.26, the bird on the left was observed from a distance with the aid of a monocular. Even then, I couldn't see it clearly. The bird on the right was sketched for reference from the field guide. Later I made a study from a museum mount.

ANIMALS ON A CHAPARRAL TRAIL

One of the more common residents will run across your path every chance it gets. Members of the lizard family sun themselves around almost every bend in the trail. The one in figure 8.27 obliged me by posing for several minutes. I sat on my stool, trying to avoid any sudden moves, while it continued to rest in the hot sun. It was just far enough away so that some of the details of head and limbs were difficult to see.

Other reptiles, without limbs, wind along chaparral paths. Garter snakes and rattlesnakes are resident here. I've chanced on the

Figure 8.27
Lizard studies, pencil and watercolor. I tentatively identified this 6-inch lizard as a western fence lizard. Identification requires attentive study. I'm told my lizard may have been an alligator lizard—but I failed to note (could not in fact see) the pattern clearly. The identity of its species must remain a matter of speculation.

former, but so far not on the latter. As you walk the damper, more forested slopes, you will undoubtedly see banana slugs, a mollusk, inching from one side of the trail to the other.

At dawn or dusk you may by chance glimpse a bobcat, coyote, raccoon, or opossum. The gray fox and mule deer will find their way into back yards near the chaparral. The remains on the roadway are all too often the only experience we have of an animal's residence in the neighboring environment. There is a thriving population of numerous animal species, most of them successful at eluding the noisy wanderer on the trail. Dawn and dusk are the times to look for most of them, although roaming a trail at such times is not always a good idea. At other times of day you will see brush rabbits and mule deer. These animals browse in the undergrowth.

Sketching a Deer

The squirrel that we examined in chapter 7 is a form softened and made less distinct by its fur. You can sketch most small mammals easily by doing little more than suggesting their more noticeable attributes. The opossum and the raccoon are recognized mostly by their markings. But with the larger form of a deer, coyote, or mountain lion, the appearance of the animal is more recognizably affected by the skeleton and muscles. The movement of the limbs is an ever-changing array of shapes. Now the steps we took to understand the form in a squirrel gain new importance, and should be followed with greater care. Take time to review the steps outlined in chapter 7.

How completely you can sketch a deer or any other animal in the wild depends upon the access you have to areas where animals graze or forage. It depends also on the amount of time you can devote to patient waiting. To do more complete study sketches, I have turned to regional zoos and natural history museums (see chapter 10). Sightings in chaparral are likely to be fleeting, with the animal moving. It is a gesture sketch that is best done at such a moment, before memory has faded. Such a sketch is easier to do if you have given some time to researching the basic forms of the animals you have an interest in sketching.

The gestural sketch, as we've seen, conveys movement or a briefly assumed posture. Rarely will it clearly delineate contours. There just isn't time. Such sketches are of benefit in giving a liveliness to more complete sketches or drawings done from photographs or prepared museum mounts. (If you have made quick sketches of the live animal, you will note any stiltedness in a photograph or mount.)

In figure 8.28, several typical movements are sketched. I have added axis lines to show how the limbs bend, and have in effect shown the location of the long bones of the limbs. The axis line I have drawn along the spine should be understood as a flexible line. In contrast to the unyielding nature of the bones of the limbs, the spine is composed of segments. Each segment moves slightly in relation to its neighbors as the back bends or straightens. Such movement is more limited in the larger mammals, more pronounced in the smaller. The neck also bends and twists to a limited extent, but can drop or lift to a greater extent at its juncture with the shoulder.

The movements illustrated in figure 8.28 are sketched as gestures in figure 8.29. Continuous, sweeping hand movements are used to sketch a line that suggests movement. It is obvious that no drawing or sketch "moves" in any real sense. Movement is implied. When you glimpse an animal only momentarily, the gesture sketch can be a very satisfying way to capture the experience. (See chapter 10 for more on sketching the large mammals.)

PREPARING FOR A VISIT

Chaparral regions contain many parks and hiking areas. Some have been set aside to remain in their natural state, and contain trails that allow the interested visitor to explore. Others are crisscrossed by equestrian trails, not all of which permit hikers. A horse and rider are a commanding presence on a trail. Exercise caution, and move off the trail if possible. Keep in mind that horses can be startled. Don't approach them or make any sudden movements, and stay well clear of their legs. The rider risks being thrown if the horse is spooked by your actions, and many less-experienced riders are understandably apprehensive when they encounter you unexpectedly.

Much of the chaparral is privately owned land. Be sure to observe posted boundaries.

Hiking

The remarks on hiking in chapter 7 apply here, and it would be a good idea to review them. Comfortable shoes, anticipation of

Figure 8.28
Postures and actions of mule deer. The axis lines illustrate the positions of the long bones of the limbs and the movement of the spine.

Figure 8.29
Gesture sketches of mule deer. The poses illustrated in figure 8.28 were based on these sketches. I saw the deer in the headlights of our car just before dawn. They were crossing the suburban road toward fresh grazing. Finally, all three leaped over the guardrail and down the slope. I sketched them from memory moments later.

possibly muddy conditions, insect repellent, and sensible clothing are all necessary considerations.

Hazards

Two notable hazards are present in chaparral: poison oak (fig. 5.18) and the western rattlesnake. Poison oak is plentiful. Its red-tinged, somewhat glossy, three-leafed form is not too difficult to learn to recognize. The reddish quality is not always present; don't rely on it. The remarks on poison oak in chapter 5 are worth reviewing.

Natural springs are sometimes found in chaparral. If you walk a trail through reeds or rushes obscuring the ground, exercise caution.

Recent medical findings have noted a tic whose bite can produce a malaise that sometimes leads to more serious medical consequences. Straying off trails increases the risk of coming into contact with such insects. Here, insect repellent will be of no help.

Moving quietly along a trail, you will hear movement in the brush. Although it could be a rattlesnake, it is more likely to be a deer, coyote, fox, rabbit, quail, or any other of the many inhabitants of the chaparral who are seen but fleetingly. Remember that it is their home.

9
DESERT AND MOUNTAIN

I first saw the desert as we drove eastward from the Sierra, and it quite took me unawares. There were no sand dunes or saguaro cacti, no warning signs of heat or dryness. Leaving the meadows of the high Sierra behind us, we drove through an alpine pass and were suddenly thrust into a land of bleached color and dwarf shrub. To experience it for the first time is to pass through a gateway into what seems a land at the end of the earth. Faded green sagebrush is everywhere, matting the stony desert floor far into the distance. The breeze is a hot dry wind, carrying the aroma of the brush.

After the drama of the mountains, the desert seemed an uninviting, uninspiring expanse with little to sketch. Our first impulse was to turn around and return the way we had come. Then we looked up at the clouds and back toward the mountains, and the desert began to work its magic.

The Sierra stands as a commanding wall at the western edge of the desert, the Pyramids of the American desert. Geology field guides refer to this side of the Sierra as the eastern escarpment, an appropriate name suggesting the ruggedness of the sharply rising rock face, variegated in color, cut through with canyons formed by advancing and retreating glaciers. Peaks are touched with red, not from the light of a rising sun, but from remnants of the seabed out of which the mountains rose.

In the onset of a summer afternoon, cumulus clouds materialize, drifting eastward from the mountains, to tower above you. The light becomes dappled, patterns of light and shadow constantly shifting, creating a chiaroscuro across the desert. The clouds seem to accumulate into the evening, all the forms—cumulus, cumulonimbus, cirrus—blending from horizon to horizon. Thunderheads blend into night, and lightning dances in the mountains to the east.

A DESERT SEA

There is an oasis here. The streams that descend eastward from the divide of the Sierra flow into the Great Basin, giving it its name. Some flow into a small saline desert sea, now much diminished, called

Mono Lake. A marsh on its northwestern shore provides a green contrast to the surrounding warm gray of volcanic earth. A freshwater stream, sporting willows and cottonwood trees, flows through it. In a quiet moment here, we observed a wren nesting in the scaly bark on the trunk of a willow. The nestlings, in the joy of new life, were too noisy to remain unnoticed. The female wren scurried about the limbs of the tree in great determination, securing—or so we supposed—insect food. She seemed to take a dim view of our attentions.

Mono Lake has two islands, remnants of volcanoes that once rose from beneath its surface. Freshwater springs precipitating minerals into the briny waters of the prehistoric sea have left irregular crystalline spires called *tufa* along the shore of the modern lake, standing higher than the tourists who come to view, photograph, or draw them (see fig. 9.1).

During fall migration, birds inundate the shore—particularly the eared grebe—attracted by the brine shrimp, one of the few creatures able to live in the saline lake. The California gull and the snowy plover nest here. I espied an old friend from the chaparral, the violet-green swallow, perched on the tufa (fig. 9.2). With water diverted from the streams that feed it, the lake is diminishing in size and increasing in salinity. It may soon cease to support bird life. The needs of a faraway city threaten to alter the face of nature here and make a desert that is truly barren.

Figure 9.1
A tufa spire, pencil and watercolor. Limestonelike formations of this kind stand approximately twenty feet above the surface of Mono Lake, an indication of the level of the lake in prehistory. Small brine flies form a black "sludge" at the water's edge.

Figure 9.2
Violet-green swallow perched on a tufa spire, pencil and watercolor. Observing this bird through a spotting scope, I was able to remain a distance away and not startle it into flight. This was a rare opportunity to study the bird at rest.

DESERT SEASONS

This is a northern desert, and between November and April it is adorned with snow. Outcrops of rock stand in stark contrast to the blue-white mantle. In its cold and forbidding aspect, it personifies the frozen face of winter. Periodic blossomings of wildflowers in the spring saturate the desert with intense color. In the summer it is adorned with earth colors and the muted greens of the brush.

It may seem lifeless and changeless at first glance, but it is not. Spend some time in it, study it, and the desert becomes alive with form, color, and animal life. And it has its seasons.

THE DESERT PLAIN

A desert landscape sketch can begin simply enough with the horizon line. Where shall you place it? High on the page to emphasize the ground plane—the seemingly endless sagebrush? Or low on the page to emphasize the lowering clouds? (See fig. 9.3.)

In figure 9.4 I looked eastward while sitting on the south shore of Mono Lake. I could see cascading, rolling mountains on the horizon, the long parallel divisions of basin and range. In the early morning light veils of blue-gray and opalescent violet played across their layered silhouettes. I sketched facing into the sun, and the sagebrush cast no shadows, fillling the interval between me and the horizon. What kinds of sagebursh did I see? *Artemesia tridentata* is supposedly common in this region of the Great Basin, but I was not sure that it was the plant that I was engaged in sketching. I sought only to suggest the plant, not to define it. It was a beginning, a first effort.

Like the coast, the desert offers a limitless horizon. Here, however, it extends outward around you on all sides. You can look upward at cloud upon cloud, or downward at shrub upon shrub. A sketch might reflect the shapes of the one in the other. Or the sky may

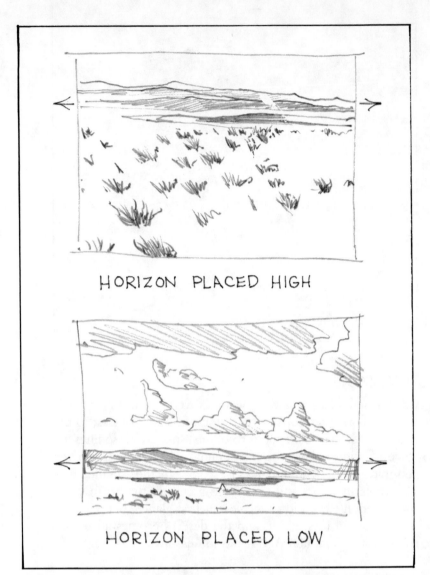

HORIZON PLACED HIGH

HORIZON PLACED LOW

Figure 9.3
In a landscape dominated by the horizon, where should you place it in a sketch? A high placement emphasizes the surface of the desert, a low placement the canopy of the sky.

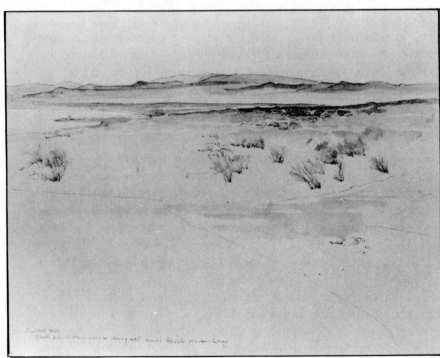

Figure 9.4
Nevada horizon, pencil and water color. No sound of surf, wind, rustling trees, or birdsong filled the air—only the burning light of the sun, and quiet.

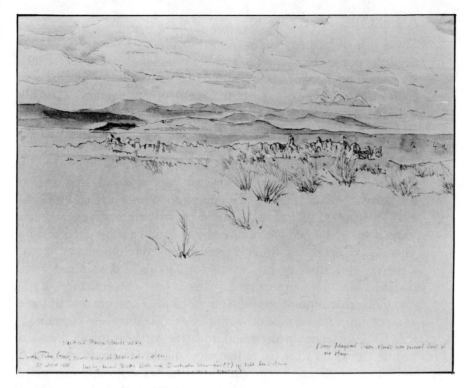

Figure 9.5
Mono Lake, pencil and watercolor. Like the ruins of a distant city, the tufa formations tower at the lake's edge. I was unmindful of the sun, preoccupied with sketching, and only later realized that I had become dehydrated.

be featureless, in contrast to the texture of the plain. A geological formation may provide counterpoint to the horizon. The tufa is such a formation (see fig. 9.1). It stands along the shore of Mono Lake at the sites of vanished freshwater springs. In the sketch in figure 9.5 I looked toward the south shore of the lake. In a lapse of common sense, I drew in the oppressive heat of noonday, shielded only by the small shade at the side of our truck.

We returned in the welcome coolness of early morning to sketch the Mono craters, plug domes and flows of geologically recent (and still dormant) volcanoes, which rise immediately south of the lake. The shape of a volcano, the surrounding pumice, is redolent of the forces at work within the earth. This thought passed through my mind as I sat on the tailgate, pad in lap, crowquill pen in hand, and ink by my side. The subject seemed to warrant the stark black line of pen and ink (fig. 9.6).

Figure 9.6
Mono craters, pen and ink. Not too far below the surface of these dormant cones, there is an active caldron of volcanic activity, ready at any time to affect the surface of the region.

AN EXOTIC LANDSCAPE

There is a town a few miles from the volcano I sketched. For the residents of the town, the volcano is a commonplace feature of their surroundings. For me, as a visitor, it could be said to be an exotic element in a foreign landscape. Such an observation is usually followed by the assertion that one would do well to depict known environments, that there is more truth and depth to be found in and conveyed by the landscape of everyday experience. Constable recorded this feeling in his letters, and his subject is invariably the countryside of his childhood. However, Moran did his best work in the "exotic" canyonlands of the American West, far from his home.

The caution against the exotic that most artists will encounter at some point in their education is really a caution against superficiality. This is a critical thought that is usually applied to finished art, not to a sketch. Nevertheless, it is worth considering. I considered it as I sketched the dormant volcano. Was it just the romance of the unfamiliar that I found appealing in its form? I am sure that this was a factor in my interest. But the simplicity of its form also appealed to me. Its association in my mind with the vital forces of the earth inspired me. I am attracted to that same quality in a landscape I know well. The movement of the earth's plates has shaped the chaparral near my home. There are other parallels in the dry conditions common to both places.

I suspect that we will always look with greater perception on a place that attracts us—not as being novel or exotic, but as inspiring a sense of attachment. For some, as for Constable, this will never be far from home. For others, as for Moran, it will include many far places. It is the attachment and appreciation that matters, not whether it is near or far.

DESERT PLANTS

Juniper trees and many forms of cactus are common to the desert. Sagebrush and associated varieties of scrub carpet the desert regions east of the central Sierra. I responded immediately to its hoary green color and fine texture, delighting in the quick gestural movements of the pencil that depict its qualities (fig. 9.7). Sagebrush is a theme with many variations. As I tried to botanize it, I discovered to my astonishment that the varieties filled a book as thick as a dictionary. Field guides that focus on local flora can be helpful in this situation, and we purchased local guides to prepare for future visits.

Until you experience it for yourself, it seems a personal conceit to rhapsodize on the sagebrush. Unlike the drama of rock form, which commands immediate attention, the sagebrush effects a seduction. Its aroma, its subtle variations of green, it's shifting mood and character in changing light are all ultimately entrancing.

A Cactus in Flower

Various circumstances have prevented my witnessing the desert in bloom—one of its most glorious moments. On a day trip, farther south into the Great Basin desert, my wife noticed a lone cactus in bloom. We were driving along a high mountain plateau. Later in the

Figure 9.7
Sagebrush studies, pencil and water-color. Unfortunately, we were unable to find any local field guides to help unravel the variations in these fasci-nating plants.

Figure 9.8
Cactus study, pencil and watercolor. As I made this quick sketch in the late afternoon, I promised myself we would return sometime to see this desert in bloom.

day, returning down the road, I stopped and quickly sketched the cactus (fig. 9.8). For many years I have taken classes to visit a botanical garden that has a cactus garden as its centerpiece. Never did I experience there the peculiar satisfaction I felt at that moment in front of the lone cactus. Its brilliant yellow blossom has only a pale counterpart on my page, and I could only hint at the profusion of spines. The plant grew in its natural habitat. It partook of the desert, and gave something to me as I sketched it. It had a single blossom, hinting at the glory of color in a spring landscape, a siren song to lure me back.

A GHOST TOWN

In our explorations of the desert, my wife and I decided to visit an abandoned mining camp north of Mono Lake. While I call it a mining camp, let me hasten to add that at the height of its brief existence, ten thousand people lived there. It is preserved in its present state of decay and is not allowed to fall further into disrepair. Visiting this ruin is an adventure. A slow rough ride on unpaved roads is guaranteed to loosen every bolt in your vehicle. Either of the two roads that lead there will take you through canyons of cinnabar that open out onto high mountain desert. There, cradled in a small valley, are the ruins of Bodie (see fig. 9.9).

Ruins have an atmosphere of romance mixed with reminders of our mortality. Abandonment suggest both a place outgrown and the ventures that failed. Histories of Bodie tell of fortunes quickly made and soon lost, daily shootings, and squalor. They also tell of earnest lives that contributed to the world beyond the camp. The abandoned objects of daily life seen through the windows of crumbling homes bespeak the harshness of life there.

Bodie's location has set it apart from the stereotype of a ghost town. Harsh wind and high altitude have refashioned the crumbling homes into natural forms. Most of the exposed wooden walls glow with amber radiance, with little of the gray pallor of old timber. If their collapsing structure did not tell you otherwise, you would think the remaining buildings newly built. Adding to the color, the hammered metal that was occasionally pressed into service as wall or

Figure 9.9
Carol J. Gayton. *Jim Todd House,* 1985. Porous-point pen, brown, 12" x 9".
(*Courtesy of the artist.*)
The power poles may seem anachronous in a sketch of a western ghost town, but Bodie was the site of the first transmission of electricity over wire.

roof has become in some instances brick red, and in others gunmetal blue.

I sat behind the church to do the sketch in figure 9.10. Here I used a No. 1 technical pen, beginning the sketch with the roof of the church. Sketching a building is a problem in perspective. Note how much of the building is above your eye level as you look toward the horizon, and how much is below (see fig. 9.11a). Then measure the illusory angles formed by the walls (see fig. 9.11b). (If you look across the top of the sketchbook, it can provide a more or less true horizontal line and aid your judgment.) Sketching the outline of the roof and walls solved the problem of perspective, and allowed me to draw without penciling in guidelines.

Much of the camp burned in the 1930s, and some of the remaining buildings have collapsed, the brick liquor warehouse among them (see fig. 9.12). As my wife sketched this, cows grazed nearby. Other than the rangers assigned here as caretakers (and as guards), the cows and the sage grouse are the only active inhabitants.

The graveyard looks down upon the camp from a hillside to the north (see fig. 9.13). One particular grave with a wooden marker, the

Figure 9.10
Bodie church, technical pen. Rangers and their families live year-round in the house fronting the church. Just as it was in its heyday, the town is snowed in for much of the winter.

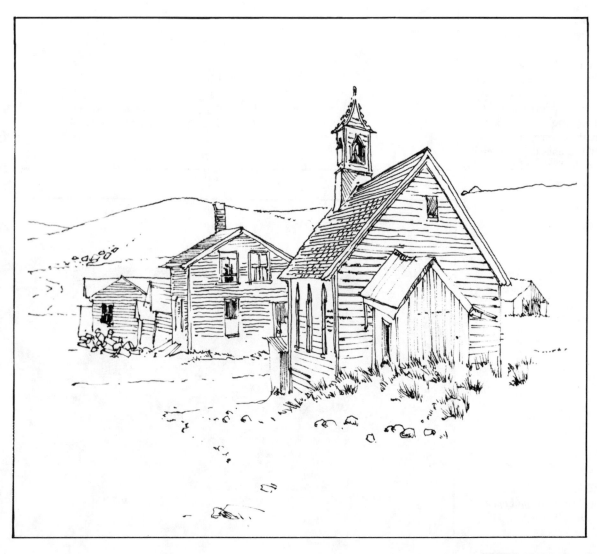

Figure 9.11a

Utilizing the horizon line to sketch the church in figure 9.10, I measured how much of the building seemed to extend above the horizon line and how much below it. The eaves of both roofs seemed to match a true horizontal when I peered across the top of my sketchbook at them, and I accepted that position for my horizon line. I also compared the overall width of the church to its overall height. Finally I compared the width of the two sides I could see.

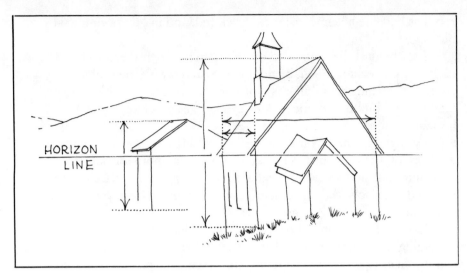

Figure 9.11b

Judging the angles of perspective (of recession) in figure 9.10. As limits, I selected the pitch of the roof and the bottom of the windows. I judged the apparent angle by again peering across the horizontal formed by the top of my sketchbook. Note that *all* the apparent angles formed by the side of a building appear to converge on a point on the horizon line.

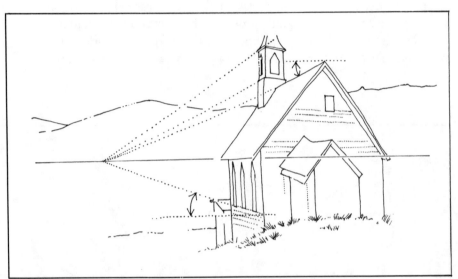

Figure 9.12

Carol Dughi Gayton. *Bodie Liquor Warehouse,* 1985. Pencil, 9″ x 12″. (*Courtesy of the artist.*)

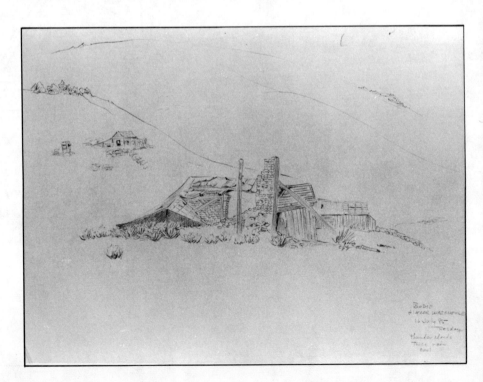

Figure 9.13
Bodie grave, technical pen.

name long since erased by the wind, the enclosed area disappearing in the growing brush, was a poignant reminder of the unceasing renewal of nature, of which we are part but not master.

MOUNTAINS

The Sierras, the basin and range, and the Rockies are a textbook in geology—cones of volcanoes or ancient seabed uplifted by colliding continental plates. Some of the mountainous terrain is sedimentary rock, compressed under prehistoric seas, uplifted to become broad mountain plains, and then partially weathered away by erosion and the cutting action of a river. Much of the landscape of the American West bears monumental if mute testimony to the drama of this eons-long process.

The cliffs and mesas of the Great Basin offer endless metamorphosis of weathered, eroded rock formation. Bands and striations of rock, layers of sediment, volcanic layers together present a panorama on an epic scale. I could note this but briefly in pencil (see fig. 9.26) as I looked through the train window while traveling across Utah. It was winter, and the desert was covered with snow. Herds of elk gathered near frozen rivers and isolated ranches, seeking food. As I looked at the geology of the Great Basin, I was struck by how familiar it seemed. I sat watching the coastline of a long-vanished sea flow past my window. I have spent all my life living near ocean coastline. With the association they suddenly had with a familiar place, this mountain and desert were bereft of their strangeness.

The mountain peaks that rise above timberline (the highest altitude at which trees will grow) are places of rock and scrub. There are canyons cut by glaciers, and passes plummeting to the plains below (see fig. 9.14).

Below timberline are expanses of conifers, creating serrated patterns over valley and canyon. Meadows and streams interrupt the forest, smaller worlds within the larger. Rock outcrop occurs here

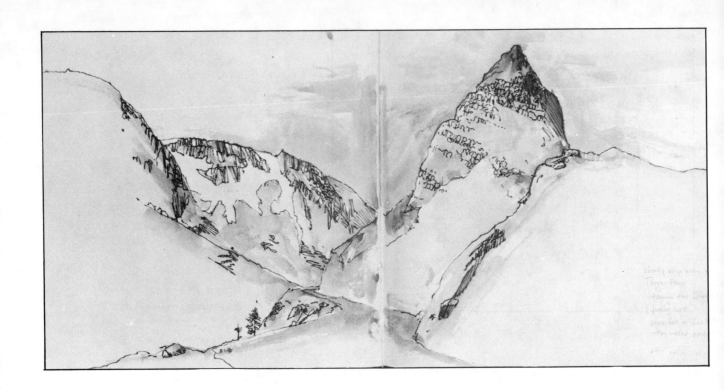

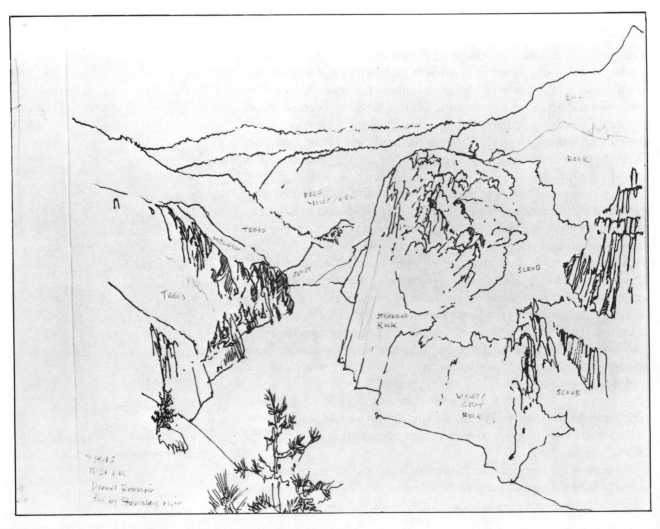

too, a place where the plant kingdom has yet to gain a foothold. The rock forms ledge for mountaineer or waterfall, sometimes dropping thousands of feet (see fig. 9.15).

When viewed from the nearby desert, the mountains seem a caldron of weather. It seems to actually materialize here, as sudden changes in temperature accompany the movement of clouds across the firmament, and monumental thunderheads with their veils of shower appear without preamble.

Through the life zones of a mountain pass all manner of small and large mammals. Ground squirrels, bobcats, mountain lions, bears, deer, elk (wapiti), and bighorn sheep are some that venture here. Birds live along (and in) mountain streams, among the branches of its forest, and in the understory. Images of the bald eagle perched in leafless trees along the Colorado still live in my mind, though I never got close enough to sketch them.

A FOREST NEAR TIMBERLINE

Bristlecone pines grow high on the White Mountains, a mountain range in the basin and range, just east of the Sierra. The bristlecone pines growing there are thought to be the oldest of living plants.[1] One (wisely unmarked) specimen is deduced to be forty-six hundred years old.

The fiercely driven sand of desert summer winds and the blasting of ice crystals in mountain winter storms have polished the surface of the bristlecone to a metaphor of endurance. This picturesque skeleton of a tree that resembles driftwood is dead tissue. The living element of the tree is contained within a thin bark that adheres to more protected portions of the trunk—that is, if any living element remains. Many of these "trees" are fossils, the dead bones of a once living form.

Sketching on a Mountain Trail

To acquaint ourselves with the world of the bristlecone, we climbed a trail called Methuselah Walk. It was our first venture into any kind of subalpine region. The trail follows mountain slopes for a circuit of five miles. We had not gone more than half a mile when we found ourselves able to look downward a considerable distance. The trail had become narrow, high on a slope of loose rock. There was nothing to hang on to, and with sketchbook and materials across one arm, I was less than perfectly balanced. (This was poor planning on my part. Everything should have been in my backpack.) Ultimately we perched on a bend in the trail that was broad enough to allow us to move about, and to sit without blocking the trail. It possessed the requisite tree at cliff edge—in fact, several of them.

Figure 9.16 is a sketch inaugurated at this spot. I sat, placed my ink where I wouldn't spill it, and began to pencil in some of the main contours of the trees. I got no further. A sudden booming reverberating through the surrounding canyons seemed ominous. The booming inspired the mountain winds, which then arose to blow an eerie accompaniment. I was unnerved and suggested a prudent return to the head of the trail. The inked line visible in figure 9.16 was added

Figure 9.14
Above the timberline, 9,941 feet elevation, at Tioga Pass, porous-point pen and watercolor. A quick pen sketch while we stopped briefly at the pass had color added to it later that evening.

Figure 9.15
Overlooking Donnell Reservoir, technical pen. Evidence suggests that a volcanic flow began here and made its way westward across what is now the Sierra, forming table mountains on the western slopes.

Figure 9.16
Bristlecone pines at 11,000 feet, pen and ink over pencil. Here we seemed to stand at the edge of the world, guests of these long-lived trees. John Muir would probably have called the prospect "glorious"; it was certainly transcendent.

to the sketch later. Studying a map, we surmised that the booming was military testing at an installation to the south.

Perhaps I cut an inglorious figure in retreat, but I was in unfamiliar terrain, an inexperienced walker of mountain trails. My head throbbed, and I found that I tired easily. I was having mountain sickness. On a subsequent trip I allowed my body time to adjust, avoiding sudden exertion. Use caution as you approach terrain and conditions you have not previously experienced. Don't attempt to penetrate to locations for which you lack proper preparation and experience.

We returned to the head of the trail and ate our lunch. A golden-mantled ground squirrel broke bread with us (fig. 9.17), and

Figure 9.17
Golden-mantled ground squirrel, pencil and watercolor. This was my only close observation of a ground squirrel, and my understanding of its form is still tentative. Compare figure 7.27.

I sketched what I could memorize of its color and markings while it darted around us. We saw others frequently as we drove through the mountains in this region. One or another would dart across the roadway with its tail held high.

With the beginning of the afternoon, we assembled our gear and went in search of a less trying vantage point. Cloud began to drift overhead, giving momentary relief from the biting sunlight. The clouds seemed to materialize out of nowhere above the peaks of the nearby Sierra, and I had been tempted to sketch them since our first day on the desert. I sat down and began the sketch in figure 9.18. In the arid mountain air the watercolor washes dried almost instantly.

Farther up the mountainside I spent the middle of the afternoon working on a study of a bristlecone. In the spirit of experiment, I worked on bristol board (a hard-surfaced paper suitable for pen and ink) with a crowquill pen (fig. 9.19). As with the watercolor sketch, the arid atmosphere dried the ink quickly—too quickly! It tended to dry right on the pen nib. After a time a crust would form, which I gently scraped away with a pocketknife. In spite of this, the leisurely study became a timeless and peculiarly satisfying effort. For a brief while, my life ran parallel to the grain in the trunk of an ancient tree.

Moving back down the trail later in the afternoon, we both sketched the cone and leaf (needles) of the living tree (see fig. 9.20).

The Substance of a Mountain

Much of the Sierra is granitic. With varying shades of gray and from varying agencies of erosion it assumes different forms. There are remnants of glaciers upon some of the peaks. Sketching the mountain peaks in the stillness of early morning, we could hear unseen meltwater flowing boisterously over rocky cascades (see fig. 9.21). The grandeur of a mountain is difficult to express in the miniature format of a sketch. The sketch in figure 9.22 took advantage of the

Figure 9.18
Schulman Grove, pencil, pen and ink, and watercolor. I began the sketch as a pen study, abandoned that idea, completed the contours with pencil, and finally approached the sketch as a watercolor study. The wind whistled, and the air was charged by the thunderclouds above.

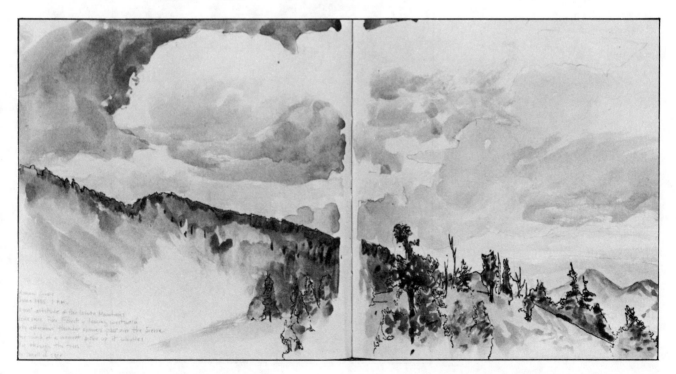

Figure 9.19
Bristlecone pine, 12″ x 9″, pen and ink. This was truly a fossil; no living element remained. Beyond the tree I could see the mountain view you see in figure 9.18. I reveled in a form that is a symphony of sinuous line.

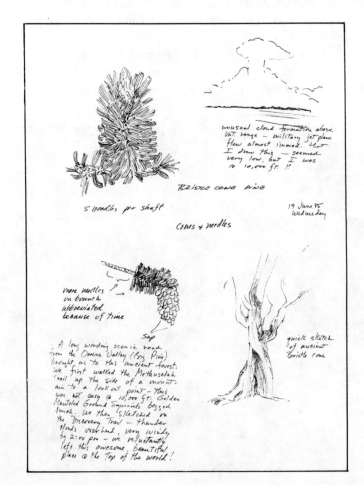

Figure 9.20
Carol J. Gayton. *Bristlecone pine cones and needles,* 1985. Porous-point pen, 12″ x 9″.
(*Courtesy of the artist.*)
As you can see, Carol is given to annotation, and her sketchbooks are as much journals as sketchbooks.

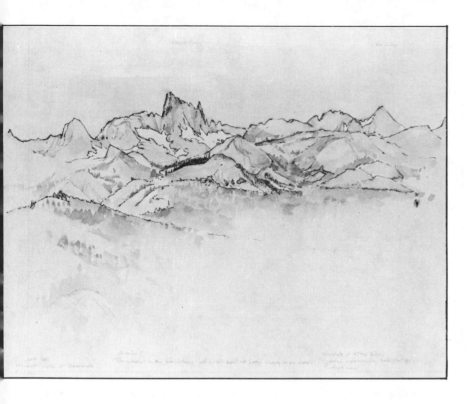

Figure 9.21
Minaret Peaks seen from the Mammoth Lakes area, porous-point pen, watercolor, and touches of pencil. The white areas near the peaks are small areas of glacier. John Muir was the first to discover the presence of glaciers in the Sierra.

Figure 9.22
Convict Lake, detail, pencil and watercolor. Stephen Whitney (see the Bibliography) likened the appearance of the folded geology here to a chocolate sundae—a delicious analogy.

Figure 9.23
Yosemite, Olmsted Point, porous-point pen. This is a popular stop for tourists, attracting momentary admiration as a flower attracts bees. There is a constant clicking of cameras, the revving up of auto engines, and much chatter—a spot to take in the wonder of the granite, but a poor locale for contemplation.

horizontal shape of two facing pages of my sketchbook. I exaggerated a sense of the diagonal in the clouds materializing above as a reference to perspective, hoping to suggest the height of the mountain. It is remarkable how successfully Leonardo expresses the scale of mountains, and at the same time how economical are his means (see fig. 1.2). Moran uses the vertical page to express height (see fig. 1.11).

In the sketch in figure 9.23 large boulders called *erratics*, deposited by melting glaciers, stud the surface of a jointed rock slope high above Yosemite. Perhaps I should have sketched a figure standing by the tree to suggest the scale. The "joints" in the rock, running like lines of longitude and latitude, are thought to represent the results of strain produced by movement along the San Andreas fault far to the west. The lines suggest the powerful forces that change the face of the planet.

Winter closes the path to the mountains for most of us. The severity of the winter can almost be felt in the frost riving, a process that breaks solid rock into blocks (see fig. 9.24). The juniper has taken root in the purchase offered as alternating heat and cold produced breaks in the rock.

With the exception of figure 9.22, these mountain sketches were done with a porous-point pen, one designed to imitate the qualities of a technical pen. The large shapes were simple and the relationships uncomplicated, giving me an opportunity to sketch without using penciled guidelines. In some I employed crosshatching to show form (described in chapter 4) and to suggest sunlight. The directness in such sketches gives a special pleasure to the moment. You fully experience drawing as perception.

For the first of these mountain sketches, I had reached into my kit for a technical pen. As I removed the cap, the sun glinted off the surface of wet ink. The pen had not so much leaked as exuded the ink through the threads of its point. As we drove up into the mountains

Figure 9.24
Sierra juniper by Lake Tenaya, porous-point pen. I began the sketch with the tree and worked outward, eliminating the need for any penciled guidelines.

the pen lay flat in the kit, and I suspect that the change of air pressure had caused the pen to leak. On a return trip I placed the technical pen, point upward, in a container that kept it standing vertically. I had no problems with leaking.

Collecting Rocks

C. R. Leslie records that after sketching Constable returned to his studio with samples of both earth and stone—in fact, with anything that would renew his vision of the color and texture of a place.[2] This account served to inspire my own rock collecting (see fig. 9.25).

In most state and regional parks, collecting of any sort is prohibited. If it were not, such places would quickly be denuded. Our collecting was confined to moraines of rock and roadsides. We returned home with a Sierra in miniature, serving as a talisman of a mountain place, and for reference.

PREPARING FOR A VISIT

Dehydration

A sketching trip into the desert or mountains is not a casual undertaking unless you already live there and are well familiar with them, or are an experienced backpacker. Food and lodging (or camping) must be researched and planned first. Carrying ample drinking water is vitally important in both environments, as each is very dry. In the intense heat of the desert you can have real problems with dehydration. (Failing to anticipate this, I found myself drinking our watercolor rinse water.) When sitting and sketching in the more intense sunlight, a hat makes good sense.

Figure 9.25
Two igneous rocks, 2B pencil, 6½" x 7". The substance of the rock on the right was laid down in a volcanic flow and occurs along much of Highway 395 at the east side of the Sierra. At home, these provide concrete reference tools—as Constable often used gathered rocks—but also serve as talismans of a place and geologic history.

Altitude and Weather

The altitude of the mountain environment deserves special consideration. On a warm summer day, the advent of cloud cover can chill the thin air to a surprising degree, chilling you to the bone as you sit sketching. Have warm clothing, and remember that a hat helps conserve body heat.

The weather can change quickly, and in the Sierra summer thunderstorms are common in the latter part of the day. One of the most dangerous places to be during such a storm is on a rocky promontory. As winter approaches, the danger presented by the advent of storms is very real. Keep abreast of weather reports if you plan to be in the mountains over a period of days.

Figure 9.26
View from a train window, pencil and watercolor. It amused fellow passengers to see my wife and me at the train window busily filling sketchbook pages—and me with a portable watercolor box doing watercolor notation "on the run."

Hiking

Hiking into the mountains is not a casual matter. Permits are frequently required. Consult someone experienced before undertaking this activity yourself.

Mountain Sickness

Altitude or mountain sickness can be a troublesome problem. Rapid ascent by car to high altitudes can bring it on. (It takes several weeks for your blood to adjust to an atmosphere with less oxygen.) Its symptoms usually consist of headache and tiring easily with any exertion. The cure is to descend to lower altitudes.

Unpaved Roads

Driving off paved roads (especially out into the desert) can be dangerous. Consult local authorities before doing so. The roads of Bodie (discussed in this chapter) are unpaved, punishing roads that can easily damage a vehicle that is in poor repair. Deep rock-ridged ruts are common in such roads. Chips of obsidian litter the volcanic earth in many parts of the desert, and can easily cut into automobile tires.

These cautions are not intended to discourage you from planning a sketching trip, but to make you aware that these can be extreme and in some cases hostile environments.

10
EXPANDING YOUR
NATURE STUDIES

When you do a hurried sketch of a kestrel before it leaps into the air, or hastily draw a few lines to capture the gesture of a coyote as it trots into the brush, you may keenly desire a longer look at what you glimpsed so briefly. The modern naturalist would track the animal, set up a blind from which to observe it, and spend many patient hours waiting and watching. Although this is without doubt the best method to further our studies of an animal, most of us do not have the free time or the resources to undertake such an approach. We can turn to zoological gardens and natural history museums.

THE ZOO

No matter how informed its approach, the zoo is not wild nature or a preserve. Conditions vary even in a single zoo. Some have incorporated the elements of a preserve, and seem humane. To their credit, some zoos have taken an active role in reintroducing animals to habitats from which they had vanished. But the zoo remains an artificial enclosure. The facts are that the zoo is there, it does house animals that are disappearing from the wild, and it does offer us the opportunity for close and sustained observation of living animals. For all its less-welcome aspects, the zoo offers the excitement and inspiration of studying animals we might never see otherwise. But there is no dismissing the dismaying reality of captivity.

A captive animal should be studied with the thought in mind that it is different from the same animal living wild. Observers who have studied this problem have noted that captivity alters behavior (for example, an animal may become less alert as it grows used to the safety of captivity).[1] Breeding an animal in captivity may lead to changes in anatomy (for example, the bone and muscles of the jaw of the zoo-bred lion do not develop as fully). Some zoo animals are raised in the care of humans, and this affects behavior. The animal comes to regard itself as human, and responds to human attention. This can lead to touching recognition from an animal you sketch frequently, as it did with a lemur I sketched named Lenny (fig. 10.1).

Figure 10.1
Brown lemur study, pencil and
watercolor. This human-reared animal
became accustomed to my visits. Draw-
ing him became like visiting an
old friend.

Figure 10.2
Coyote study, pencil. Although the
coyote lives in the chaparral where I
live, my only encounters with it have
been at the zoo. I often hear its song
echoing across the canyons at dawn
or dusk.

It was charming for me, but it was sad for the lemur. Attempts to mate Lenny with a wild lemur failed.

Konrad Lorenz, in his extraordinary studies of animal behavior, points out that it is difficult to assess the condition of an animal's life in a zoo because we project our perceptions onto the animal. What an animal really needs in the way of living conditions and what we think it needs can be two entirely different things.

However much I may dislike the captivity of animals, I do appreciate the opportunity to study them closely.

Sketching in a Zoo

Sketching in nature is usually a solitary activity. Hikers and venturers into nature will tend to respect your privacy when they come upon you. Sketching in a zoo is an altogether different matter. In effect, you become another exhibit. Much of the public has come looking for entertainment, and you provide an unanticipated attraction. Few can resist the urge to gaze over your shoulder as you draw. If you have not developed confidence in sketching, this will be unnerving. Some will not hesitate to intrude into your need for concentration with their questions. Polite, short answers will usually forestall lengthy interrogations. When you stop drawing for a while, to study the animal, you cease to be entertaining, and your audience will move on to other attractions.

There are definite, useful strategies for a sketching trip to a zoo. First, arrive early. The animals are sometimes more active in the morning hours, before they have been fed, before the heat of the sun is full upon them, and before they have been made numb by the noisy viewing public. At this time also, there is less of the public to contend with. Second, if you use a stool, use one that is small and inconspicuous. If you appear to be camped in front of an animal, you will most assuredly attract attention. (Bright clothing is not advised either.) Third, the simplicity of your equipment is the key to a successful day. Be prepared to sketch the instant there is something to sketch, for it may be gone a moment later. As zoos provide more enclosures that resemble the environment in which the animal normally thrives, you will find binoculars helpful.

I will plan to spend time with several animals during any single visit. Occasionally my early arrival will be rewarded by my arousing interest rather than indifference on the part of my subject.

A Coyote. The coyote in figure 10.2 was one of a pair. It appeared interested in my quiet and solitary study, and stood watching me for a while, much as it appears in the sketch. My previous visits had always occurred later in the day, and both coyotes had by then retired to nearly hidden corners to sleep. (The coyote is normally active at dusk and at night.) I was delighted to have the opportunity to attempt a thorough study.

I began the study with a purposefully meandering line, the kind of line visible in the lower sketch on the same page. Here the sketch has stopped at that stage; the first sketch progressed to line hatching showing the direction of the fur tracts, which soften the formerly hard contour line. The contour was not softened until I was satisfied that I had achieved a reasonable representation of the forms,

Figure 10.3
Coyote, gesture studies, pencil. Note the small size of each sketch. This allowed me to realize an image of the gesture quickly.

proportions, and posture of the coyote. I then erased the exploratory lines. (You may wish to review the discussion of studying the form of a mammal in chapter 7.) I gave particular attention to the head and feet—usually the animal is not close enough for them to be seen clearly. My observations of the coyote's face owed much to the close attention I have given to our dog's face. However, I found it necessary to remind myself that a coyote has a much narrower snout than the dog. Even at that, I erased and resketched the head several times to be sure I sketched what I saw in the coyote, and not what I remembered of our dog.

After twenty minutes the coyote tired of my attention, and began to survey the enclosure. I took the opportunity to sketch gestures, (fig. 10.3). Notice how much smaller these are than the earlier study sketch. The crowing of a rooster nearby seemed to set the coyote to howling, or, as one authority says, to singing.[2] In figure 10.4 you can see how I tried to remember the gesture, my lines growing more emphatic. It is not a success. Maybe next time. The cringing, growling behavior of the other coyote caught my attention, and this I captured with more success, as the behavior occurred frequently as I did the sketch.

My studies of the coyote were aided by reading I had done. I have formed the habit of combing reference books for insights into nature. (Some are listed in the bibliography.) As I read I make notes,

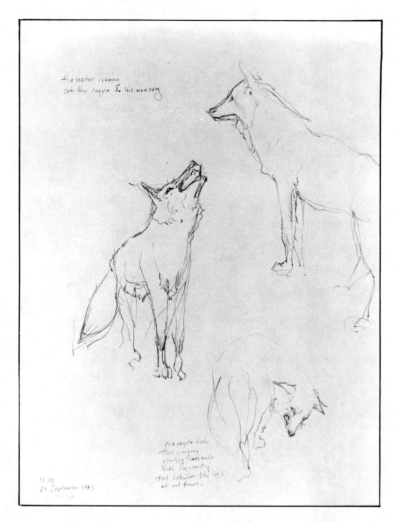

Figure 10.4
Coyote singing, pencil. Figures 10.2, 10.3, and 10.4 were all sketched in the late morning—an unusually productive session with the pair of coyotes on a single zoo visit.

and sometimes sketches, to organize observations that I feel might be useful (fig. 10.5). As you can see by reading the notes I wrote near the head of the coyote in the sketch, I learn to see one species by comparing it to another.

The Wolf. Reading about the coyote, I compared it to the wolf I had sketched on earlier zoo visits. The wolf has all but disappeared from the contiguous western states, although it still survives in the wilds of Canada and Alaska. As I sketched the wolves at the zoo, I sketched a species that may soon exist only as a creature of myth (see figs. 10.6 and 10.7).

In the sketches in figure 10.6 the wolves paced constantly and were some distance away. I used binoculars to study fur patterns, and I combined information gathered by studying several individuals to create a sketch that showed a single individual. I wanted to convey the cursorial (constantly running) nature of the wolf, and used a composite of observations. Note the number of legs in the uppermost sketch in figure 10.6.

In figure 10.7 I sketched a wolf howling, with more success than I achieved later with the coyote. It takes many studies to understand an action. Compare figure 10.7 with figure 10.4.

The Puma. The wolf has disappeared from chaparral, mountain, and desert. I have taken time to sketch another resident of the

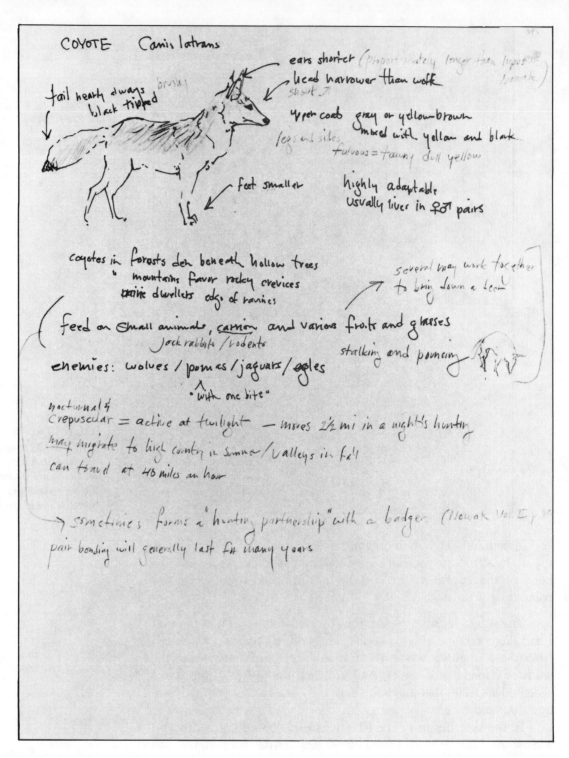

Figure 10.5
Notes on the coyote. I find it helpful to annotate any reading I do. I am more likely to remember it when I'm sketching the animal I've read about.

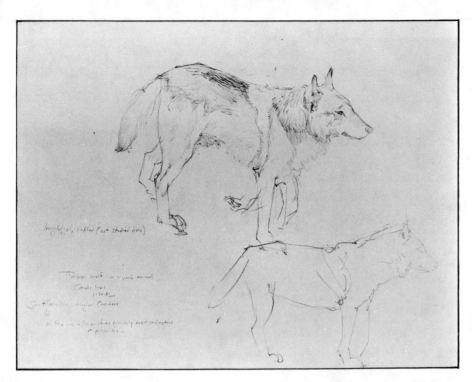

Figure 10.6
Timber wolf study, graphite and colored pencil. This is a composite wolf (note that it almost has five legs). The wolves never stopped running the whole time I sketched.

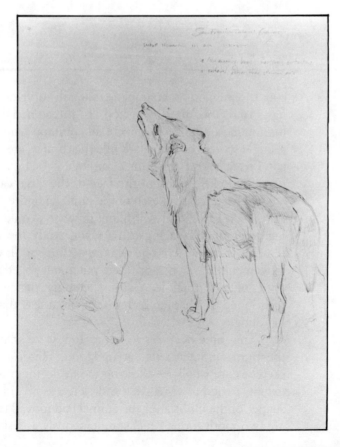

Figure 10.7
Timber wolf study, pencil. This sketch conveys the gesture, but not the haunting sound.

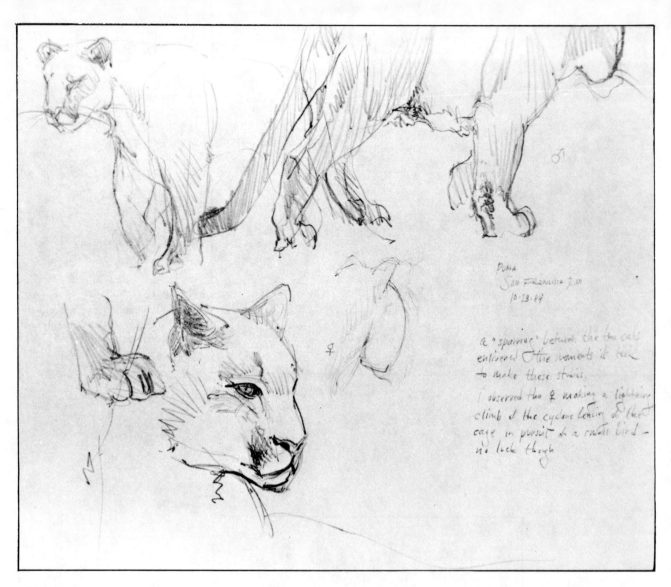

Figure 10.8
Pumas, a male and a female, Ebony pencil. One of the most majestic of the small cats, the Felidae, it seems to have the ambience of one of the large cats, the Panthera.

zoo, the puma, the large feline that still survives in these regions (see figs. 10.8 and 10.9). (It, too, is threatened by hunting.) Puma, mountain lion, and cougar are all common names for *Felis concolor,* a single species of animal. While the canines are in compounds in the zoo I usually visit, the felines continue to be housed in cages. This has permitted close study of the face of the large cats.

The truncated sketch of the puma in figure 10.8 began as a study of its feet. I found myself filling in what I could fit in of the remaining parts of the pacing cat. As you study the action of the limbs, remember to watch one leg at a time until you understand the movements of each, and then put them together. This sketch was done with a thick-lead soft sketching pencil, the Ebony pencil mentioned in chapter 2. It has a bluntness that prompts a bolder handling.

The three postures in figure 10.9 were studied and sketched as the puma momentarily sat or stood. Here, as in figure 10.3, the sketches are smaller—allowing me to do them quickly. To a limited extent, I tried to visualize the skeleton as an aid to remembering the shapes of the limbs after the animal had moved (see fig. 10.10). There are two motivations I feel simultaneously as I sketch. In part, I wish

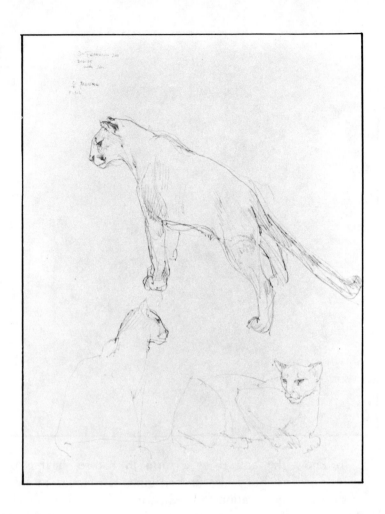

Figure 10.9
Gestures, pencil. As you can see from the sketch on the lower left, no pose or aspect is assumed for long.

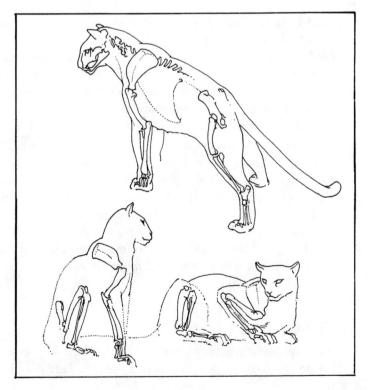

Figure 10.10
The skeleton of the limbs in the gesture sketches in figure 10.9. Visualizing this can be an aid to memory. Note the location of elbow and knee in the two lower sketches.

Figure 10.11
Badger study, pencil. This was an injured animal that could not be released back into the outdoors and be expected to survive. It seemed forlorn. Was I projecting human values onto an animal?

to know the animal as a form in nature, having recognizable proportions. But I also find an inner satisfaction in entering into a state of concentration focused on my subject. The animal's presence brings forth some element from within myself, expressed in whatever I choose to emphasize in a sketch. I can never anticipate what this will be.

Apart from the large metropolitan zoo, many regions possess smaller municipal zoos or junior museums that house small mammals, reptiles, and birds. The metropolitan zoos themselves maintain animal resource centers that visit local schools with the small animals in their collections. In some instances these are animals that were rescued, having suffered injury, and with little likelihood of remaining alive in the wild. The badger in figure 10.11 is an example. The red-tailed hawk in figure 10.12 had been discarded in a trash container. Although it was rescued, it lost an eye—the result of being a target for a not-so-sharp shooter. The perpetrator intended to dispose of the evidence, but, like the firebird of legend, the hawk rose from its "ashes," and now educates many young minds to have a concern for its kind.

The small zoos allow more intimate viewing of the animal, less distraction than a large zoo, and more opportunity to gain a knowledge of the animal.

THE AQUARIUM

In an aquarium you may penetrate the sea and look below a surface that on the coast would only mirror the sky. Tide pool exhibits, and

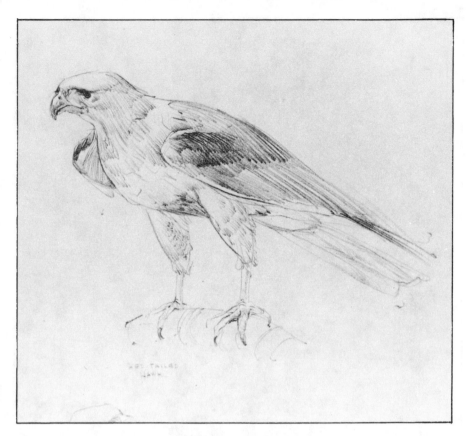

Figure 10.12
Red-tailed hawk, pencil, 4½" x 6".
Abandoned in a trash can as dead, it
was rescued and now serves in an
animal resource center teaching chil-
dren (and adults) about birds of prey
and the humans that prey upon them.

tanks that represent local coastal regions, nurture your understanding
of both pelagic (deep-sea) and intertidal life. After sketching here,
you will see with greater perception when you visit the coast. In this
watery world, plant and animal blend imperceptibly one into the
other, the distinctions blurred to the untutored eye. A sea anemone,
for instance, appears for all the world to be a plant, but is a class of
animal life, the Anthozoa. (See fig. 10.13.) This class includes the
corals.

 Sketching here presents two problems you must prepare yourself
to meet. An aquarium is inside a building, and sketching away from
public notice is next to impossible. Also, it is often darkened, the
light coming only from the tanks.

 With the popularity of an institution like an aquarium, it is
unlikely that you will escape the curious, and you may even find
yourself perceived as a nuisance. (Some art museums now prohibit
unauthorized sketching in their galleries.) I plan my visits for early in
the day on weekdays—the moment the aquarium opens its doors. My
use of a clipboard as a sketchbook makes it less obvious that I am
drawing. For a quick sketch I may stand, but in any sustained
drawing this places a strain on the back, and I sit upon a small,
unobtrusive portable stool. (See fig. 2.12.)

 The moment I am seated, there is no hiding my activity, and I
must field the inevitable questions: "Are you an artist?" and "Do you
do this for a living?" On weekdays I sometimes find myself sur-
rounded by schoolchildren or young adults from a high school, all on
a field trip. Briefly there is bedlam. I feign continued sketching
(working at a portion of the sketch of no consequence) until they
have passed. School groups usually have vanished by midafternoon.

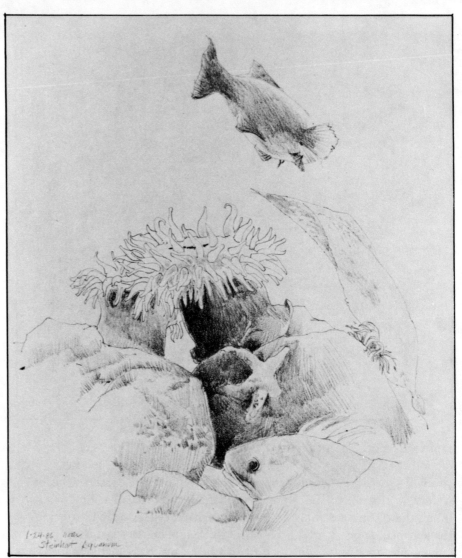

Figure 10.13
Study in an aquarium, colored pencil. I began this sketch with five tentacles of the anemone on the right. Having sketched these complicated shapes (partly in anticipation of the anemones' closing up), I then proceeded easily to everything else. In the low light, contrast guided my selection of color: the anemones are a deep maroon and the sea star or starfish is a yellow-orange on reddish-brown rocks.

What will strike you most in an aquarium will be the stunning color, radiant in the darkness surrounding the tanks. In figure 10.13 the colors of the sea anemones and their environs was interpreted with colored pencil, the least troublesome color tool to manage in dimly lit aisles thronged with people. Coping with the dim light takes some ingenuity. One of my students contrived a battery-powered light attached to a clipboard. Although it helped, it did not provide quite enough light. The sketch of the octopus in figure 10.14 was executed in the almost-nonexistent light coming from the tank. Once again, memory plays an important role in such a sketch, which must be completed in daylight, as soon as possible after you leave the darkened corridors between the tanks.

THE NATURAL HISTORY MUSEUM

Sketching or drawing animals inevitably requires a visit to a museum that exhibits taxidermic specimens of the animal in contrived but natural-appearing surroundings. While this is undeniably an invalu-

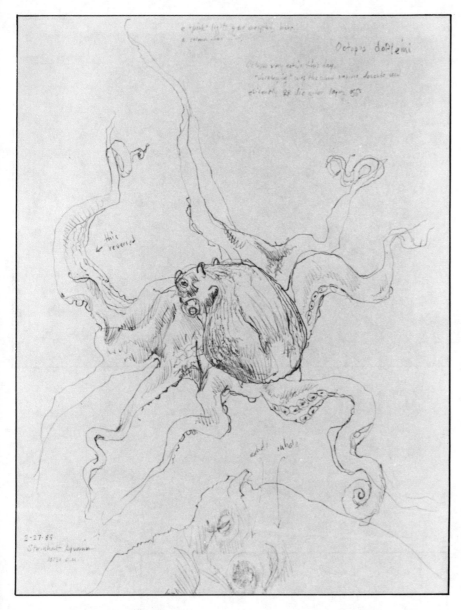

Figure 10.14
Study of an octopus, pencil. This was an unexpected pleasure. It is rare that my visits to the aquarium have coincided with the octopus in any activity. More often than not, it is at rest, compressed into a corner of the tank.

able source of natural history education, it has a serious pitfall for the unwary novice who wishes to draw animals. The flush of life is gone from your subject; it is no place to form initial impressions of an animal. If living animals are unavailable, making your first sketches from photographs is preferable to drawing from specimens.

Modern museum taxidermy mounts are sometimes freeze-dried preparations, particularly with the smaller mammals. An animal suffering accidental death without anatomical disfiguration is brought to the museum and immediately frozen. The subsequent steps in this process tend to preserve the quality of the animal more successfully than the older method of mounting skins. Postures, actions, and even facial expression can be re-created with some success (see figs. 10.15 and 10.16).

The well-prepared museum mount offers you the opportunity to study details of anatomy that cannot be discerned in a living, moving subject. Rarely do photographs have sufficient clarity of detail to effectively show hair tracts, the form of the eye, nose, mouth, and ear, the shape of toes, or the patterns of feathers (in the case of birds). The

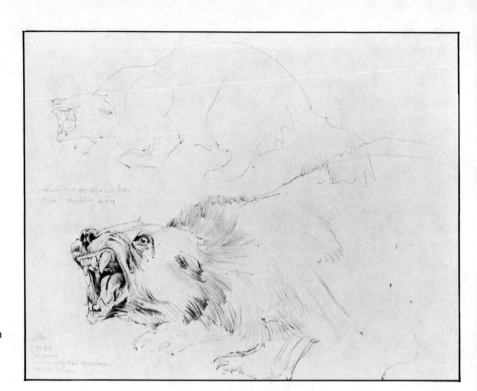

Figure 10.15
Wolverine study, museum specimen, Negro pencil. Even when sketching a specimen—and therefore dead—animal, I try to keep a living, breathing animal in mind.

Figure 10.16
Desert bighorn sheep study, museum specimen, pencil. Visual understanding of animals you rarely see (or have never seen) in life is hard to come by. The natural history museum is an important resource. Television nature films often provide close observation of animals you will see no other way. I often sketch from them.

museum mount is one of the last sources you consult, a source that adds focus to the impressions you have formed of the living animal.

Studying Bird Skins: A Lost Opportunity

The authors of many books on animal drawing written in the first half of this century tell of the many fruitful hours spent studying bird skins in the storage rooms of natural history museums. They present an almost idyllic picture of this activity—a very important part of the education of the artist who will specialize in birds. Now, however, most large museums can no longer permit casual access to their study collections. Small staffs and large demand have made it impossible. Access can be gained only if you demonstrate professional need, or are part of an educational program associated with the museum.

This is a serious loss to the artist who is too young to present convincing credentials, and yet may be developing a knowledge of things like the specific coloring that separates two nearly identical subspecies. (Color photographs at their best are still too inaccurate to be helpful here.) The bird mounts on permanent exhibit must serve.

I have observed the silhouette of the red-tailed hawk spiraling in afternoon thermals high over chaparral. I have sketched captive red-tails during summer exhibitions put on by an animal resource center (see fig. 10.12.) Ultimately, it was only in the mounted bird specimen that I could study the detail of its form (fig. 10.17). Cumulatively, these experiences have helped me form a working knowledge of the bird—a working knowledge, but not an authority. Authority belongs to the specialist, to the ornithologist-illustrator like the late George Miksch Sutton (see the Bibliography). However, I have come to know the bird, and my world is the richer for it.

Figure 10.17
Red-tailed hawk study, museum specimen, Negro pencil, 8½″ x 14½″. In my desire to do a large sketch of the hawk, I ran out of room for the tail feathers and had to extend a second page to be attached to the first.

11:30 A.M.
Strybing Arboretum
26 FEBRUARY 1986
a warm Spring morning

Figure 10.18

Magnolia blossoms on a tree in an arboretum, pencil and watercolor. I look forward to the early flowering of this tree, which is planted in many gardens near our home.

THE BOTANICAL GARDEN

In the midst of urban surroundings, the botanical garden or arboretum is seemingly a retreat into nature. But for many, the planned and arranged quality of a public garden may strike a false note that is difficult to ignore. I found more satisfaction in sketching a small cactus in the natural surroundings of its desert than I did in sketching more magnificent specimens in a garden.

On another note, the botanical garden offers the opportunity to make sketches of plants that are rare or are found only in far parts of the world. Conversely, you may find here plants that are not native to your region, but are planted around homes in your neighborhood—the plant that has become naturalized by way of cultivation. Alien or not, it has—for a time—become part of our botanical environment. The eucalyptus was introduced into the Pacific coast from Australia as a lumber crop and a windbreak. Having no natural inhibitors here, it has proliferated. It is loved and hated, depending on whether the question is one of aesthetics or ecology. It is now inescapably part of the landscape of the chaparral regions of California.

The magnolia tree in figure 10.18 has always brightened my Februaries with its flowering. It may not be native to my hillsides, but it is common to my streets. I was delighted with the one I found in flower at the arboretum.

Gardens are outdoors, and suitable clothing should be considered. The problems of sitting in the hot sun, or becoming chilled

in the cool air, apply here as they did in all the outdoor locations discussed earlier. Insects, particularly bees, are attracted by the profusion of flowering plants that are concentrated here. On occasion, I have been routed from a desired spot that happened to be near their center of activity.

During pollen seasons, botanical gardens will have a concentration of pollens. Should you suffer from allergies, a pollen mask will be needed. I have found them effective.

As in the instance of the zoo or museum, be prepared to come under the public eye.

11
THE FIGURE
IN THE LANDSCAPE

As we make treks into nature, sketchbook in hand, we will draw the landscape and the animals we find in it. We might tend to ignore any human presence we come upon, viewing it as intrusive, as breaking the spell of our communion with nature, or as being too difficult a subject to sketch. But consider the idea that the portrayal of a human presence creates a contrast and a connection with the landscape, that it will accent the remoteness of a geography with the intimacy of a small presence, a reflection of ourselves. In the expanse of a meadow or on a stretch of coastline, a figure has small scale, and it need not be difficult to sketch.

If you glance back at figure 6.9, you will notice two small figures on the shore, tending their fishing gear. You may not have noticed them at first, but their presence adds a small focal point to the panoramic view of the rugged shore. Without them the sketch would communicate a general scene with no specific indicator of its scale. With them, the sketch not only contains a reference that communicates scale but seems to represent a specific moment.

A SENSE OF MOMENT

A landscape without a figure or an animal seems timeless and eternal. Sketch in a figure and you suggest a particular day and hour. In both figures 11.1 and 11.2 the landscapes are identical, but in figure 11.1 I show a man whom I saw walking toward us along the side of the road as we drove near the edge of the desert in the early morning. His presence in the early hour gave scale and moment to the vastness of the landscape.

The sketch suggests but does not clearly describe the passing figure. I saw his shape as a vertical accent to a place dominated by the horizon and the diagonal slopes of the mountains. His solitary presence touched some inner sensibility and was impressed on my memory. I had time to notice only that his eye level matched the horizon. At home the following day I sketched what I could remember. What a figure may add to a landscape can be seen by comparing figures 11.1 and 11.2 and drawing your own conclusions.

Figure 11.1
Walking on the desert, pencil 3½ x 4½″. The man walked far from any apparent point of origin, toward some distant destination. He struck a chord in my imagination as he passed by us on our way home from the desert, and I sketched what I could remember of him.

Figure 11.2
The same desert view as in Figure 11.1, but without the human presence. How much did it add—or detract?

Of course, much depends on the motive of your sketch. When the landscape itself is your inspiration, the inclusion of even a small figure may break the spell.

SCALE

Human figures, sketched into their surroundings, may provide a contrast that suggests how large a hill might be or how high a cliff looms (see fig. 11.3). Here, the people lining the shore were netting small fish, joined in their activity by a harbor seal and numerous

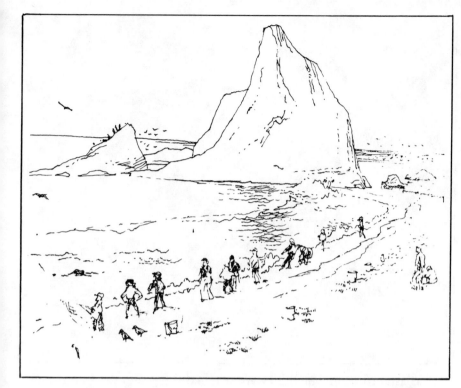

Figure 11.3
Fishing for smelt, technical pen. I began the sketch with the central figures, then sketched those to either side of them, following a gentle diagonal. I stood high on an embankment, and thus the horizon was well above the figures.

birds. The figures are the merest jottings, little short of stick figures, depicting the various gestures of standing, pulling, and holding a net. They were so small on the page that I had few problems with proportion to concern me. I limited my attention to making sure that the legs made up almost half the standing height of the figure—a basic proportion.

In figure 11.4 you can see how simple stick figures can be transformed into the suggestion of small figures. The stick figure represents the axis lines of the various parts of the human form. As with the deer discussed in chapter 8, this is a way of suggesting gesture and movement. Heads, hands, hats, jackets, skirts, and pants are sketched as simple shapes over the stick form.

In figure 11.5 both the figure and the animal are dwarfed by the

USING A STICK
FIGURE TO
SUGGEST GESTURE

USING SHAPES
TO SUGGEST
A FIGURE

Figure 11.4
Methods to sketch figures simply and quickly. Compare the figures sketched here with their counterparts in figure 11.3.

Figure 11.5
Silhouettes on a rock, pencil and watercolor. The shapes of shadows sketched attentively can imply the strong light of the sky.

coastal rock on which they are perched. They and the fishing tackle extend above the horizon line, giving them a preeminence in spite of their small size. I first sketched each in silhouette, noting the contour of the shape that each formed. This is a method I often use when sketching figures in the out-of-doors. I am usually too far from them to see the forms distinctly, and I treat each element of clothing as a shape, the shape it presents to my eye at the moment.

IN CONTEST WITH NATURE

Here is the drama of the outdoors. Hunting and fishing have been a part of the portrayal of nature by nearly all cultures. The earliest drawings of animals at ancient cave sites are thought by some to be associated with hunting—and often hunters are portrayed alongside the animals. The actions, the gestures of fishing, are moments of a contest. While the figure with a gun doesn't appeal to my particular sensibilities, figures with a net, or with a pole, line, and hook, do.

Figures 11.6 and 11.7 were sketched along the same fishing beach depicted in figure 11.3. In them, I used a Japanese brush-pen for the line. The subjects in figure 11.7 and the lower sketch in figure 11.6 were begun with the shape of the central article of clothing—the overalls on one, the jacket on the other. I added touches of watercolor to two of the three sketches, attempting to suggest the reflections on the wet overalls and the foaming surf.

The figure in each of these sketches has become the subject. I have emphasized movement and gesture as reflected in the folds of the clothing. It is no longer the simple expansion of a stick figure used in figure 11.3, or the simple silhouette used in figure 11.5. The figure is here depicted with the same attention to form and proportion given to the animals discussed in chapters 7, 8, and 10. This degree of definition of the figure will take some practice.

The subjects in figures 11.8 and 11.9 were not in contest with

Figure 11.6
Figures and surf, brush-pen and watercolor. Predator and prey, a contest with nature—I thought of both. My elevated vantage point made for unusual relationships of arrangement in the upper sketch.

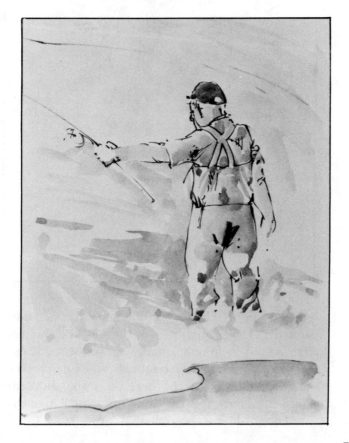

Figure 11.7
Casting, brush-pen and watercolor. I was taken by the shapes in the overalls, and the legs disappearing into the surf. I also thought of the Japanese artist Hokusai, who loved to portray human activity in the midst of nature.

Figure 11.8
A lone figure seated on his smelt bucket, lost in solitude, brush-pen.

Figure 11.9
Beachcomber, technical pen. This sketch is little more than the shapes of shadows.

nature. Rather, they were lost in contemplation, a contemplation about or inspired by the surrounding forces of nature. The roar of the surf, the glaring brightness of the sun, and the incessant wind have transported them momentarily out of the mundane.

In a sense, we have returned to a human presence giving a sense of moment to a landscape (here a seascape), but somewhat in reverse. Here the landscape has given its eternal moment to the passing presence of human perception.

12
FROM SKETCH
TO WORK OF ART

The uncomplicated pleasure of the sketchbook comes into full flower as you sit and draw all that delights you in the out-of-doors. Sitting and leafing through its pages, you may recall your first sighting of an eagle or the liberating expanse of a landscape. Indeed, the sketchbook is a journal of discovery. But there is another side to it as well. It can be, and has become for many, a wellspring for an art inspired by nature.

A landscape painting or an illustration of an animal or flower can easily take shape in a simple sketch. Its brief outlines may tantalize you. You find yourself wanting to do more with the image. You explore the qualities of light, the possibilities of a vantage point, and various compositions—all on the pages of the sketchbook as you sit on location.

Sketches can be done with the subject immediately before you. You may refer to it as you study form, movement, light, and surface. Later, the painting, print, or illustration can be worked up at home in the convenience of a comfortable environment. The sketches have become your subject, your reference. The artwork relies on the sketches, but it may also reflect your thought and your memories of the subject. It may be a literal portrayal, accurate in detail, or it may be an abstraction. Between the sketch and the finished work, there is a process of transformation, a piecing together of fragmentary sketches to form a fully developed and unified visual idea.

THE SKETCH AS ART

All the sketches illustrated in the preceding chapters concerned the recording of nature—mountain, flower, bird, and sky. Consider how these sketches might provide the ingredients of a painting or illustration. A sketch may offer immediate possibilities, needing little change or addition, even to its casual and intuitive composition. The brief sketch in figure 12.1 focuses on the chance arrangement of erratics (rocks deposited by retreating glaciers) in a Sierra location I visited. Soon after returning home I painted a watercolor from the sketch. Color and light were improvised from memory. The sketch served, with little alteration, as the basic design. I chose to trust the

17 JULY 1985
near Lake Tenaya

Figure 12.1
Three erratics, pencil. This became the basis for a watercolor. An earlier trip to the region had prompted a number of sketches from memory (see fig. 5.6), which in turn primed me to seek the possibility I explored in this sketch.

seemingly accidental configuration of arrangement that had prompted me to do the sketch.

Whether you wish it or not, your personality governs what you select to sketch, and what you select to emphasize within the sketch itself. If you retain the preferences that seem to emerge in the sketch, making them a component of your painting, the painting is more likely to convey subtlety in your response to nature. This is the unique value of sketches, a value that is likely to be lost when you defer to photographs for the "truth" of what you saw.

A sketch can be evocative, and come to be valued more highly than the artwork it engenders. Thomas Moran's watercolor sketches (figs. 1.10 and 1.11) are good examples. During his lifetime his reputation was based on large elaborate oil paintings of western landscapes, with the sketches known by few. Now, the sketches have come to be considered his best work. To our modern eyes, educated to an appreciation of spontaneity and direct execution, the sketches seem better to convey the truth of Moran's experience of the monumentality and overpowering grandeur of the mountain and river scenes that inspired him.

A sketch can illustrate. Ann Zwinger's pencil sketches (figs. 1.12 and 1.13) focus on the particular. We walk around the plant with her, seeing several of its aspects. We pick it up and look closely at its intricate forms. The sketch is a sequence of contemplative moments, and remains of as much interest as the illustration it will become—if not more.

THE SKETCH AS REFERENCE

Rather than serving as a complete solution, as in figure 12.1, the sketch may provide only part of it, with numerous other sketches adding still more parts. The spirit and atmosphere of a place, the

quality of its light, the character of the landscape, and details of flower, leaf, and bark may be the subject of numerous sketches—all to contribute to the creation of a single work.

How many sketches are needed? How complete should they be? How accurate? And what about photographs?

Photographs and Slides

Photography is a useful reference tool, and many use it to gather information that cannot be obtained in any other way. It is invaluable in the study of animal movement, where the human eye sees little more than a blur. When locales are difficult to revisit, or circumstances do not permit sketching, using the camera is common sense. However, the photograph is seductive in its seeming reality. Lacking self-confidence, many will defer to the "truth" of the photograph, not taking into account how the properties of a camera lens may distort visual fact.

Aside from its obvious usefulness, the photograph can still mislead you. First, the camera has but one eye. What it sees close up with its one eye is quite different from what you see close up with two. You see farther around small forms and have a wider field of view. Close-up photography appears to distort what we normally see. Unless we are familiar with the subject in the photograph, we are unlikely to detect and compensate for the distortion. For subjects in the middle distance, the distortion is less noticeable, but it is still there. Close one of your eyes and you will notice that foreshortening appears exaggerated. This is what a camera sees. This causes problems when working from photographs of animals, especially three-quarter views. The nearer portion of the animal will look too large for the farther portion.

Second, no film accurately reproduces light levels or color. Depending on the chemical properties of the film, the time of day, weather conditions, your camera lens, and the film and print processing, the photograph will emphasize some colors, falsify some, and lose others altogether. Superficially, the slide or photograph will appear to be accurate, but the true qualities of the colors in nature have been lost. To the degree that it partakes of the color and light balance in the photograph, your painting will have an artificial appearance.

My advice? Use photographs sparingly. Always do your own photography (for ethical reasons, if for no other). And beware—the mechanics of raising the camera to the eye, composing through the viewfinder, focusing, and checking the aperture and shutter speed may occupy your attentions to the point where your experience of the subject itself is much diminished.

How complete should sketches be to serve the purpose of reference? How many do you need to do? How accurate must they be? The answers to these questions are matters of quantity and quality and cannot be stated in absolute terms. It depends on the nature of the project for which the sketches are intended. It depends on how much experience you have had, and your working methods.

You might find that the barest sketch is enough to bring an image—even detail—to memory. Then the sketches can be brief and

summary. Or you may find that you require more detail, more information than quick sketches provide. Then you will need to sketch to a greater degree of finish; you will need to do studies. The end product you have in mind has much to do with what the sketches need to be.

Exploratory Sketches. It is a good beginning to any project to acquaint yourself with the place or subject through quick sketches. The lie of the land, the plants, even the insects are worth noting. Although any one of these may not apply directly to the purposes of your painting or illustration, they will be effective aids to memory when you are no longer on location.

Study Sketches. As an exercise, do several sketches of a subject you may wish to paint or illustrate. Do them from a variety of vantage points. Do detailed studies of any more complex aspect of your subject. Written notes, amplifying the sketches, can be very helpful. When you return home, array the sketches on a table. Undertake a complete study—or a painting, if you like—using this source material. The first efforts are likely to be frustrating, because you are placing unaccustomed demands upon memory. Note down what you find lacking in your field sketches, and return to your location with the purpose of sketching the needed material. In addition to sketches that define the contours of forms, do sketches that note the quality of light, texture, patterns, arrangement, and scale. With a little experience you will know what your sketches need to contain.

There are pitfalls. The pursuit of accuracy can overtake you, causing you to lose sight of the nature of your original idea or inspiration. It is an accomplishment to be able to reproduce a subject accurately, but always ask yourself if that is your central intention.

When you are preparing for a painting or illustration, do no more study sketches than you think you will really need. If your studies are carried too far, they may rob the finished work of the excitement of discovery and the challenge of problem solving. Too much preparation can make the final painting redundant.

SKETCHES FOR AN INTAGLIO PRINT: AN EXAMPLE

Northern Elephant Seals, Año Nuevo (fig. 12.2) is a drypoint. The drawing was scratched into a zinc plate and then inked and printed in the manner of an etching. The idea for the plate grew out of numerous sketching trips to Año Nuevo, a California State Preserve where elephant seals mate and rear their young. (See chapter 6.)

On our first visits I was inspired to do small watercolors of the point and its dunes. The first sketches I did were incidental to these watercolors, occupying moments between washes or between different watercolor studies. They were exploratory; no preconceived goal was attached to them. The sketch of Año Nuevo itself, an island with its abandoned lighthouse keeper's home, just off the point, is cursory (fig. 12.3). I took more pains with the sketch of the plants growing in the dunes (fig. 12.4) because I wanted to identify them later on. This sketch was done three days after the sketch of the island. On a return trip the following year I sketched the dunes and the afternoon clouds

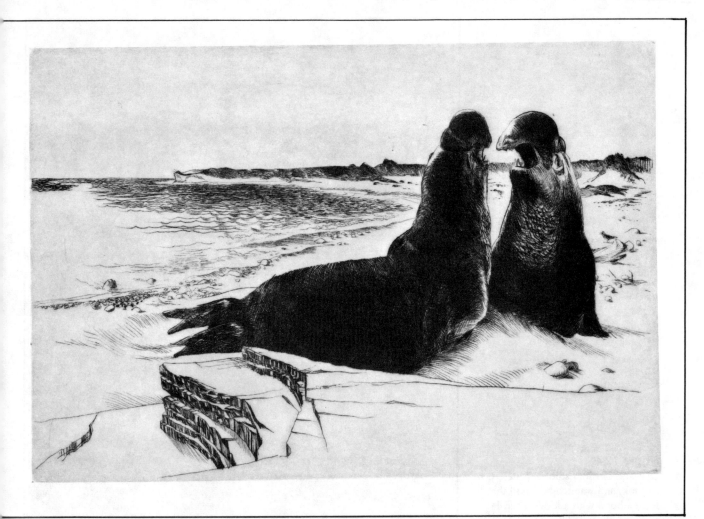

Figure 12.2
Northern elephant seals, drypoint,
6″ x 9″.

Figure 12.3
Año Nuevo Island, pen and ink. This
was a casual experiment with the pic-
torial possibilities of the island.

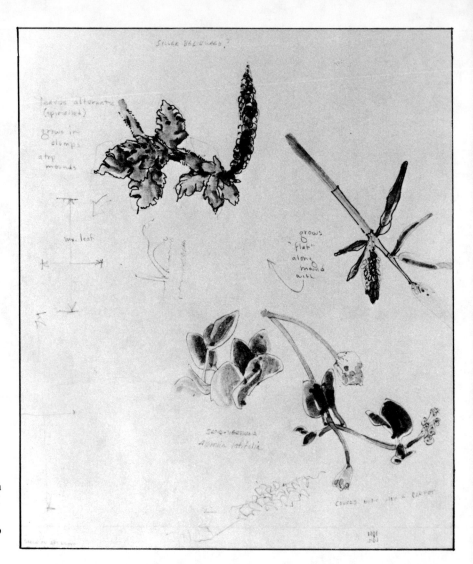

Figure 12.4
Leaf and blossom studies, pencil, pen and ink, and watercolor. I find that I form a bond with a locale when I make an effort to know its plants—to botanize.

blowing down the coast (fig. 12.5). On trips two years later I turned my attention to the elephant seals.

There had been few elephant seals on the point when we made our original trips there. There would be one or two males resting peacefully on the shore, molting. Then, in successive years, we began seeing them in greater numbers. More were coming onto the beach during the summer, the season of our most frequent visits to the site. There was more activity, with mock challenges between young bulls and not-so-mock challenges between the older ones. Twenty-five or thirty of them might be on the beach, with more swimming in the surf.

The sketches I undertook of the elephant seals were study sketches. They were not done as casual intervals between watercolors; I gave my full attention to them. Even here, I must admit, I did not have any kind of finished product in mind. I found myself interested in the elephant seals; I wanted to know them better. I have found that I come to know what I draw, and sketching has become my method of inquiry. When I get home with a group of sketches, I spread them out and ask myself if I believe them. I ask myself if I observed with comprehension the subject of the sketches. It is at this point that I frequently open the reference books to see what I can learn about my

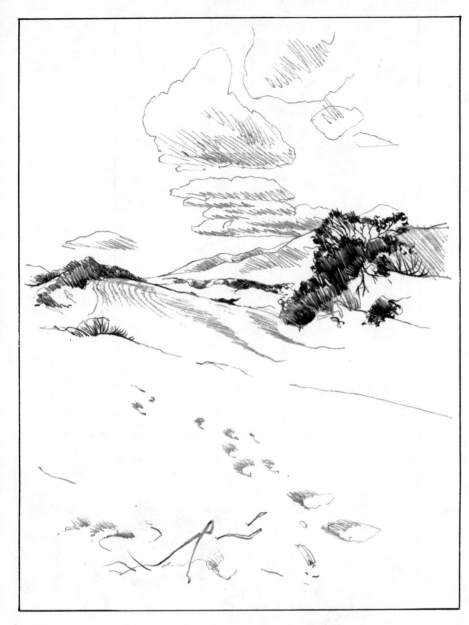

Figure 12.5
An exploratory sketch of the dunes, pencil. The configuration of land at Año Nuevo is ever changing as the dunes migrate across the point, carried by the winds. Yellow lupines grow in more stable areas of ground.

new interest. When I return to the location I reexamine the subject for what I may have missed the first time. I approached sketching the elephant seals in this way.

In eight day-long trips over two months I accumulated fourteen pages of studies (see figs. 12.6 and 12.7). Most of them were specifically sketches of postures and anatomical details of the seals. A few of them depicted groups of seals in their surroundings. Almost all were pencil sketches with watercolor added to show molting or the reddish mottling of the throat. The trial of using watercolor in a sketch while sitting in the midst of blowing sand seems a good recommendation for colored pencils, but I prefer the directness of watercolor.

Some months later a colleague offered to print proofs of drypoints, were I to do some. After several unsuccessful experiments, I remembered the elephant seal studies. I felt that the black velvety skin of the elephant seal would be well suited to the qualities of a drypoint.

Figure 12.6
Studies of the northern elephant seal, pencil. Pale pencil lines exploring an unfamiliar form may not photograph or reproduce well. A light touch is useful, in fact essential to this kind of explorative sketch.

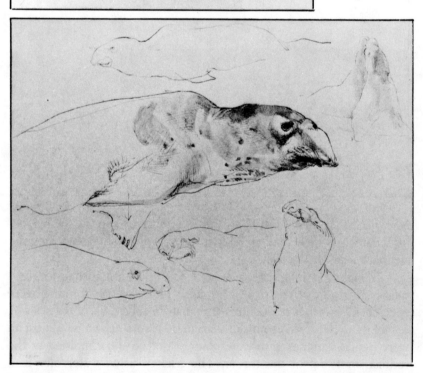

Figure 12.7
Studies of the northern elephant seal, pencil and watercolor. In part, these sketches were a way of coming to know an animal of the sea, but I also considered the possibility that the sketches might suggest a painting.

My first step was to gather my studies and array them in front of me. From the first, I considered two alternatives. I thought of depicting many seals upon the beach, much as I had seen them. I did several studies exploring this possibility (see fig. 12.8). It was too busy for the small scale of the print, and failed to convey the magnificence of the elephant seal. I abandoned it. The second alternative was to focus on a moment of challenge between two bulls.

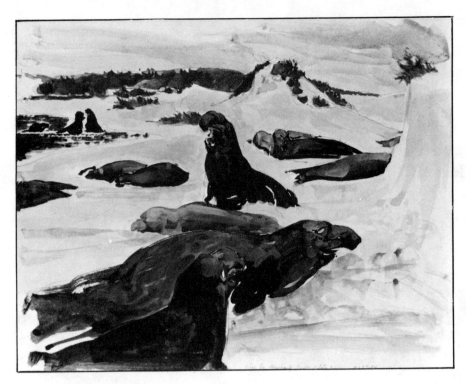

Figure 12.8
This began as a pencil sketch at Año Nuevo. Back home I added washes of ink to the shapes of the seals, and watercolor to the landscape—partly to explore the patterns this would yield. Still later I added tempera to the seals' shapes to give them form. It remained an exercise, not an idea that stimulated my imagination.

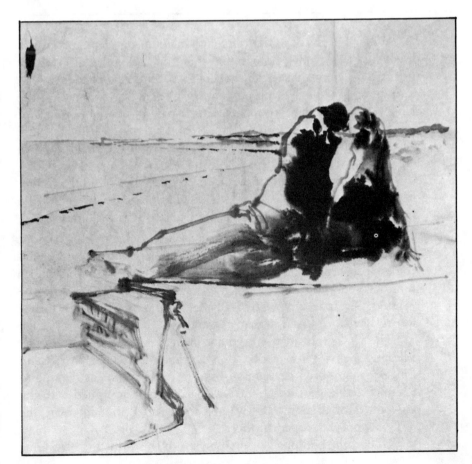

Figure 12.9
Seal sketch, Chinese ink and brush on rice paper, 12″ x 12″. This combined the rock formation in figure 12.2 with a pair of seals from the packet of sketches I had accumulated. This is one of the many variations that I explored on this theme. The rice paper made it easy to reverse the sketch for the execution of a print.

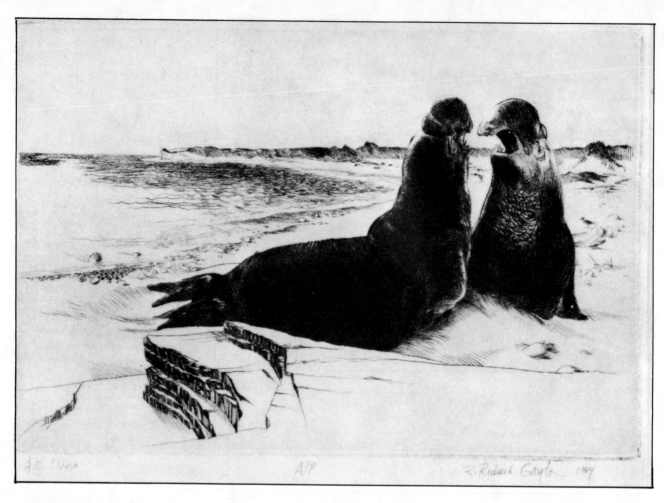

Figure 12.10
This trial proof of the drypoint, printed by my colleague, has a stark clarity. Prints are often developed further using the trial proof as a guide to determine editing or addition.

When I had consulted reference material on elephant seals, I discovered that many photographers had been as taken as I was by the image of elephant seals in challenge. It seemed, in fact, as though every photographer had photographed the same two animals at the same moment! Being thoroughly indoctrinated in the importance of originality, I almost abandoned my second alternative as well. But I decided to emphasize locale in a way that none of the photographers had.

The second series of studies focused on the seals and the feeling of Año Nuevo (see fig. 12.9). As a way of anticipating some of the qualities of the print, I decided to use rice paper with Chinese brush and ink. There were many advantages here. It took almost no time at all to experiment with a variety of compositions. I am not adept with Chinese brush painting methods, and it was easy to keep the studies from becoming too fussy. Last, the drawing on the plate had to be reversed. Rice paper is nearly transparent, and I had only to turn it over to have a reversed drawing as a guide.

The trial proof of the drypoint in figure 12.10, printed by my colleague, has a stark clarity. It is a common practice to develop prints further—even drypoints—using the trial proof as a guide to determine editing or addition. As I had become intrigued with the possibilities of drypoint and wanted to learn to print my own, the print was not developed further.

One of the editions I printed myself of this print sits before me

now, tempting me to develop others. But I know that before I plan more prints of this impressive animal, I will return to sketch it again.

A POSTSCRIPT

This book is addressed to all who have an interest in sketching in the out-of-doors. Whatever the main preoccupation of your life, it is my conviction that you will find reward in the observation of our world that sketching engenders. Sketching has long been associated with inquiring minds, without necessarily connoting an artistic undertaking. However, when your interest in it begins to include painting, printmaking, or illustration, you enter the domain of the artist. If you begin to consider a long-term commitment to an art education, it is a good idea to first study at least briefly with someone whose work you respect and whose counsel you trust.

Some will claim that they are self-taught and advise you to find your own way. None of us learn in a vacuum. Whether you seek formal instruction or investigate the whys and wherefores of your art without guidance, you learn much by example—example that others have provided. In our culture we are inundated with images, many of them from the history of world art. We may choose to absorb these influences in ignorance (and we cannot shut them out), or we may choose to study them and understand them, consciously absorbing influences that suit our purpose. Acquaint yourself with the history of art, and be guided by your interests.

There are a multiplicity of art worlds, and none of them are idyllic. Each has its politics. Illustration, the art of natural history (which includes bird art and landscape painting), western art (the art of the American West), and fine art are all distinct areas of endeavor. Unfortunately, influential critics and art historians have stated or implied that these are levels of endeavor, with fine art at the top of the hierarchy.

The nub of the issue of politics is the problem of critical attention. Early in this century wildlife artist Carl Rungius noted that if he introduced an animal into a landscape—a landscape that without the animal had received critical notice—the inclusion of the animal would end all critical mention.[1] Critical mention, pro or con, is often important to the sale of an artist's work.

We all want our efforts to be taken seriously, especially when we believe our performance to be exceptional in the context of our endeavor. Critical elitism can be denigrating. When it is part and parcel of a pursuit of novelty and a concomitant indifference to the world of nature, it is tragic.

It is unfortunate that an art which seems a worthy undertaking and a worthwhile focus of the human spirit should be mired in philosophical bickering. Perhaps you will conclude that the rewards of sketching out in nature are sufficient unto themselves. Or you may wish to join those who hope that an art inspired by contact with nature will come to be valued by our cultural pundits, and that we may all come to appreciate the precarious balance with nature in which we live.

Notes

1 BEGINNING A SKETCHBOOK

1. Bradford Torrey and Francis Allen, eds., *The Journal of Henry David Thoreau* (Salt Lake City: Gibbs M. Smith, 1984), 9:341.

2. Zbigniew T. Jastrzębski, *Scientific Illustration, A Guide for the Beginning Artist* (Englewood Cliffs, N.J.: Prentice-Hall, 1985), p. 86.

3. Torrey and Allen, 2:373.

4. Jean Paul Richter, ed. and trans., *The Notebooks of Leonardo da Vinci* (New York: Dover, 1970).

5. Carlo Pedretti, *Leonardo da Vinci Nature Studies from the Royal Library at Windsor Castle* (Johnson Reprint Corporation, 1980), p. 32.

6. C. R. Leslie, ed., *Memoirs of the Life of John Constable* (Ithaca, N.Y.: Cornell University Press, 1980).

7. Claude Roger-Marx, *Delacroix's Universe* (Woodbury, N.Y.: Barron's for Henri Scrépel, n.d.), p. 43.

8. Hubert Wellington, ed., *The Journal of Eugène Delacroix*, Lucy Norton, trans. (Ithaca, N.Y.: Cornell University Press, 1980), p. 371.

9. Ibid., p. 368.

10. Paul Kane, *Wanderings of an Artist Among the Indians of North America* (Toronto: Radisson Society of Canada, Limited, 1925).

11. J. Russel Harper, ed., *Paul Kane's Frontier* (Austin: University of Texas Press, 1971), p. 39.

12. Ibid., p. 21.

13. Carol Clark, *Thomas Moran: Watercolors of the American West* (Austin: University of Texas Press, 1980), p. 4.

14. Ibid., p. 50.

15. Charles Le Clair, *The Art of Watercolor* (Englewood Cliffs, N.J.: Prentice-Hall, 1985), pp. 12, 66.

16. Ann H. Zwinger, *Run, River, Run* (Tucson: University of Arizona Press, 1984).

17. Zwinger, private correspondence, 1985.

3 SKETCHING AND THE CONCEPT OF DRAWING

1. Jean Paul Richter, ed. and trans., *The Notebooks of Leonardo da Vinci* (New York: Dover, 1970), 2:179.

2. Rudolph Arnheim, *Art and Visual Perception* (Berkeley: University of California Press, 1974), p. 36.

3. Richter, 1:247.

4. William Charles Libby, *Color and the Structural Sense* (Englewood Cliffs, N.J.: Prentice-Hall, 1974), p. 13.

5. John Ruskin, *The Elements of Drawing* (New York: Dover, 1971), p. 143.

6. Sherman E. Lee, *Chinese Landscape Painting* (New York: Harper & Row, n.d.), p. 4.

7. Irma Richter, *Selections from the Notebooks of Leonardo da Vinci* (Oxford: Oxford University Press, 1977), p. 140.

8. Bradford Torrey and Francis Allen, eds., *The Journal of Henry David Thoreau* (Salt Lake City: Gibbs M. Smith, 1984), 2:215.

9. Michael Sullivan, *The Arts of China,* rev. ed. (Berkeley: University of California Press, 1977), p. 163.

4 Pen-and-Ink, Wash, and Colored Pencil

1. Keith Brockie, *Keith Brockie's Wildlife Sketchbook* (New York: Macmillan, 1981).

5 SKETCHING ON LOCATION

1. Jean Paul Richter, ed. and trans., *The Notebooks of Leonardo da Vinci* (New York: Dover, 1970), 1:231.

6 SKETCHING ON THE PACIFIC COAST

1. Edward MacCurdy, ed. and trans., *The Notebooks of Leonardo da Vinci* (New York: George Braziller, n.d.), p. 315.

2. Clare Walker Leslie, *The Art of Field Sketching* (Englewood Cliffs, N.J.: Prentice-Hall, 1984), p. 17.

7 IN THE REDWOODS

1. Linnie Marsh Wolfe, ed., *John of the Mountains* (Madison: University of Wisconsin Press, 1979), p. 228.

2. Mai-Mai Sze, ed. and trans., *The Mustard Seed Garden*

Manual of Painting (Princeton, N.J.: Princeton University Press, 1977), p. 53.

3. John Ruskin, *The Elements of Drawing* (New York: Dover, 1971), p. 120.

8 THE CHAPARRAL

1. Bradford Torrey and Francis Allen, eds., *The Journal of Henry David Thoreau* (Salt Lake City: Gibbs M. Smith, 1984), 4:83.

9 DESERT AND MOUNTAIN

1. Jay Heinrichs, "Is This the Oldest Living Thing?" *National Wildlife,* vol. 25, no. 1 (Dec. 1985–Jan. 1986), p. 21.

2. C. R. Leslie, ed., *Memoirs of the Life of John Constable* (Ithaca, N.Y.: Cornell University Press, 1980), p. 236.

10 EXPANDING YOUR NATURE STUDIES

1. Jonathan Kingdon *East African Mammals* (Chicago: University of Chicago Press, 1984), 1:3.

2. Francois Leydet, *The Coyote, Defiant Songdog of the West* (San Francisco: Chronicle Books, 1977).

12 FROM SKETCH TO WORK OF ART

1. Thomas A. Lewis, "50 Years of Wildlife Art in America," *National Wildlife,* vol. 25, no. 1 (Dec. 1985–Jan. 1986), p. 15.

Bibliography

Reference Books and Manuals on Drawing

Ellenberger, W., H. Dittrich, and H. Baum. *An Atlas of Animal Anatomy for Artists.* New York: Dover, 1956. At first glance the illustrations may seem too technical—and there is no text. But take the time to compare the plates of different key animals, and it becomes obvious what a wealth of information is contained here. Mammals only.

Grzimek, Dr. *Grzimek's Animal Life Encyclopedia,* ed. H. C. Bernhard. New York: Van Nostrand Reinhold, 1972. A thirteen-volume reference work on the entire animal kingdom, for the layman. Well illustrated, informative, and of incalculable value. It is available in paperbound volumes, but is better consulted in libraries.

Leslie, Clare Walker. *Nature Drawing: A Tool for Learning.* Englewood Cliffs, N.J.: Prentice-Hall, 1980. A thorough introduction to nature drawing, and to artists who have devoted their energies to it.

————. *The Art of Field Sketching.* Englewood Cliffs, N.J.: Prentice-Hall, 1984. An excellent source book for examples of sketching by a wide variety of artist naturalists.

Muybridge, Eadweard. *Animals in Motion.* New York: Dover, 1957. A photographic atlas, with a useful introduction to how animals move. Includes some birds.

Rüppell, Georg. *Bird Flight.* New York: Van Nostrand Reinhold, 1977. Excellent and instructive photography. A good description of the movement of the bird wing.

Sweney, Frederic. *The Art of Painting Animals.* Englewood Cliffs, N.J.: Prentice-Hall, 1983. A good all-around introduction to representing mammals, and one of the few sources for good information on representing birds.

West, Keith. *How to Draw Plants.* New York: Watson-Guptill Publications, 1983. There is much useful information here on pen-and-ink and on dry-brush watercolor technique.

Sketchbooks of Artist Naturalists

Brockie, Keith. *Keith Brockie's Wildlife Sketchbook.* New York: Macmillan Publishing Co., 1981. Sketches of wildlife, plants, flowers, and landscape by an accomplished artist naturalist. His emphasis is on birds.

Harper, J. Russell. *Paul Kane's Frontier.* Austin: University of Texas Press, 1971. This includes Paul Kane's own *Wanderings of an Artist among the Indians of North America,* and is amply illustrated with Kane's sketches. Now out of print, it may be found in libraries.

Hunt, David C., and Marsha V. Gallagher. *Karl Bodmer's America.* Omaha: Joslyn Art Museum and University of Nebraska Press, 1984. Sketches of landscape and portraits of American Indians made during a journey up the Missouri River in 1832–34. It is lavishly produced, with excellent reproductions of the watercolor sketches.

Luce, Donald T., and Laura M. Andrews. *Francis Lee Jaques: Artist Naturalist.* Minneapolis: University of Minnesota Press, 1982. Inspiring and instructive.

Peck, Robert McCracken. *A Celebration of Birds: The Life and Art of Louis Agassiz Fuertes.* New York: Walker and Company, 1982. Fuertes is acknowledged as an important influence by many well-known artists who have specialized in birds.

St. John, Charles. *A Scottish Naturalist: The Sketches and Notes of Charles St. John 1809–1856.* London: Andre Deutsch, 1982. His sketches are buoyant and ingenuous, his bird studies of great charm, and his diary entries informative. This may be hard to find.

Natural History Literature

Bakker, Elna. *An Island Called California.* 2nd edition. Berkeley: University of California Press, 1984. Excellent introduction to all the landscapes I have talked about here. (California covers enough of western North America to be considered a region as well as a political boundary.)

Fox, William T. *At the Sea's Edge.* Englewood Cliffs, N.J.: Prentice-Hall, 1983. Excellent introduction to the tides, coastal weather patterns, and the geology of the sea's edge. Illustrations by Clare Walker Leslie.

Krutch, Joseph Wood. *The Desert Year.* Tucson: University of Arizona Press, 1985. First published in 1952. An instruc-

tive, engaging, and contemplative study of the natural history of the Southwest—and the experience of encountering it.

Le Boeuf, Burney J., and Stephanie Kaza, eds. *The Natural History of Año Nuevo.* Pacific Grove, Calif.: Boxwood Press, 1981. Special chapters on the birds of the coast, geology, and the elephant seals.

Muir, John. *The Mountains of California.* Berkeley: Ten Speed Press, 1977. A good introduction to this well-known naturalist's writings.

Ricketts, Edward F., and Jack Calvin. *Between Pacific Tides,* revised by Joel W. Hedgepeth. Stanford, Calif.: Stanford University Press, 1968. First published in 1939, this is an excellent guide to the intertidal world at the shore.

Russell, Israel C. *Quaternary History of the Mono Valley, California.* Lee Vining, Calif.: Artemisia Press, 1984. Don't let the title put you off. It is a well-illustrated and engrossing firsthand account of the landscape of the Mono Lake region, written in 1889.

Ryser, Fred A., Jr. *Birds of the Great Basin: A Natural History.* Reno: University of Nevada Press, 1985. More information about more birds than in any similar reference work. This is a treasure!

Seton, Ernest Thompson. *The Arctic Prairies.* New York: Harper & Row, 1981. Originally published in 1911. A captivating narrative of a journey by canoe in northwest Canada "to see the Caribou." By his own account, he did over five hundred sketches on this summer journey, and some are used here as illustrations.

Sutton, George Miksch. *To a Young Bird Artist: Letters from Louis Agassiz Fuertes to George Miksch Sutton.* Norman: University of Nebraska Press, 1979. A good introduction to the special problems of representing birds.

Whitney, Stephen. *A Sierra Club Naturalist's Guide to the Sierra Nevada.* San Francisco: Sierra Club Books, 1979. Not a field guide in the usual sense, the geology, meteorology, botany, and zoology are all treated in depth and as interrelated aspects of the Sierra. Extraordinarily well done—and with the author's own drawings as illustrations.

Zimmer, Kevin J. *The Western Bird Watcher.* Englewood Cliffs, N.J.: Prentice-Hall, 1985. A useful guide to identifying (and, therefore, observing) birds special to western North America. The section on shorebirds is of particular interest.

Zwinger, Ann H. *Run, River, Run.* Tucson: University of Arizona Press, 1984. A moving introduction to the landscape and history of the Green River as it winds through Wyoming, Colorado, and Utah. Illustrations by the author are based on her sketches.

————. *Wind in the Rock.* New York: Harper & Row, 1978. A natural history of the Four Corners region. The narrative of a personal journey intertwines with recounted history, and is illuminated by sketches.

West Meets East

The art of the Far East has a long tradition of representing nature. It is worth some investigation.

Michener, James A. *The Hokusai Sketchbooks.* Rutland, Vt.: Charles E. Tuttle Co., 1958. Hokusai's representations of nature were an early inspiration for me, and it caused me no little regret that I was unable to secure permission to reproduce one or two of Hokusai's woodblock prints. Although they are not sketches in the sense of the word as used in this book, they are a delight of spontaneous and spirited observation.

Yu, Leslie Tseng-Tseng. *Chinese Painting in Four Seasons: A Manual of Aesthetics & Techniques.* Englewood Cliffs, N.J.: Prentice-Hall, 1981. The American West is the gateway to the Orient. The art and traditions of the Orient have much to offer in any growing appreciation of nature. This manual is valuable in that regard, whether or not you choose to do the brush painting.

Field Guides

Most field guides are helpful, and I have decided not to list them here. To an extent, you will discover that it often takes more than a single guide for each area of your interest. This is especially true of wildflowers—no small guide could possibly contain all the different species. However, I *have* found one particular field guide to birds easier to use than the others, although all are good.

Robbins, Chandler S., Bertel Bruun, and Herbert S. Zim. *Birds of North America.* Rev. ed. New York: Golden Press, Western Publishing Company, 1983. Users sometimes call this "Singer's guide," as it was illustrated by Arthur Singer. Range maps, information, and illustrations appear on facing pages.

Index